AUSTRALIAN FALCONS

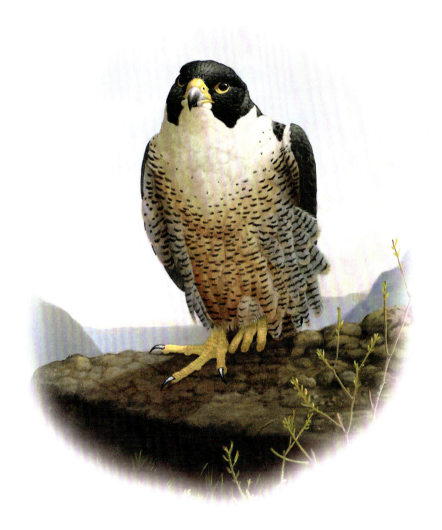

PETER SLATER

with SALLY ELMER

Special thanks to RAY GARSTONE and RAOU

First published in 2024 by Reed New Holland Publishers
Sydney

Level 1, 178 Fox Valley Road, Wahroonga,
NSW 2076, Australia

newhollandpublishers.com

Copyright © 2024 Reed New Holland Publishers
Copyright © 2024 in text: Peter Slater and Sally Elmer
Copyright © 2024 in images: Peter Slater and Sally Elmer, with additional material as credited on page 239

All rights reserved. No part of this publication may be reproduced, stored in a retrieval system or transmitted, in any form or by any means, electronic, mechanical, photocopying, recording or otherwise, without the prior written permission of the publishers and copyright holders.

A record of this book is held at the National Library of Australia.

ISBN 978 1 92554 674 3

Managing Director: Fiona Schultz
Publisher and Project Editor: Simon Papps
Designer: Andrew Davies
Production Director: Arlene Gippert
Printed in China

10 9 8 7 6 5 4 3 2

OTHER TITLES BY REED NEW HOLLAND INCLUDE:

The Slater Field Guide to Australian Birds. Third Edition
Peter Slater, Pat Slater and Raoul Slater
ISBN 978 1 92107 316 8

Field Guide to Birds of North Queensland. Second Edition
Phil Gregory and Jun Matsui
ISBN 978 1 92554 625 5

Australian Birds In Pictures
Matthew Jones and Duade Paton
ISBN 978 1 92107 317 5

Parrot Conservation
Rosemary Low
ISBN 978 1 92554 646 0

Encounters With Australian Birds
Stephanie Jackson
ISBN 978 1 92554 695 8

A First Book of Beautiful Bird Songs (book with speaker)
Fred van Gessel
ISBN 978 1 92554 677 4

For details of these and hundreds of other titles keep up with Reed New Holland and New Holland Publishers

 ReedNewHolland
 @ReedNewHolland and @NewHollandPublishers

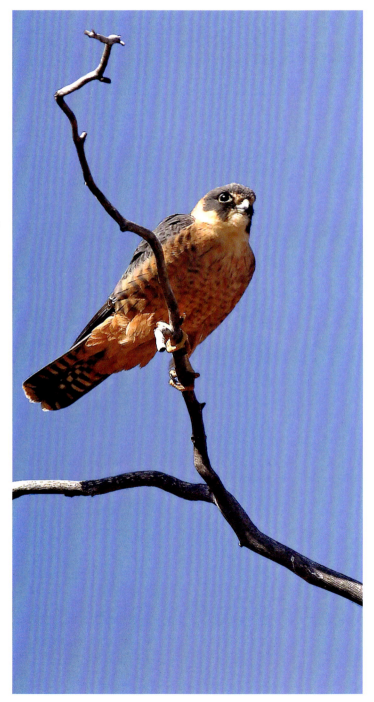

FOREWORD

In 1970 Peter Slater published *A Field Guide to Australian Birds: Non-Passerines,* the first field guide of its type in this country. The guide was a godsend to birdwatchers and ornithologists. The CSIRO's John Calaby, Graham Chapman, Harry Frith, Gerry van Tets and others contributed text for certain bird groups, Peter illustrated the volume and wrote the section on Falconiformes, the group he knew best.

My first contact with Peter, in 1972, was about Black Falcons and Peregrines, and our contact over the next few years was mostly about these two species. Based on a photograph, Peter had painted yellow feet on the Black Falcon in the 1970 guide and he wondered if this was an error. I lived in Port Augusta where the species was fairly common and trapped and photographed an adult to show Peter its whitish-grey feet. Peter came down from Brisbane and we visited Black Falcon nests at Beltana Station (middle Flinders Ranges) and at Tom Brandon's farm in Melrose where Peter took notes. Always alert to opportunities for learning, Peter watched carefully as we drove through the ranges. He spent time watching Samphire Thornbills (now called Slender-billed Thornbill) at Stirling North, "filling a gap in my knowledge", he said, for his next book, *A Field Guide to Australian Birds: Passerines,* which was published in 1974.

In December 1973 Peter phoned about a project at Sydney's Mascot Airport. Silver Gulls and other birds were considered a danger to aircraft and the authorities wondered if a Peregrine would scare them, and also if it could be controlled so the falcon itself did not imperil aircraft. The Peregrine was considered by many to be the 'ultimate' falcon, with its muscular chest, pointed wings, extraordinary speed, and ability to capture birds in mid-air. A fright machine. Peter visited again, this time with his wife Pat and son Raoul, where we tested a trained Peregrine on gulls and Galahs near Port Augusta, and planned a trial with this falcon and two trained Black Falcons at Mascot.

Peter brought along a loose manuscript of a birds of prey book, parts of which would eventually become *Australian Falcons*. But in 1973 he was a little dismayed by comments from a museum curator who critiqued this first draft. My guess was that the curator did not understand Peter's aim – to produce a volume of personal observations, interesting encounters with raptors, and detailed descriptions of behaviour that would inform and delight the reader, and illustrate these with great art. The curator's comments may or may not have been a factor in delaying the completion of this book for almost 50 years.

As a requirement for obtaining the falcons used in the Mascot trails, National Parks and Wildlife Service South Australia asked me to write a report on the biology of Black Falcons and Peregrines near Port Augusta. Peter and Pat helped with the

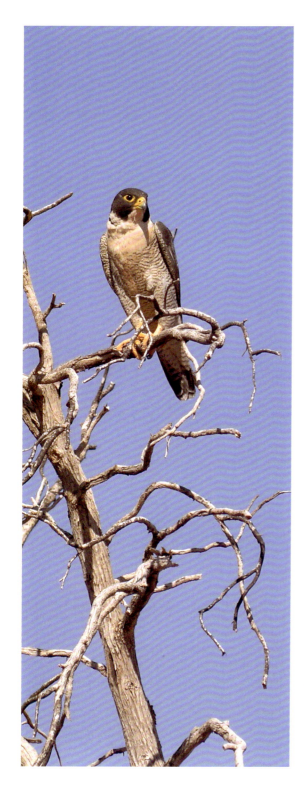

Pages 1 and 4: Australian Hobby.
Pages 2, 3 and above: Peregrine Falcon.
Opposite above: Female Black Falcon preening.
Opposite below: Brown Falcon.

report, and Peter generously supplied illustrations. Pat was the 'wordsmith' and Peter consulted her on questions of grammar and word choice. I saw first-hand how close the family was, how Pat and Peter worked together as a unit, shaping words and images. Raoul hammered on some plasticine project on the floor much of the time, completely self-contained, but encouraged by his parents in everything he did. His interest in birds came later.

At Mascot Airport we flew the Peregrine, a Black Falcon I trained, and one that Peter trained. Peter and Pat called this falcon 'Black'. Peter's motivation was to help ensure the safety of air passengers, but also to avoid the tragedy of shooting so many seabirds each day. At one point, while he watched the evening shoot, Peter walked to the shore and picked up a tern that had tumbled from the sky full of shot. He tried to revive it but, after five minutes, it stopped breathing and lay still. Peter expressed sadness over the loss and retuned to his room with the dead tern to paint its image on paper before the colours of the beak, eye and bare parts faded. Peter never saw himself as a falconer, but 'Black' flew well at Mascot. He understood the psychology of falcons and never lost the desire to study and write about them.

Australian Falcons is about Australia's six falcon species. Fuchs *et al.* (2015) grouped the six Australian species with the world's other falcons in this way:

Nankeen Kestrel *Falco cenchroides* belongs in the 'kestrel group' with other kestrel species including the Common Kestrel of Eurasia.

Brown Falcon *Falco berigora*, with its relatively long legs, is a taxonomically and morphologically distinctive falcon owing to its more hawk-like shape.

Australian Hobby *Falco longipennis* belongs in a clade consisting of the Old World hobby falcons such as the Eurasian, African, and Oriental Hobbies, and Eleonora's and Sooty Falcons.

Black Falcon *Falco subniger* is allied to the 'Hierofalcon' group comprising the Lagger Falcon of the Indian Subcontinent, Lanner of Africa and the Mediterranean, Saker Falcon of Eurasia and Gyr Falcon of Arctic Regions.

Grey Falcon *Falco hypoleucos* belongs to a group comprising 11 species including the Red-necked Falcon of Africa and India and the Prairie Falcon of North America, and the 'Hierofalcon'-Peregrine cluster.

Peregrine Falcon *Falco peregrinus* of the Australian subspecies *macropus* is part of a cosmopolitan group including the now reclassified (as Peregrines) Barbary Falcon of North Africa and Kleinschmidt's Falcon of Patagonia, and the smaller Taita Falcon of Africa.

All six, and in addition the vagrant Eurasian Hobby *Falco subbuteo* which is also briefly covered, have the anatomical features that separate falcons from other raptors – a single 'tooth' in either edge of the upper mandible used for cutting the spinal cord and dispatching prey: a dark mark under the eye, rather like that of a Cheetah, to reduce glare at high speeds; a flare on the trailing edge of the wing that joins the wing to the body, making a smooth line, unlike most raptors where the trailing edge dips into the body making more of a leaf shape. However, each species differs from the others in important ways, and Peter's powers of observation, and superb photographs, paintings and drawings, beautifully detail the behaviours, morphology, and hunting methods that separate each falcon from the others, and enable it to fit into its own niche.

Australian Falcons is a memoir, an art book, and a treatise filled with information and reflections on falcons, collected over many decades, expressed through prose and the camera lens and paintbrush. It is a book for anyone who wants to learn from an expert who knew and loved falcons, as Peter did.

Jerry Olsen
Institute for Applied Ecology, University of Canberra

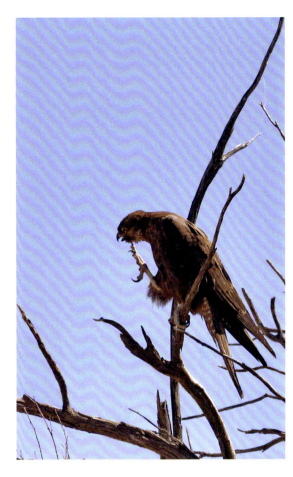

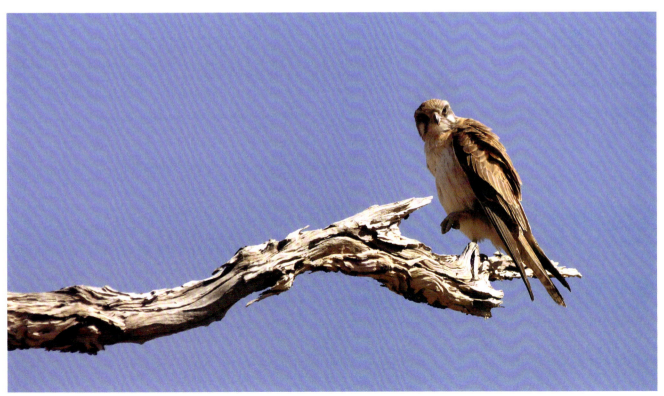

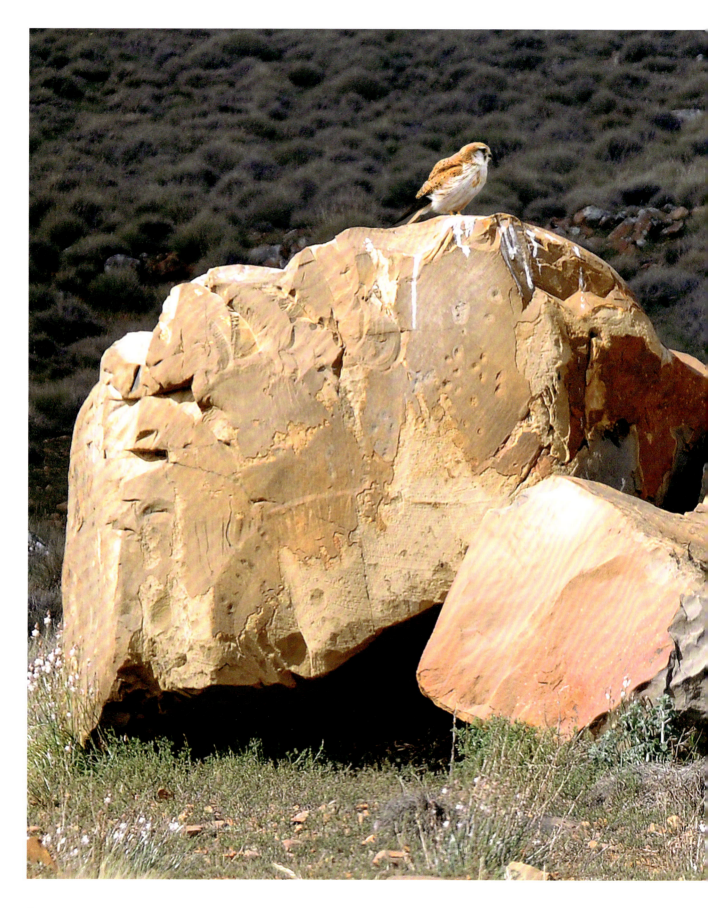

CONTENTS

FOREWORD	5
INTRODUCTION	11
NANKEEN KESTREL	17
BROWN FALCON	45
AUSTRALIAN HOBBY	123
EURASIAN HOBBY	159
BLACK FALCON	161
GREY FALCON	195
PEREGRINE FALCON	206

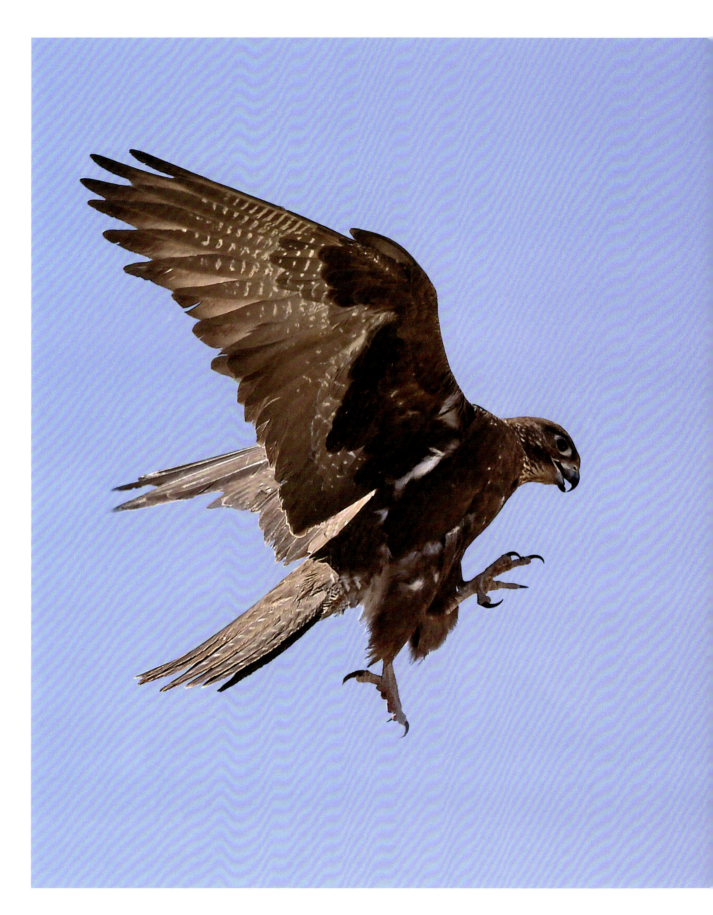

INTRODUCTION

The One I worship is not found in a cathedral, mosque or temple, but in wide open spaces, soaring above desert breakaways, skimming through open woodlands and dancing on burnished wings among sun-split clouds. Lord of all lesser beings, it is Horus, the falcon.

Apart from a few highlights such as getting married to Pat and the birth of a son, Raoul, the best days of my life have been spent watching falcons, eagles and hawks, revelling in their mastery of flight. I stand earthbound, but soar with them, freed from the constraints of gravity. In my imagination I hear the whisper of wind in my ears, growing to a roar as I dive, straight down, feel the g-forces as I pull up, up, up to soar again. I follow the sparrowhawk through the bush, admire its nervy energy, hair-trigger reflexes and passionless stare. I sit in hides a metre or two from the wildest of wild creatures and watch the gentleness of the females as they tend their broods. They don't know I'm there and I sit motionless, taking it all in, time suspended. I remember the day I sat in a hide at a nest belonging to a pair of Little Eagles when a fierce storm blew up, dizzily whipping around the branches that supported me and the eagles. I thought I was going to die, not having eagle wings to cushion the inevitable fall, and hoped that at least the photographs I had taken would survive.

Among these days, never enough of them, there have been some that are even more special. Like the nine months when I was joined on my daily walks by a wild Peregrine Falcon. She used me and my dog as beaters, chasing the quarry we flushed. I revelled in her awesome speed, felt pity and regret for the ducks she killed and my part in their demise, but was nevertheless back next day. I remember one particular bird-crowded event that stands out above all others. It was an exceedingly hot November day at a waterhole in the West Kimberley, WA, when we saw all of the falcons as well as other raptors in action. The water level was sinking as November progressed and thousands upon thousands of doves, finches and parrots, as well as honeyeaters and friarbirds, flocked to the water to drink. This is what I wrote later that night:

"The whirr of wings was so loud that Pat and I could not communicate as we settled under a paperbark to watch. All about us birds, desperate to drink, fluttered, settled, panicked and settled again. In the trees, on the ground and wheeling above, Whistling and Black Kites, too slow to do their own slaughtering, waited. They didn't wait for long. A grey bullet streaked through the swirling mass of birds, selected one panicking feather-fluttering dove and knocked it to

Black Falcon at Eyre Creek, Qld.

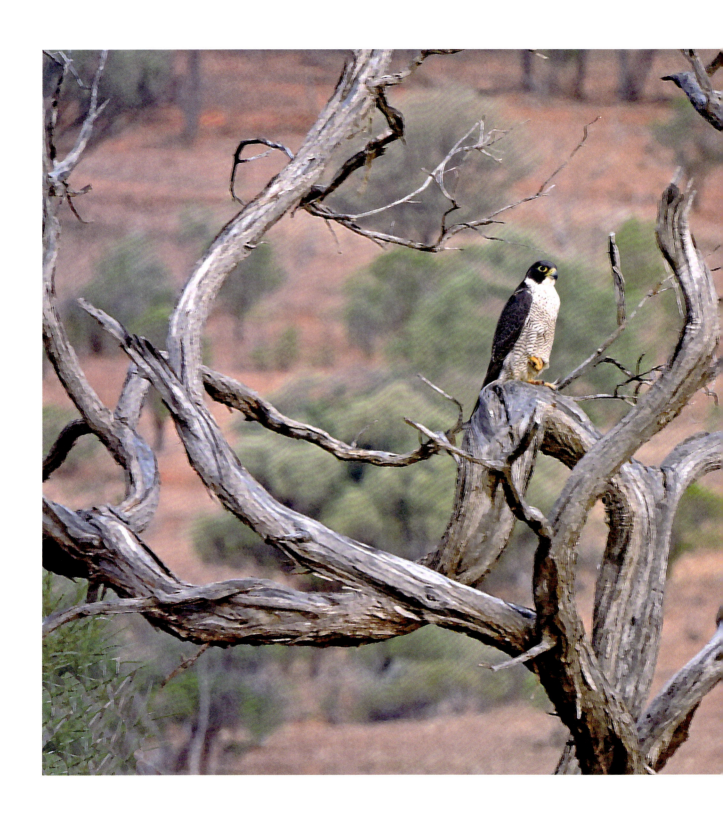

the ground near where we sat. It was our first sight that day of the dynamic Grey Falcon in action. The smoky blue-grey falcon wheeled, losing momentum, swung down and neatly scooped up the still fluttering dove, just beating a covetous kite. As it swept past we saw its large yellow-ringed eyes, wispy black moustaches and grey plumage. It gained altitude as another stooped and we signalled each other: two Grey Falcons in one day! But it had only just started. A Peregrine Falcon spread its tail far above, circling, waiting for the right moment. Down he came – words can't describe it – and plucked his offering from the table spread below. An Australian Hobby, like a miniature Peregrine, drifted in, took a look and whistled through several times before binding to a dove.

"We thought we had seen everything but we were still with the entrée, for shortly a pair of Black Falcons arrived. At first we failed to notice them among the soaring Black Kites, but no-one ever saw a kite suddenly stoop through a multitudinous tangle of doves, knocking down several as he went through. They fell fluttering behind him and the Whistlers and Black Kites acrobatically vied with each other to pick them up. Again and again he dashed into the doves while his mate circled above, leaving more for the kites. Was he displaying his expertise for her? Anxious to take a photograph I dashed out onto a tongue of land jutting into the waterhole. The thirsty birds paid no attention to me or the falcon. Down he came again and a dozen metres from my face overtook and grasped a Diamond Dove, carried it for 20 metres then, I swear, deliberately let it go. The dove incredibly, flew on. Eventually the falcon carried off a bird and his mate followed, circling higher and higher as they went, joining the whirlpool of kites. I imagine they had a nest nearby, as did the Grey Falcons, Peregrines and Australian Hobbies, because all were back later in the day.

"A Brown Falcon, long-legged and slower, took a bird on the ground – it may have been injured by the Black. We think this is the Brown we have seen throughout the year near the waterhole; usually we see it taking grasshoppers and lizards. To round out the day, we also saw either several goshawks or one that returned a few times. We also noted a kestrel that nested in a nearby baobab. There were also spectacular aerobatics as kites tried to dispossess each other of the doves they had picked up following the Black Falcon's forays."

A few years after Pat died Sally Elmer, an artist and friend who painted wildlife, joined me on my annual pilgrimages into the desert, searching out birds of prey, particularly Brown Falcons. We are fascinated by the variations of plumage it exhibits and try to photograph each bird we see. Thankfully they are generally quite tame, and we can usually approach to within camera range. Every now and then we find a dead kangaroo surrounded by Wedge-tailed Eagles, and set up our cameras, hoping to record the different interactions and displays as well as plumage variations. We keep a log of every bird of prey we see.

Peregrine Falcon at Yowah, Qld.

13

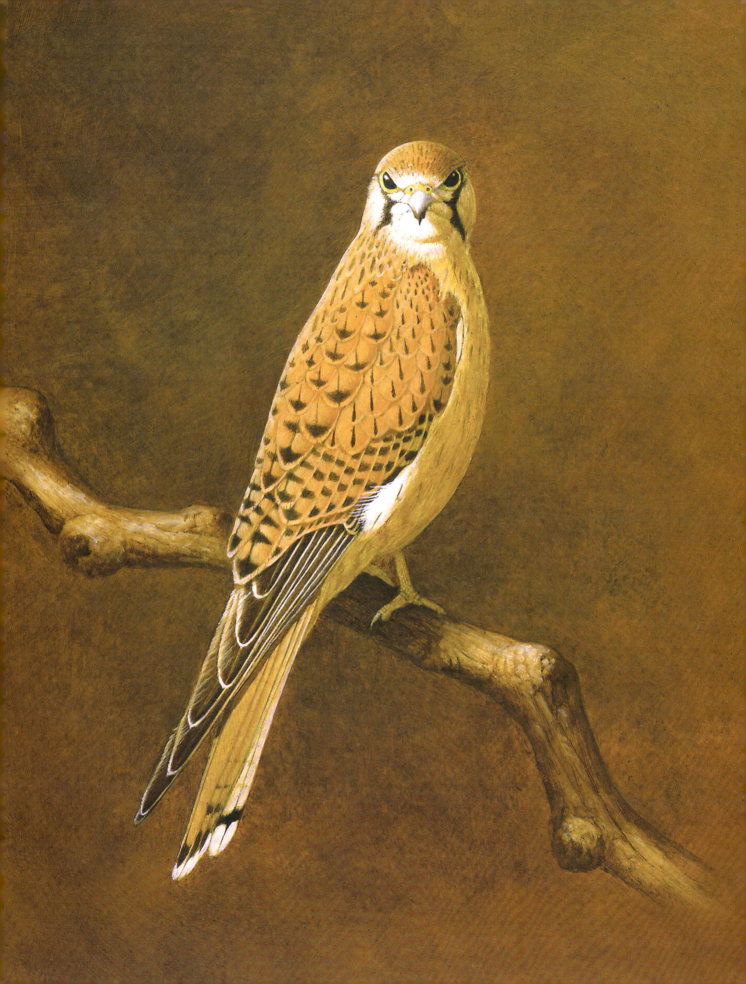

There have been other days enjoying falcons, kites, hawks, eagles, bazas and buzzards, never enough but remembered with gratitude. Each day with a raptor seen is a day worth remembering, but there is only room here for recounting a few.

Opposite: Portrait of female Nankeen Kestrel.
Above: Brown Falcon sketch.

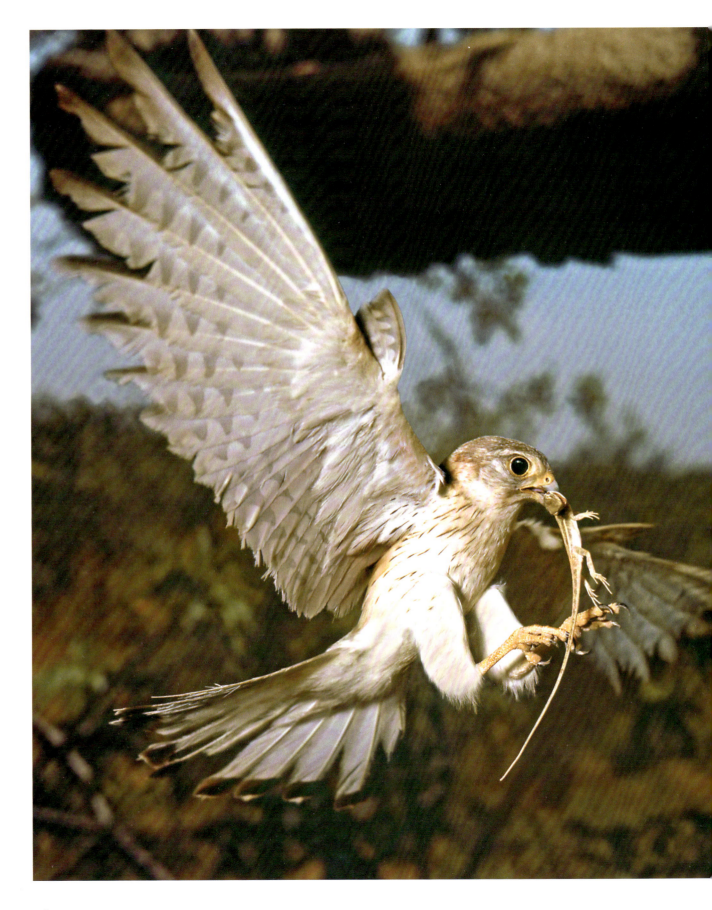

NANKEEN KESTREL
Falco cenchroides Vigors and Horsfield 1827

Falco cenchroides Vigors and Horsfield, *Transactions of the Linnean Society of London*, vol. xv, p. 183, 1827.
Tinnunculus cenchroides Gray, *The Genera of Birds*, i, p. 21, 1844; Gould, *The Birds of Australia*, 1, plate 13, 1848; *Handbook to the Birds of Australia*, i, p. 35, 1865; Diggles, *The Ornithology of Australia*, part 8, 1869.
Cerchneis immaculata Brehm, *Isis von Oken*, col. 357, 1845.
Cerchneis cenchroides Sharpe, *Catalogue of the Birds in the British Museum*, i, p. 431, 1874.
Cerchneis unicolor Milligan, *The Emu*, vol iv, p. 2, 1904.
Cerchneis cenchroides milligani Mathews, *Novitates Zoologicae*, vol. xviii, p. 253, 1912.
Cerchneis unicolor Mathews, *The Birds of Australia*, 1916.
Cerchneis cenchroides cenchroides Swann, *Synopsis if the Accipitres*, p. 218, 1922.
Cerchneis cenchroides unicolor Swann, *Synopsis of the Accipitres*, p. 218, 1922.

George Caley was a botanist employed by Joseph Banks to collect plants, seeds and other items of natural history in the new colony in Australia, where he arrived in 1800. He was adventurous in his pursuits in search of specimens, among them an unsuccessful attempt to cross the Blue Mountains. As well as collecting for Banks he acquired a collection of his own, including mammals, reptiles and birds. He left the colony in 1810, and sold some of his specimens in 1811 to the Count of Hoffmannsegg through an intermediary, and others to the Linnean Society in1818. As there were many new birds, Nicholas Vigors, a zoologist, and Thomas Horsfield, Keeper of the East India Company Museum, described them in papers presented to the Linnean Society in June 1825 and January 1826, which were published in the society's journal on 15 February 1827.

A Nankeen Kestrel collected by Caley was named *Falco cenchroides* by Vigors and Horsfield, and they added the collector's notes to their description:

"This bird is called the Nankeen Hawk by the settlers. It is a migratory species. My specimens were shot in May and June 1803. At that time the species was plentiful; but ever afterwards I observed it sparingly. I made the following note: I saw no Nankeen Hawks this autumn – I never observed it attacking the fowls."

Various authorities in the 19th century noted sufficient differences to suggest that kestrels should be classified apart from other falcons, and the names of *Tinnunculus* and *Cerchneis* were proposed as generic names. Currently kestrels are retained in the genus *Falco*.

In 1904, Alexander Milligan, honorary ornithologist of the Western Museum, described a bird from Yalgoo, WA. as a new species, the Western Kestrel, *Cerchneis unicolor*. From the description it appears to be a typical juvenile Nankeen Kestrel, and the illustration by H Goodchild of a 'Western Kestrel' in Mathews's *Birds of Australia* appears to confirm this opinion.

There was a move to change the vernacular name to Australian Kestrel on the premise that most people didn't know what nankeen was, and confused it with Nanking, a city far away. In a tongue-in-cheek submission I suggested that readers of historical romances were well aware that the hero invariably wore nankeen breeches, and that their colour approximated that of the kestrel as well as the night heron. Obviously my compelling argument succeeded.

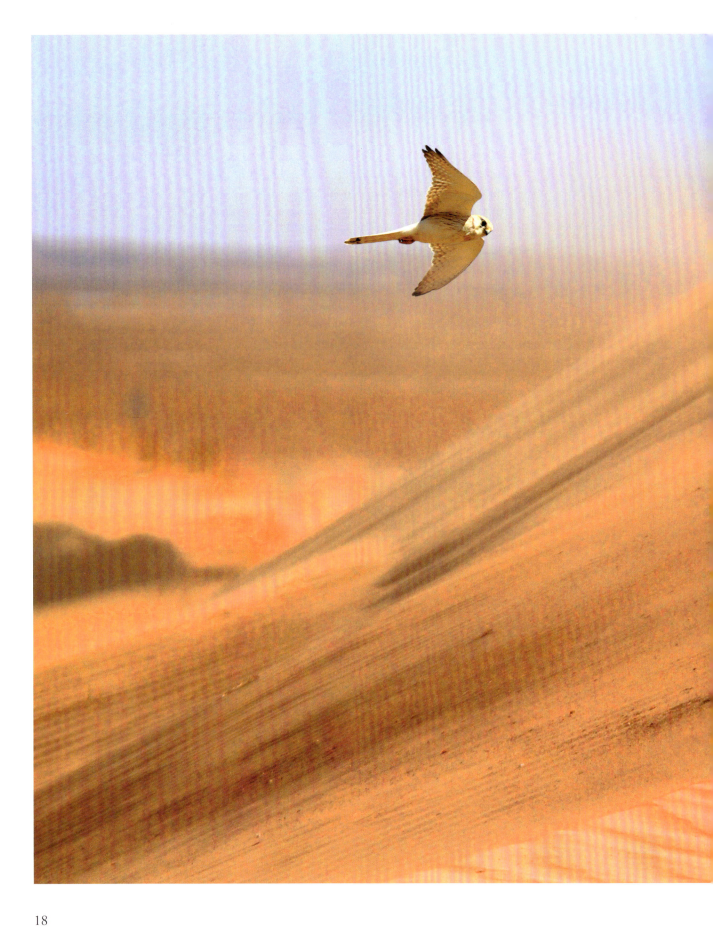

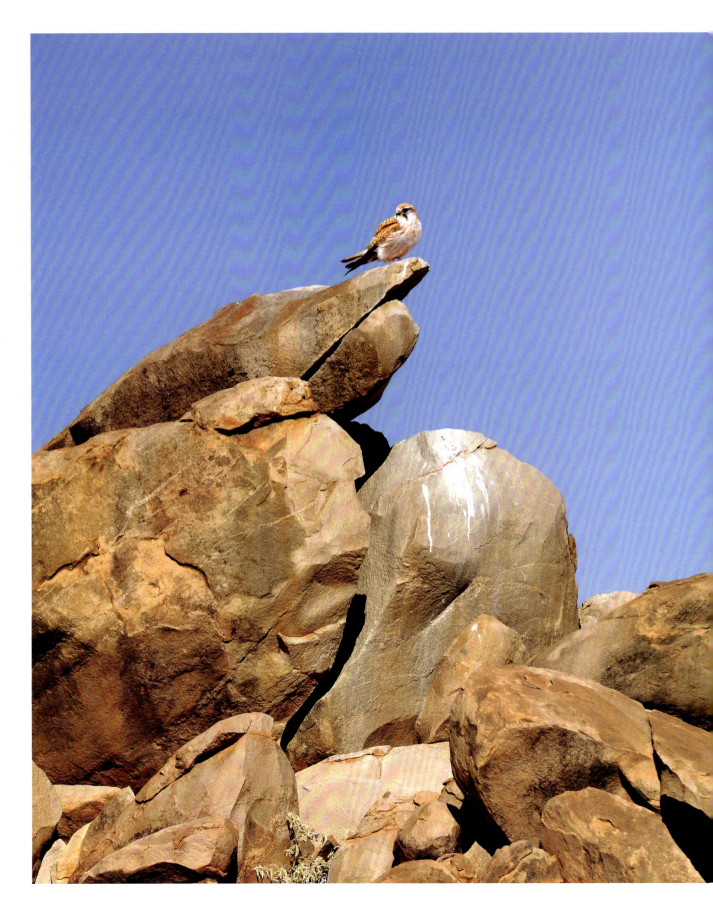

Have you ever paused to think, while boarding an aeroplane, what forces combine to deliver you to your destination. Do you ever contemplate the curvature of the wing, derived in the first instance from the wing of a bird, that conspires with the power of the engines to keep you aloft? Birds are so common, all around us, even in the most populous cities, and as a consequence most of us rarely, if ever, think about the miracle of flight. But when the opportunity arises, free the mind of prior clutter and marvel as if for the first time at an eagle soaring, effortlessly riding thermal updrafts to spiral into the heavens to come face to face with God; or feel the breathtaking power of a falcon stooping on its prey, Thor's hammer Mjölnir dropping like doom from the clouds; or the delicate mastery of a kestrel hovering, strung there in the wind, surfing the zephyrs, while incredibly acute eyes search the ground below for lowly prey, grasshopper or mouse. Such a seemingly simple thing keeps them aloft, the differential between airflow over and under the wings. I have never lost the joy I felt as a small child when I first saw a kestrel hanging in the wind, and even now eighty years later I still cannot resist watching and marvelling at such birds in flight.

Of the various falcon species, the kestrel is by far the easiest to watch for it occurs all over Australia from deserts to cities. All it needs to exist are grasshoppers, mice and a hollow to nest in. We have found pairs nesting in tree hollows in eucalypts and baobabs, cavities in rocks, under eaves of houses, in niches in public buildings and in blowholes on the Nullarbor Plain. In the western Queensland desert where there were no hollows we found them on stick nests of crows and kites, and on Thevenard Island we photographed a pair at a nest on the ground under a bush. There are some habitats they don't exploit; I don't recall ever seeing a kestrel in wet sclerophyll forest or rainforest, but we have encountered them in open forest, mulga, gidyea and mallee woodlands, spinifex plains, beach dunes, ocean cliffs, offshore islands, mesas, breakaways and mountain ranges; we saw one take a dragon lizard only metres from the shore of Lake Eyre where its only perches were rotting sleepers, remnants of the old Ghan railway.

Because they often perch on exposed branches they are easy to spot, but the number seen doesn't necessarily reflect how many birds are in any given area. In 1964 Pat and I drove from Perth to Port Hedland in August and saw many kestrels perched on exposed tree limbs. In those days I didn't keep a log of raptors we sighted while travelling, but on this occasion estimated we had seen more than fifty. So on the return trip in September, we decided to keep a count. We only saw three. Thinking about it later, I realised that on our northward trip we were seeing females on prominent perches waiting to be fed by their mates prior to laying. On the return trip, all the females were sitting in their hollows on eggs, and the males were occupied in looking for food for them. If our only knowledge of kestrels was based on one or the other of these trips, we would have assumed either that they were very common or quite rare.

Nankeen Kestrel on rocks at Dajarra, Qld.

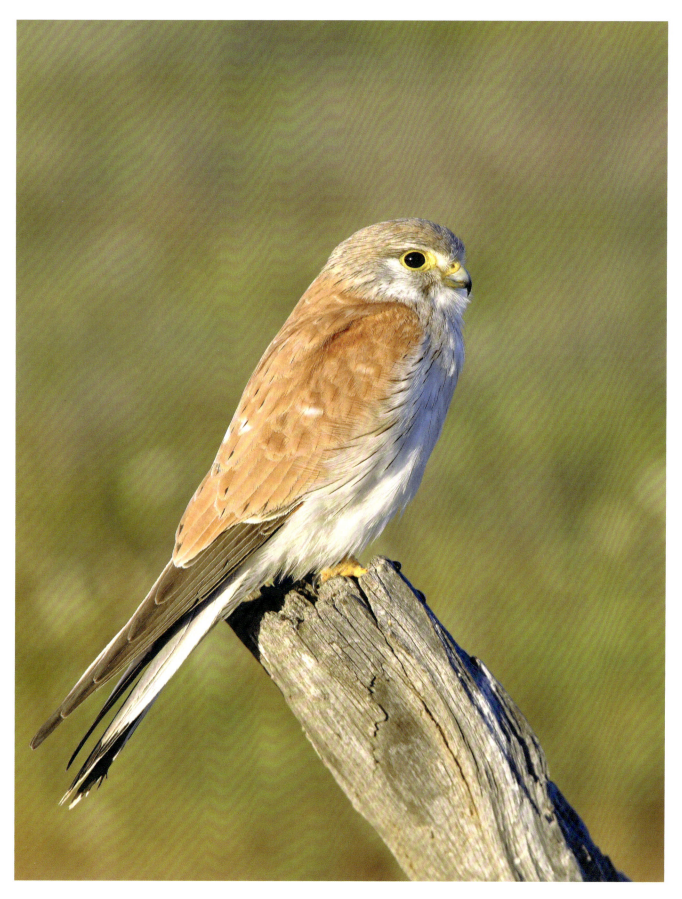

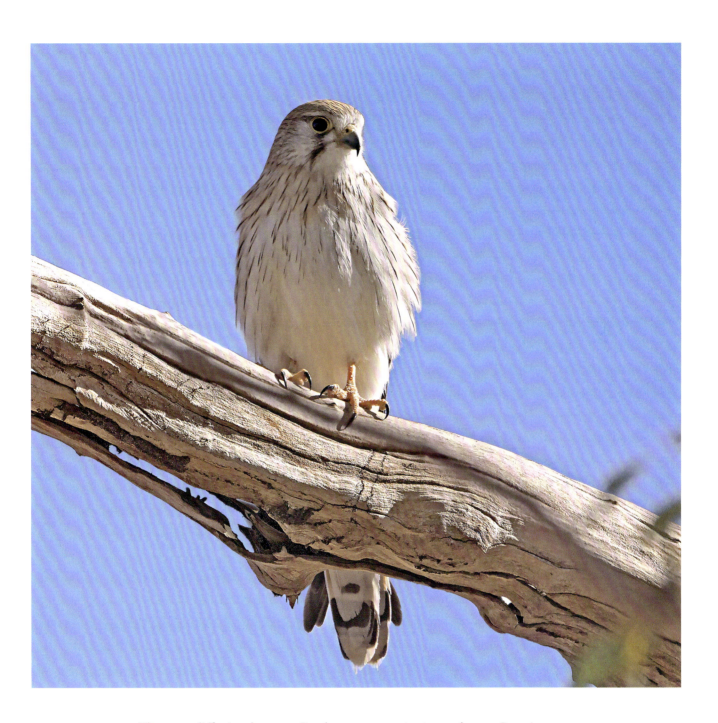

The sexes differ in plumage. On the page opposite is a male near Port Augusta, SA; the back and upperwing feathers are virtually unmarked. In old males the crown is grey; this example has a rufous suffusion so is probably only two or three years old. The tail is grey with a broad subterminal band towards the tip. Above is a female pictured on her regular early morning perch near Bladensburg, Qld.

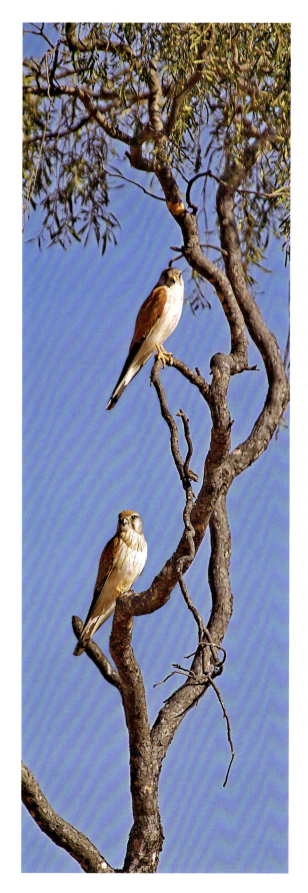

On the left is a pair of kestrels at Bladensburg, Qld. The male is uppermost and is appreciably smaller than his mate. He is older than the bird on page 22 and has a grey crown. The female has a rufous crown and numerous bars in the tail. Her back and upperwings are more rufous and each feather has a dark mark in the centre.

The Nankeen Kestrel is unlikely to be confused with any other bird in Australia. There may be some momentary hesitation when the observer sees a bird hovering, for both the Brown Falcon and Black-shouldered Kite hover expertly, but one glimpse of the rufous back should be sufficient to identify the bird, although some Browns are similar in colour. Both the falcon and kite hover more clumsily than the kestrel, usually with legs dangling and tail depressed, and with deeper wing-beats. When hovering both birds display considerable dihedral while the kestrel holds its wings flat.

The kestrel usually employs either of two methods of hunting. The less spectacular consists of sitting on a prominent perch, such as a dead tree, telegraph pole or cliff, watching the ground below until some likely quarry moves, whereupon it glides down to secure its victim. At a quarry near Fremantle, WA, we were able to measure roughly the distance over which the resident kestrels were able to detect prey. Several times they flew more than a hundred metres to pick up grasshoppers. The other common method of hunting is hovering. The kestrel flies into the wind then hovers with wings quivering to maintain its station while it searches the ground below. It normally hovers at heights between ten and thirty metres and for three to twelve seconds. If some movement is detected it may hover for longer periods and may drop lower for a closer look. Occasionally individuals hover much higher, yet still are able to detect prey. Once a grasshopper, cricket or mouse is found there is a high proportion of successful strikes. Some individuals are very proficient: one female I photographed at Armadale, WA, did not miss once in the two weeks I watched her. She hunted from a low

Left; A pair of kestrels at Bladensburg, Qld.
Above right: Female with lightly marked back, but heavily marked front, in the Simpson Desert, Qld.
Below right: Female with more heavily marked back and lightly marked front at an abandoned homestead in the Tirari Desert, SA.

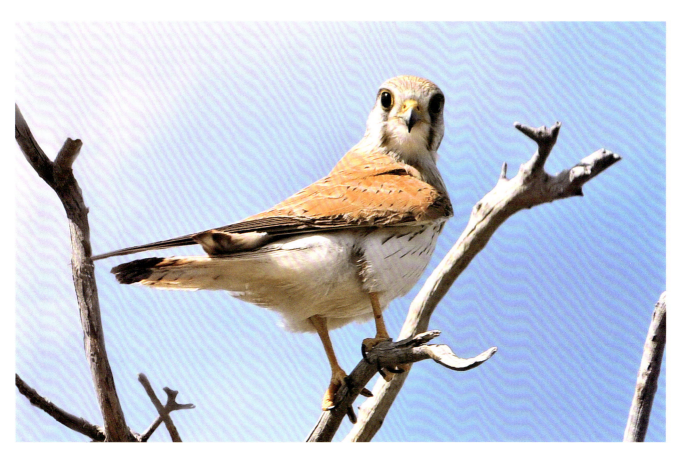
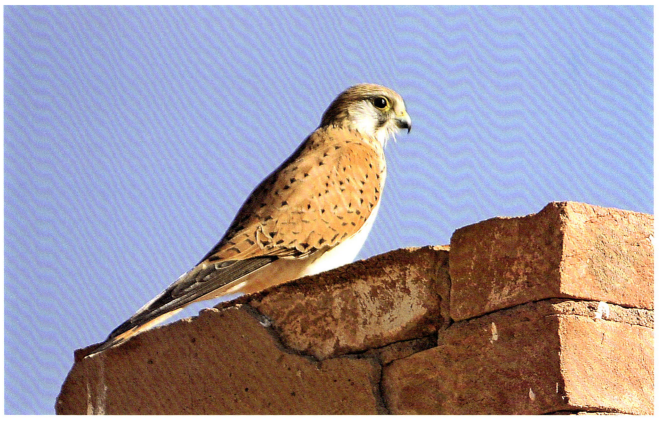

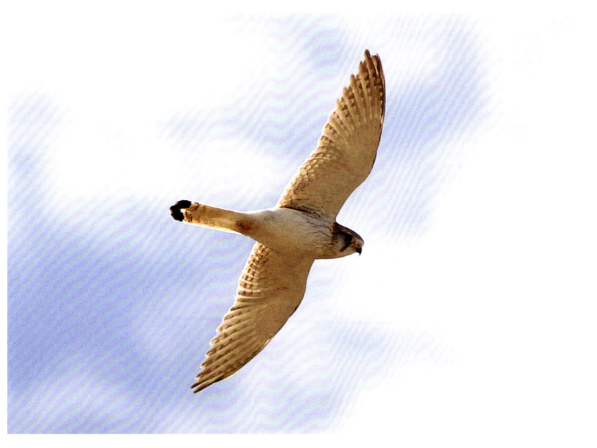
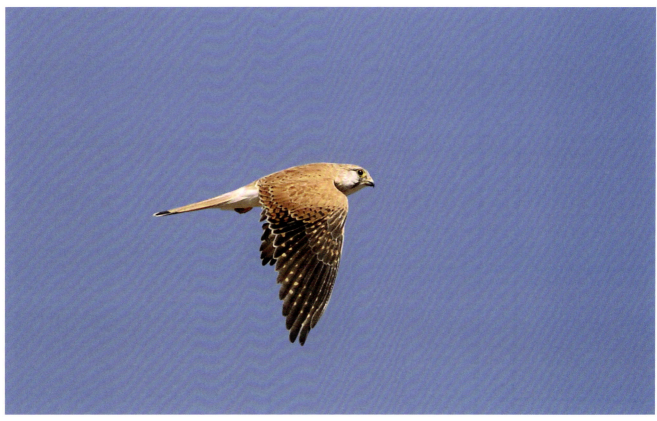

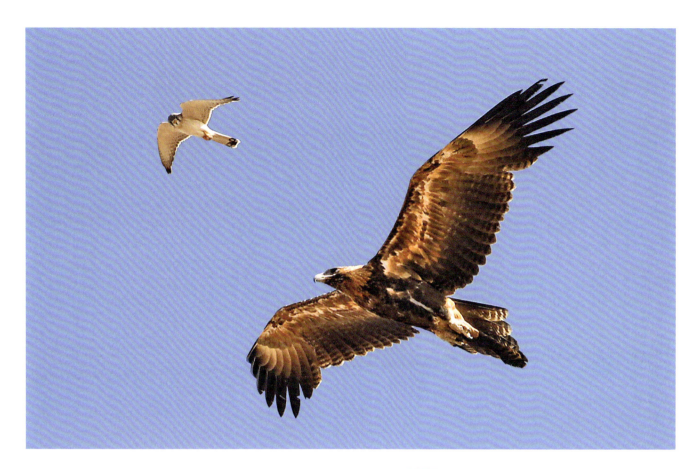

dead tree about five metres high and her prey was grasshoppers. Grasshoppers probably account for most of the kestrel's diet, but lizards and mice also figure. In my experience it is less dependent on mice than the Black-shouldered Kite. One I photographed at Beaconsfield, WA, brought two Laughing Doves to the nest, probably representing the maximum load that a kestrel can carry. At our home in Anstead, Qld. we were often able to watch a male kestrel take recently fledged Fairy Martins. A colony of martins nested on our front verandah; as far as we could see, each year all of the chicks were taken shortly after making their first flights by either the kestrel, a hobby or a male sparrowhawk. We also saw the kestrel chase sparrows and once a Striated Pardalote; conversely we have seen a flock of starlings chasing a kestrel. On occasion we have noted kestrels attacking other raptors, and also soaring with Wedge-tailed Eagles, exploiting the lift from the bigger birds' wings.

When breeding, kestrels in most cases choose a cavity to nest in, the most favoured site being a tree hollow, but if none are available

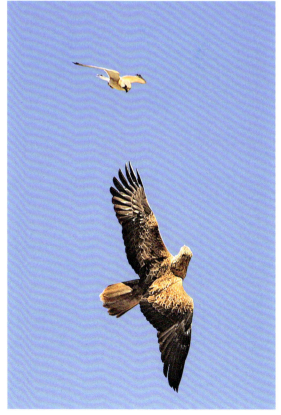

Above: Kestrel soaring with a Wedge-tailed Eagle.
Right: Kestrel harassing a Whistling Kite.

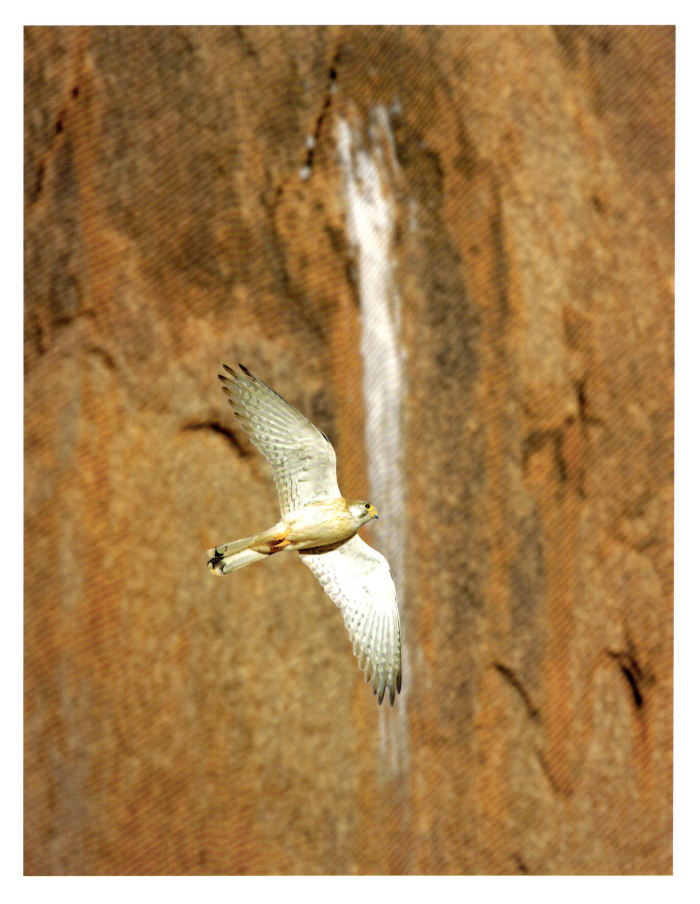

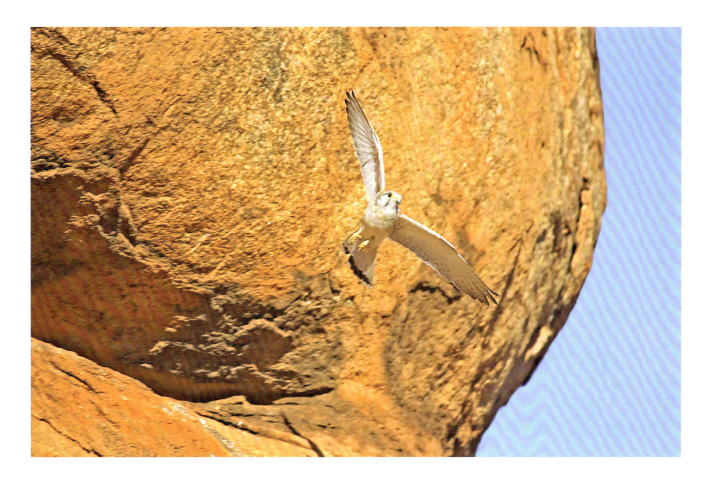

they will use niches in rock-faces, old crow or raptor stick nests, or even holes in buildings or under overhanging eaves. Eric McCrum showed me a nest in a 'blow-hole' on the treeless Nullarbor Plain near Reid, WA, barely wide enough to climb down and about five metres deep. He knew of several other nests, all in blowholes.

Kestrels begin their courtship comparatively early in the year; the earliest I have seen courtship behaviour was in central NSW in late May 1970. Two pairs I watched at Derby, WA, had adjacent territories and were courting in late June. Each female spent most of her time on a dead tree near the nest hollow. Every hour or so the male would arrive, calling loudly and carrying food which was sometimes passed to the female and sometimes carried to the nest hollow where the female joined her mate. Occasionally when the male arrived he stooped at the female, sometimes hovering just above her. Mating often occurred after the pair returned to the dead tree. The last offering of the day was brought by the male at sunset, and both birds slept in the hollow. This behaviour remained constant until early in October when the female began to spend more time in the nest. The eggs were apparently laid in mid-October, as thereafter they remained in the nests, emerging only for food.

I didn't notice any courtship activity any earlier than late June around Derby, but some pairs laid earlier than the pair I watched; the earliest had large young in a hollow directly below a Grey Falcon's nest on 17 September, so the eggs

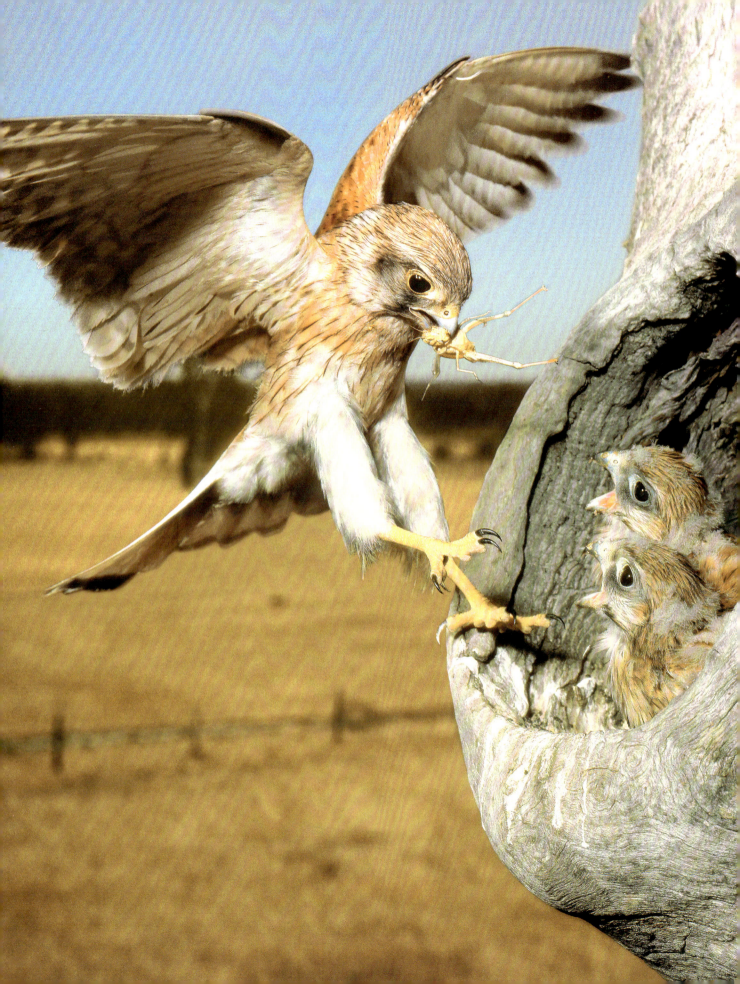

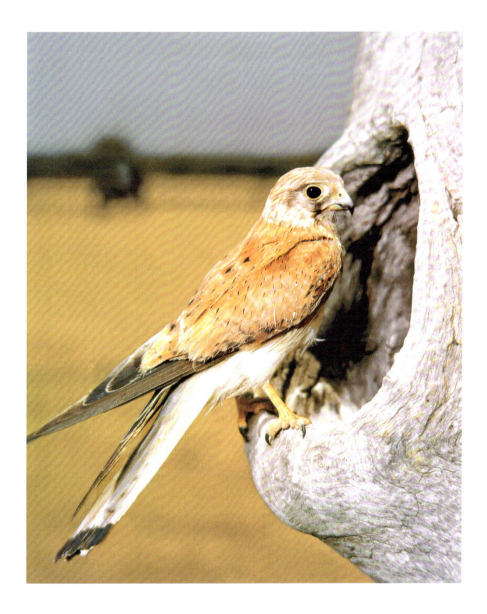

must have been laid about mid-July. Estimated laying dates at other nests we found near Derby were 14, 18, 24 and 27 August, 7 September (two nests) and 20 October. The following year we located three nests with eggs on 5 September, a nest with chicks ready to leave on 13 November, and one with chicks just hatched on 19 November. In the year we spent on 'Wallace Brae' at Guluguba, Qld, mice were plentiful and we found nineteen nests on the farm. The male at one hollow close to our house disappeared and its place was taken a few days later by a bird still in immature plumage which successfully reared the young. We didn't follow all the nests but of those we checked, all save one successfully fledged their young; we estimated that about fifty chicks were raised that year on the 270-hectare property.

Probably because kestrel nests are so easy to locate, I spent more time photographing them than any other bird of prey. Usually a situation suitable for photography was not difficult to find without too much looking, usually in

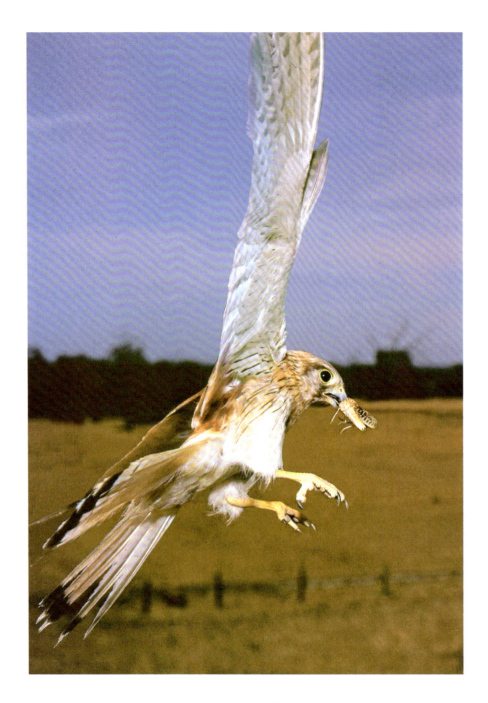

hollows or spouts in trees; none were easier than one we found on the ground under a bush on Thevenard Island off the north-west coast of WA (page 34). I also photographed nests in a cave, in a quarry, in hollows in a eucalypt and a baobab, and in an old crow's nest. The first nest I photographed was in a disused quarry at Beaconsfield, WA. The chicks were fed on mice, grasshoppers and, on two occasions, Laughing Doves. While the eyasses were still in down, the adults rendered the prey for them, but as they acquired feathers the hungriest took the whole victim from the parent, turning its back on its siblings with raucous cries and out-stretched wings. Usually the mouse or grasshopper was swallowed whole but as the chicks grew they began to tear up their food.

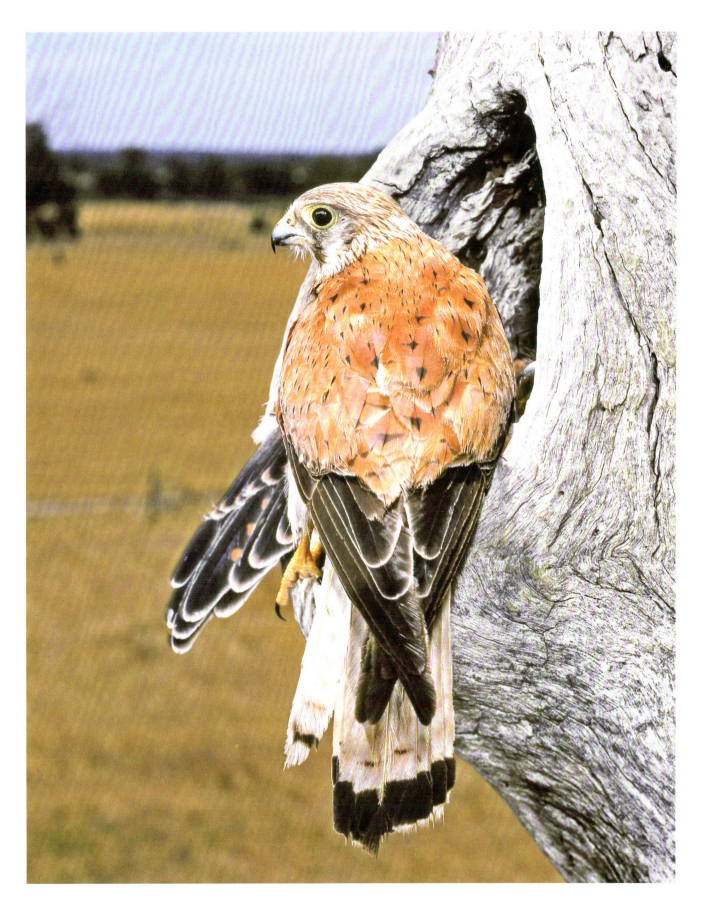

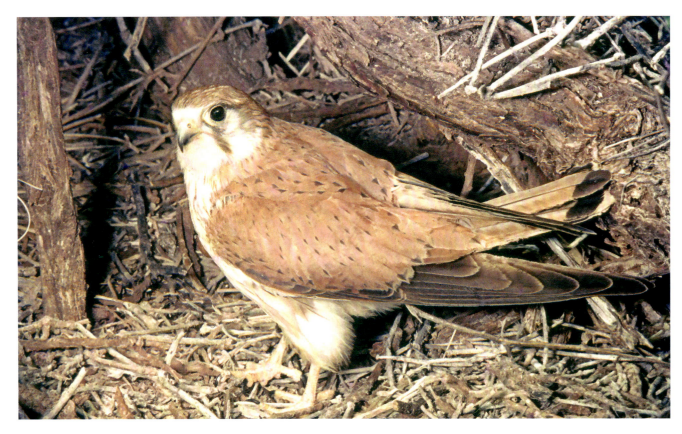
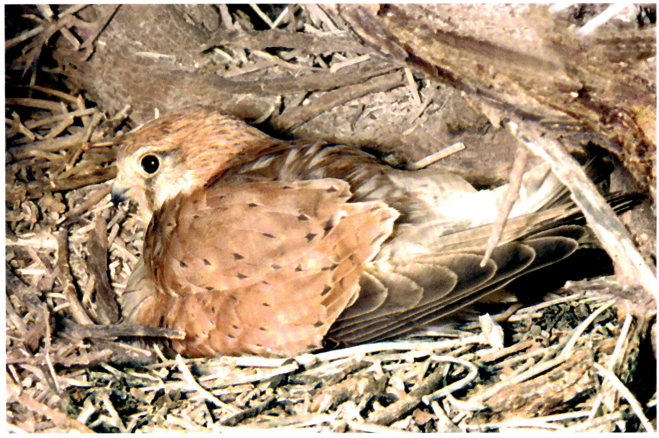

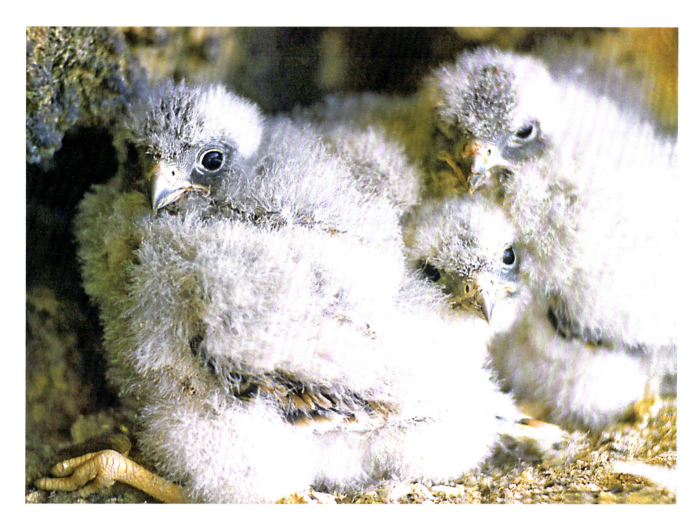

Another nest I photographed was in a hollow in a baobab near Derby, WA. When I climbed up to the nest on 19 November it contained two recently hatched chicks, no more than a few days old, and one egg that turned out to be infertile. The chicks had bluish-brown eyes – the only reference I had at the time was *Birds of Western Australia* by Serventy and Whittell, which stated that the chicks' eyes were red. On 3 December the chicks were still in down but the wing quills were showing. By 11 December feathering was beginning to show on the back, breast, wings and tail. The eyasses were well feathered by 18 December and were coming to the nest entrance to receive their food. One chick left on 20 December and the other left on the following day. Thus the fledging period proved to be a few days in excess of a month.

It was interesting to note the frequency with which the chicks were fed – the food consisted almost entirely of skinks and small dragon lizards, the few exceptions being grasshoppers. On 3 December six visits were made between 9 am and 12 noon. On 11 December four visits occurred between midday and 4 pm. On 18 December there were seven visits between 9 am and 3 pm.

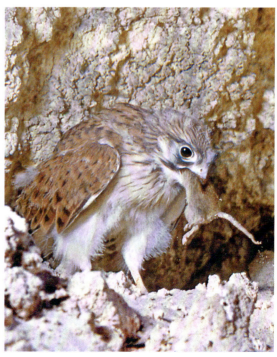

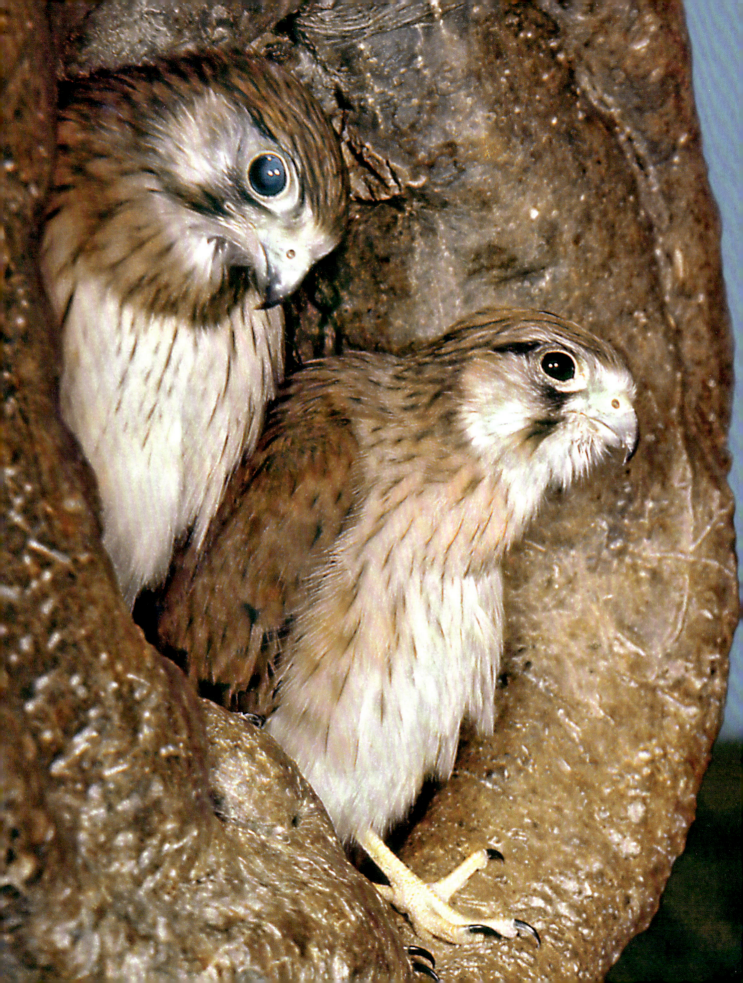

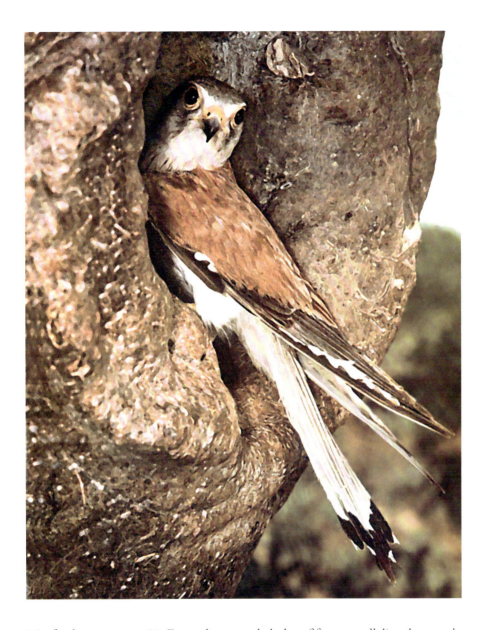

My final session on 20 December revealed that fifteen small lizards, mostly skinks, were brought to the nest, most between 6 am and 11 am. Thirteen of them were consumed by the chick remaining in the nest while the chick that had left ate only two. Most of the food I recorded was provided by the male and the constant landing against the rough baobab bark frayed his tail. Apparently the dark subterminal band was made of tougher stuff than the grey, for it remained almost intact.

At a nest near Armadale, WA, where grasshoppers were the principal fare, visits were far more frequent, sometimes as many as a dozen in an hour. As with the other nests there was little activity in the afternoon. The female at this nest was apparently an old bird as she had partially acquired the male characteristics of a grey head and tail. Normally the female is rufous on both head and tail. In contrast to the situation at the Derby nest, here the female did the bulk of the feeding.

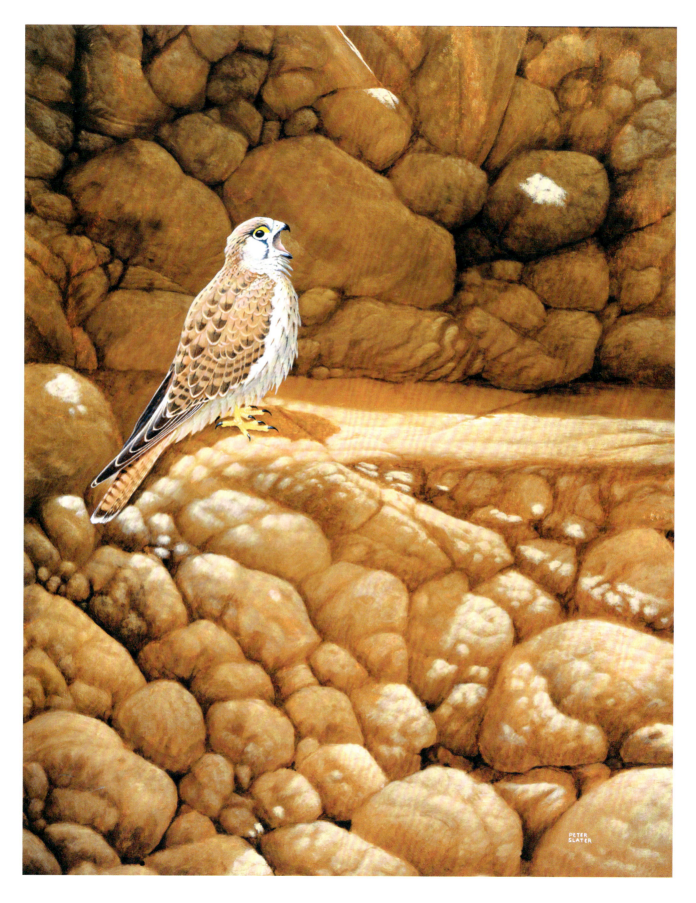

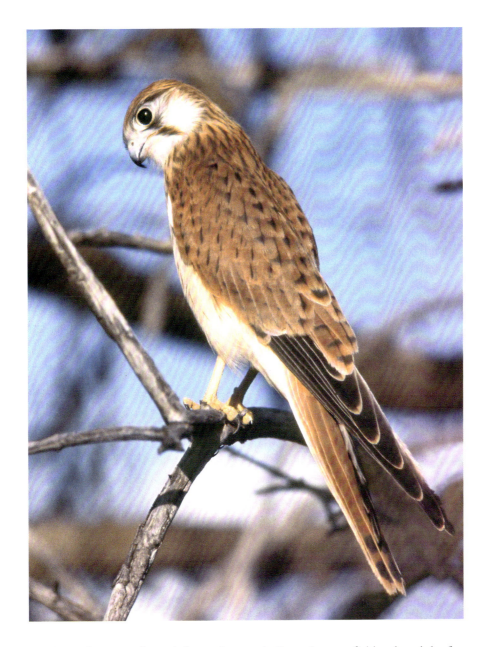

Once the young kestrels leave the nest hollow, they are fed by the adults for about three weeks before they start catching their own prey, usually grasshoppers. Those we have watched during this period were very vocal when an adult arrived with food and occasionally competed vigorously to snatch the offering.

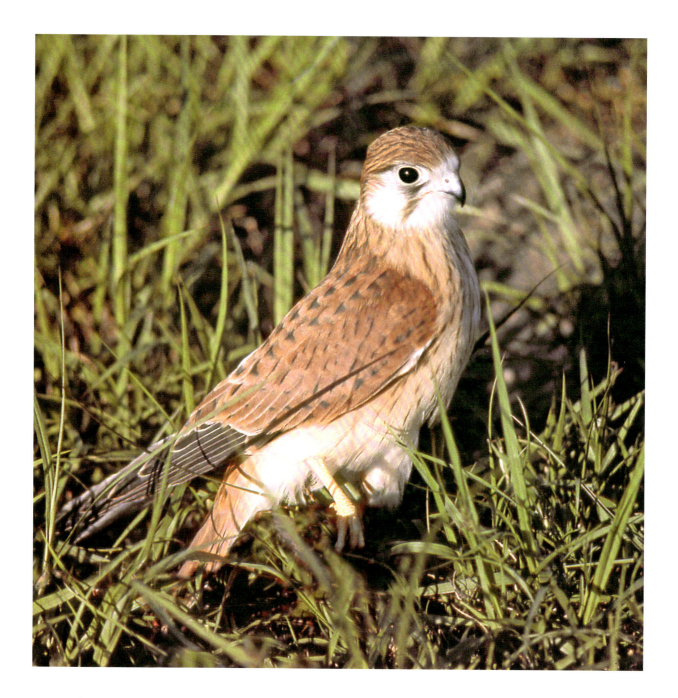

The young ones are more heavily marked than the adults, with more streaking on the underparts and many had an attractive pale rufous flush over the breast like the one in the image above; we saw this bird making what was probably its first kill. The bird opposite was photographed with one of its first victims at Kelmscott, WA. The colouration is rather different; it looks something like the one illustrated by H Goodchild in Mathews's *Birds of Australia*, which was included as a separate species, the 'Western Kestrel', *Cerchneis unicolor*.

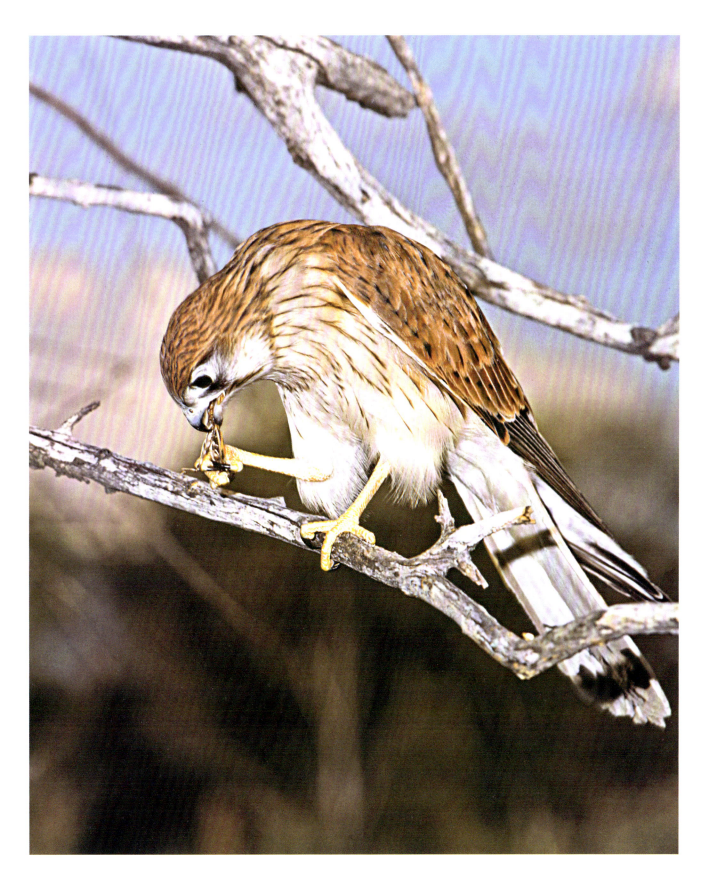

artistic kestrel

painting red rock desert walls:

perhaps graffiti?

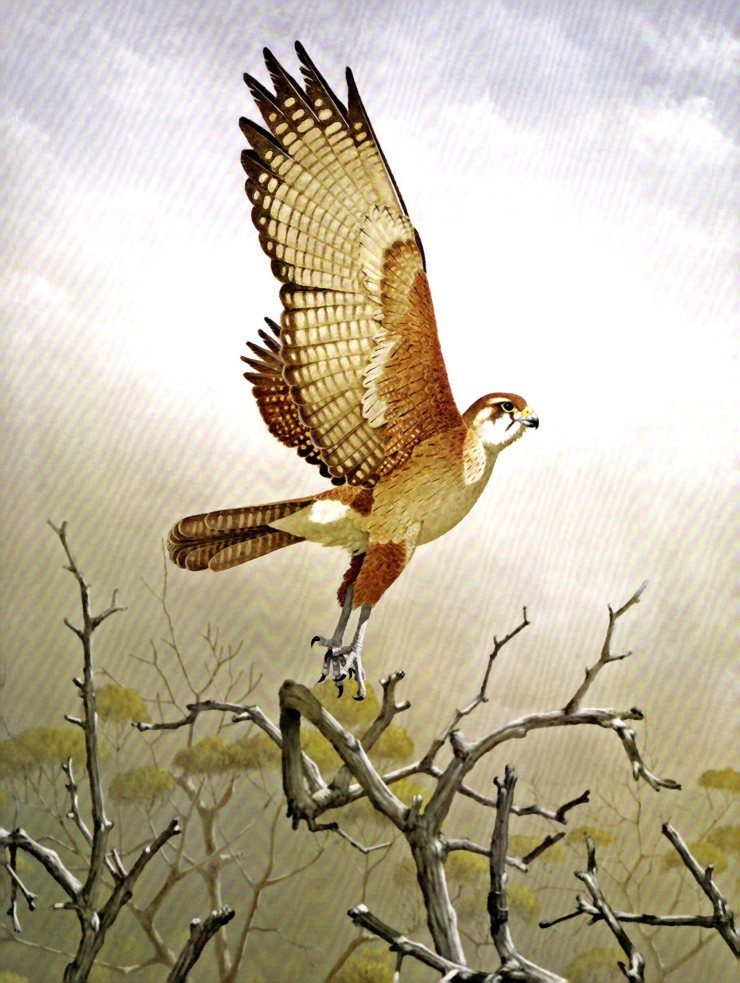

BROWN FALCON
Falco berigora Vigors and Horsfield 1827

Cream-bellied Falcon Latham, *General History of Birds*, i, p. 230, 1822.
Falco Berigora Vigors and Horsfield, *Transactions of the Linnean Society of London*, xv, p. 184, 1827.
Ieracidea occidentalis Gould, *Birds of Australia*, p. 105, 1844.
Hieracidea berigora Gould, *Birds of Australia*, i, plate 11, 1848.
Hieracidea berigora orientalis, Schlegel, *Naum.*, p. 254, 1855.
Falco berigora Schlegel, *Mus. p-b. falc.*, p. 37, 1862.
Hieracidea orientalis Sharpe, *Catalogue of the Birds of the British Museum*, i, p. 42, 1874.
Hieracidea novaeguineae A.B. Meyer, *Journal für Ornithologie*, p. 89, 1894.
Ieracidea berigora melvillensis Mathews, *Austral Avian Record*, i, p. 34, 1912.
Ieracidea berigora tasmanica Mathews, *Birds of Australia*, v, p. 276, 1916.
Ieracidea berigora kempi Mathews, *Birds of Australia*, v, p. 277, 1916.
Ieracidea berigora centralia Mathews, *Bird of Australia*, v, p. 277, 1916.
Ieracidea berigora berigora Swann, *Synopsis of the Accipitres*, p. 212, 1922.
Ieracidea berigora orientalis Swann, *Synopsis of the Accipitres*, p. 212, 1922.

Dr John Latham saw a specimen of a Brown Falcon in the collection of Major-General Davies, who received birds from contacts in Australia, and named it the 'Cream-bellied Falcon' in his book *A General History of Birds* in 1822. It is the first description of the species but because it did not include a Latin name it has no precedence.

The Brown Falcon was one of the birds collected by George Caley while he was in Australia in the early 1800s. Most of his collection went to the Linnean Society of London, and the new species it contained were described by Vigors and Horsfield in the society's journal in 1827, including the Brown Falcon which they named '*Falco Berigora*'. The notes accompanying the description read: "The native name of this bird, which we have adopted as its specific name, is *Berigora*. It is called by the settlers *Orange-speckled Hawk*. Mr Caley informs us, that the orange marks in the plumage of this species are considerably stronger in recent specimens than those of the society's collection, which are much faded. The specific characters of this bird accord very closely with those of Dr Latham's '*Cream-bellied Falcon*'; but that bird is described as having a double tooth to its beak, while ours is single-toothed as in the genuine falcons."

John Gould saw Brown Falcons while he was in Australia, but they were all apparently juvenile or immature birds, so when he received adult specimens from WA collected by John Gilbert, he thought they represented a different species, which he named *Ieracidea occidentalis*. Considering the variability of the Brown Falcon it is not surprising that it has been given a variety of names, most of which are synonyms, for instance *novaeguineae*, *centralia*, *kempi*, *occidentalis*, *orientalis* and *tasmanica*.

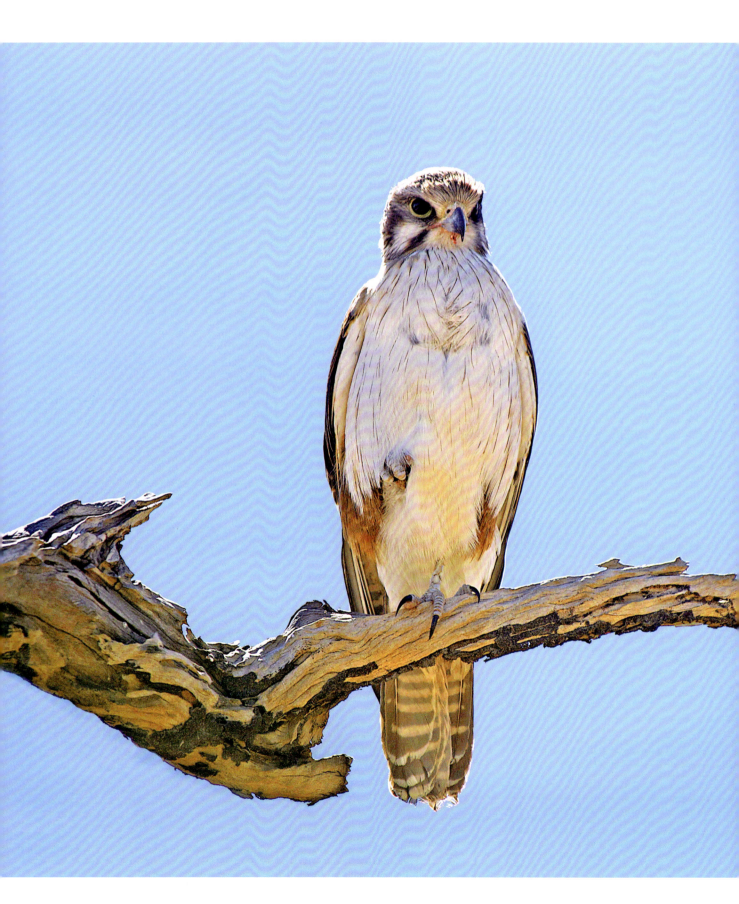

We are driving along a road near Big Red in the Simpson Desert, Qld, our Prado dampening the corrugations occasionally when we hit the right speed. We do this sort of thing in the interior of Australia for a couple of months each year. What we are doing is looking for raptors, especially Brown Falcons. Most birdwatchers only look at this species to check it's not a Grey Falcon. It's too common. We stop to look at each one we see, and try to take a photo of it. Why? Because each one is slightly different, variations on a number of original themes, ranging from very dark to very pale. So when we see this one (left) sitting on a dead branch, as Brown Falcons are prone to do, we grab cameras and head off in its direction. It is an old bird, with the skin of the orbits around the eye and the cere yellow, the underparts white with fine dark streaks and the crown brownish-grey. If it was older still the crown could be grey. We know from experience that a bird like this won't mind us approaching, unlike younger darker birds, but just to be sure, we approach slowly, tangentially. No problem. It sits calmly, majestically, one foot tucked up. We know that as long as the foot remains tucked up it is comfortable with our approach. Soon we are within camera range. It occasionally looks at us but more often directs a distant stare at the horizon. We walk around the tree taking pictures from all angles; foot still tucked up. Now we are close we can see a spot of red on its chin, all that remains of its last meal. We see how its eyebrows curve up, giving it a frowning stare, and how the beak appears to give it a smile, so its gaze is a mixture of benign and severe. We leave it reluctantly and carry its image away with us to add to the hundreds we already have.

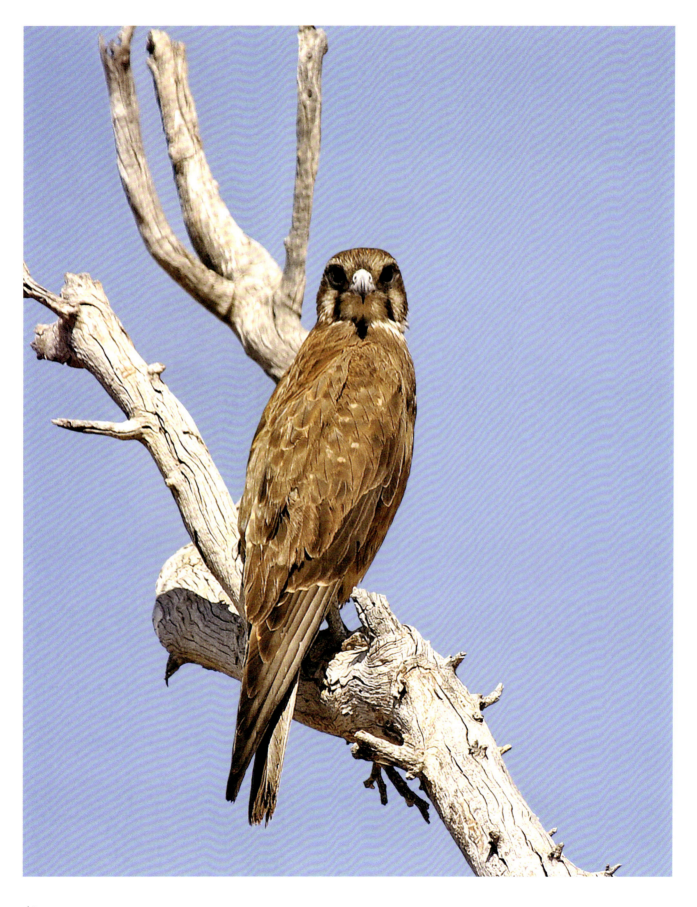

When I was quite young in the 1950s I was given a Brown Falcon by an old Aboriginal woodcutter. He had cut down a tree and found the bird on the ground, apparently having fluttered from its nest as the tree fell. It was injured, with one eye red with blood. Anyway I was delighted to accept the gift to look after. It quickly became tame and alert although the damaged eye remained opaque. I object strongly to giving names to wild creatures brought into captivity, but my sister Lyn began calling it Whitmont after an advertisement for shirts, featuring a male model wearing a black patch over one eye, and despite my aversion the name stuck. Soon it was flying to me for food and I felt confident enough to take it into the bush. We had many enjoyable moments chasing lizards, mostly Crested Dragons. Whitmont didn't need to be taught to chase lizards – as far as I recall she took off after the first one we encountered and seemed to instinctively grasp the head to avoid being bitten. Usually however the lizards dived into burrows at our approach. The falcon soon learnt to wait beside me while I dug one out, standing on the ground beside me as I excavated, then dashing after the lizard when it was uncovered. As soon as one was caught I offered the falcon a reward of beef heart and placed the unharmed quarry in a bag to take home. Dad had built an enclosure in the back yard for my lizards and soon I had a large collection. My old mate Bob Wearing recently reminisced that I usually had a lizard or two in my shirt in those days – I can't remember if it is true or not but I do remember my Aunt Topsy coming to stay. She decided it wasn't right to keep poor lizards in captivity and while I was otherwise engaged let them all out. Suddenly Kalgoorlie was overrun by reptiles, and I

Above: Whitmont looking for a lizard in WA. Opposite: This young bird is quite similar in appearance. It was photographed on the opposite side of Australia, in the desert near Boulia, Qld.

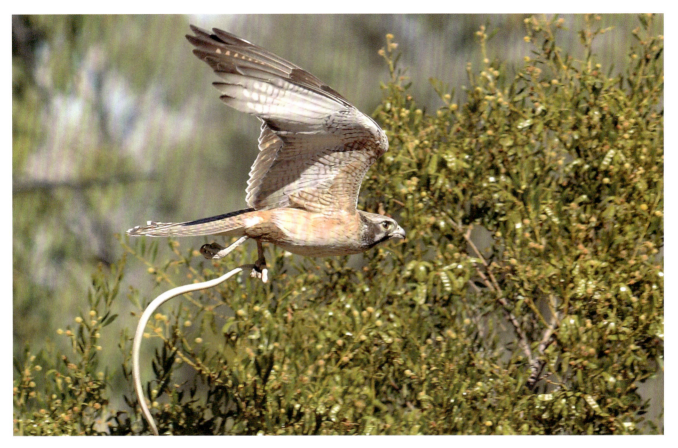

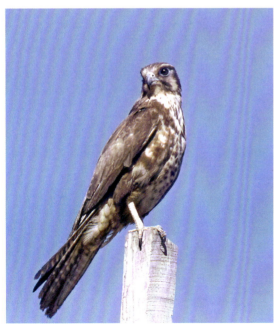

Top and opposite: Male Brown Falcon with an Eastern Brown Snake near Jundah, Qld.
Above: This is the falcon that regularly followed me at the Kimberley Research Station, WA.

moved on to other pursuits, namely trying to photograph birds. The Brown Falcon was released, and although she hung around for a while she eventually headed off, well equipped to survive despite the loss of an eye. In the short time that we were partners I did learn a bit about Brown Falcons and I hope she learnt something about humans too. One thing I can remember and can still recall clearly is the scent of her breath. Other Browns I have handled exuded the same nutty smell, quite unlike other falcons.

It is not surprising that the Brown Falcon I was given settled down into its association with me so quickly, for of all the Australian birds of prey this species is the most tame and easiest to approach. We have often been able to stand under birds perched in even small trees. Generally the tamest appear to be old males, and the least approachable dark-plumaged young ones. Two wild birds I remember learnt to follow me while I was walking through the bush. In each case I followed the same path on a regular basis and the birds soon found that I inadvertently flushed suitable offerings for them to catch. The first was at the Kimberley Research Station on the Ord River in WA, where I walked each day along the river bank. An immature Brown in speckled plumage often followed me from tree to tree when I ventured into its territory, and chased grasshoppers, lizards and on one occasion a snake. I've seen Browns

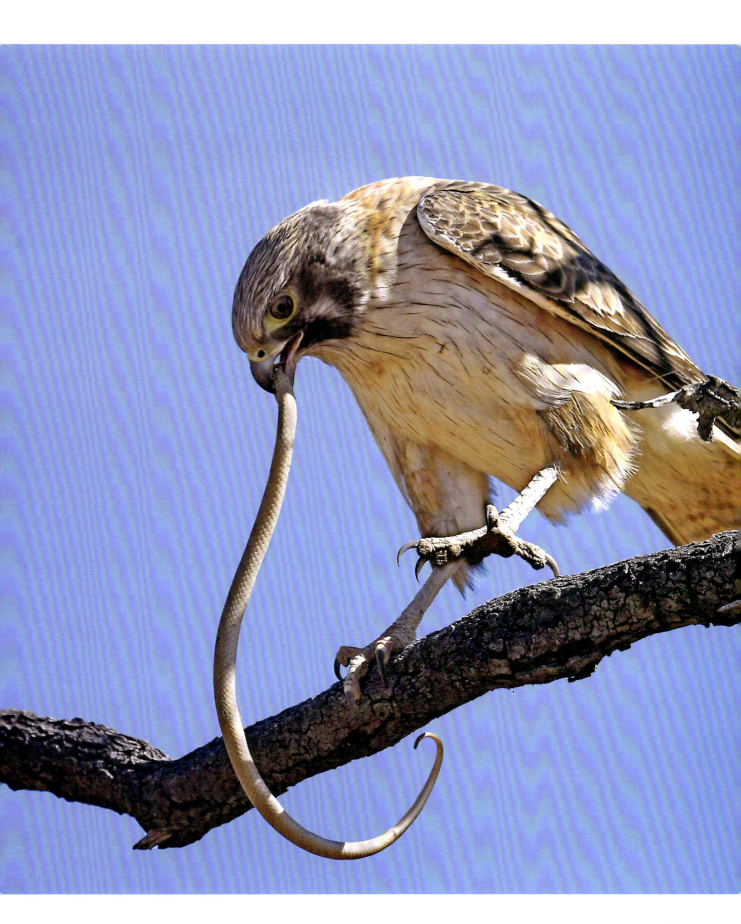

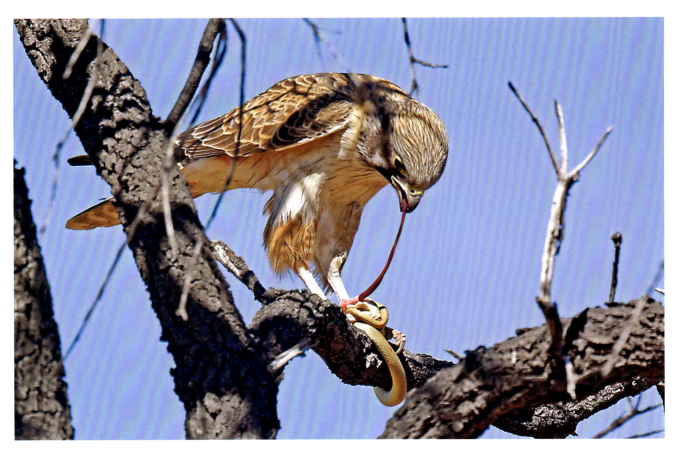
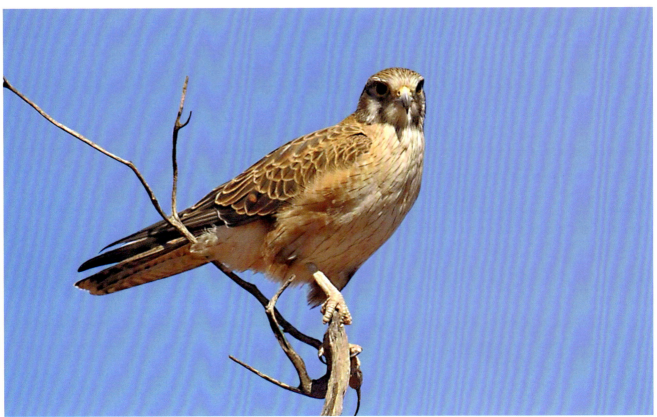

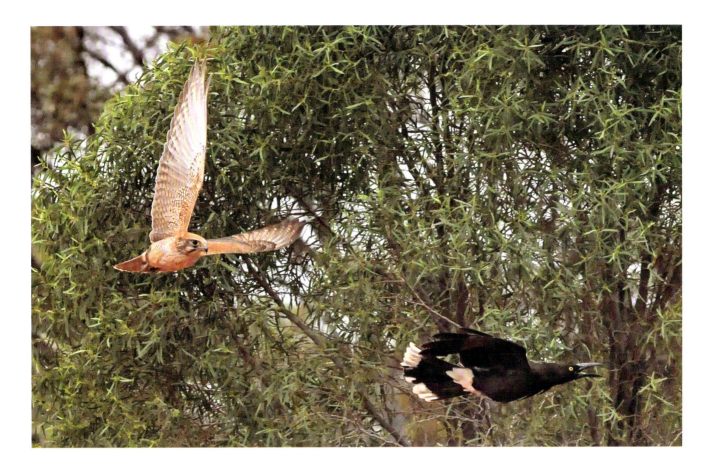

with snakes on other days but without managing to witness how it was actually dispatched. This one actively manoeuvred just out of striking range and soon extended an extremely long leg while resting on the shank of the other. It didn't occur to me at the time but I now think the long legs, longer than those of any other falcon, are an adaptation to taking reptiles. The snake was quickly dispatched but continued writhing as the falcon flew off. When we lived in the West Kimberley our regular beat was at a waterhole called Munkejarra. We used to leave the vehicle a kilometre or so away and more or less sneak through the long grasses so we didn't disturb the birds around the waterhole. A young Brown learnt that we disturbed grasshoppers and often arrived as soon we turned up.

Most of the prey we have seen taken consists of grasshoppers, reptiles and birds. A good place to determine what is being caught is at a nest. At one nest all of the items provided by the male were birds. Because they are plucked before being carried to the nest they were difficult to identify, but one retained enough feathers to indicate that it was a Little Buttonquail, which were plentiful in that vicinity. At another nest in the Kimberley all of the offerings were reptiles. I remember coming across a moving plague of grasshoppers in the Kimberley attended by dozens of Black Kites, Whistling Kites and Brown Falcons. Many of the falcons were on

Above: At Gluepot Reserve, SA, we witnessed a Brown Falcon attacking a black-winged form of the Grey Currawong. We believe it was the same falcon that we later saw chasing a corvid, probably a raven. In neither case did we see a strike, but in both cases the pursuit was persistent and very fast. I was too intent on watching but Sally managed to take this shot of the interchange with the currawong. Because we didn't see the outcome we are not sure whether this was territorial defence or whether the falcon intended to prey on the currawong.
Opposite above: Feeding on a small brown snake.
Opposite below: A Brown Falcon with a mouse dispossessed from a Black-shouldered Kite.

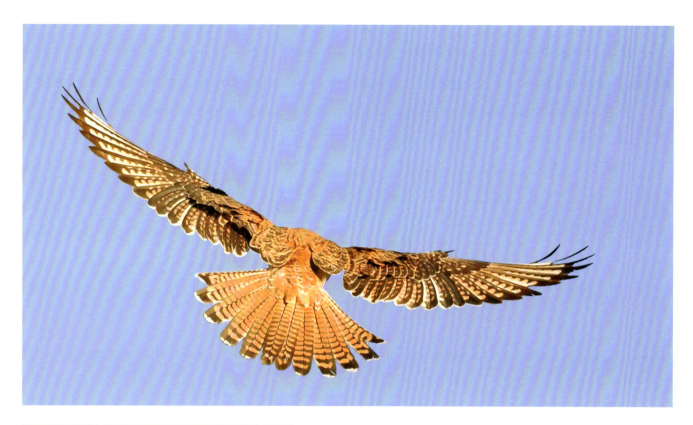

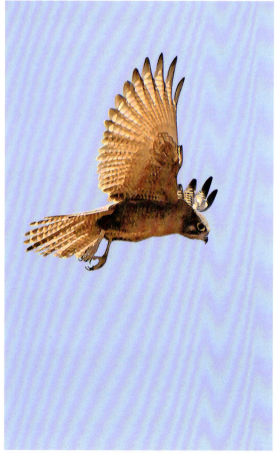

the ground, running after the insects. An interesting item of prey was flying ants (or termites, I'm not sure which) observed on a steamy evening at Gluepot Reserve, SA. A solitary falcon followed the swarm, probably at fifty metres above the ground. We in turn followed the falcon for about ten minutes, watching it snatch and devour a lot of insects. Some of the snakes caught are quite big. Ray Garstone and I saw one flying with a Dugite which it dropped and we were able to roughly measure at about four feet. Some regularly take Tiger Snakes.

The hunting technique we see most often utilises a vantage point, usually the uppermost branches of a tree, a pole or electricity wires. There the falcon waits patiently until a mammal, reptile or insect appears, then swoops down in a long glide. One attack we measured covered more than two hundred metres, a testament to the bird's eyesight .

Browns often hover, facing into the wind, rather more clumsily than Nankeen Kestrels or Black-shouldered Kites, and usually higher, although we saw one in Victoria persistently hovering below five metres. Other hunting techniques include tail-chasing and dispossessing other birds of their quarry. On one occasion I was alerted by agitated Grey Butcherbirds to a Brown sitting on their nest, obviously eating the eggs. My arrival flushed the falcon and it left. One of the butcherbirds then removed broken egg-shells and the nest was subsequently abandoned.

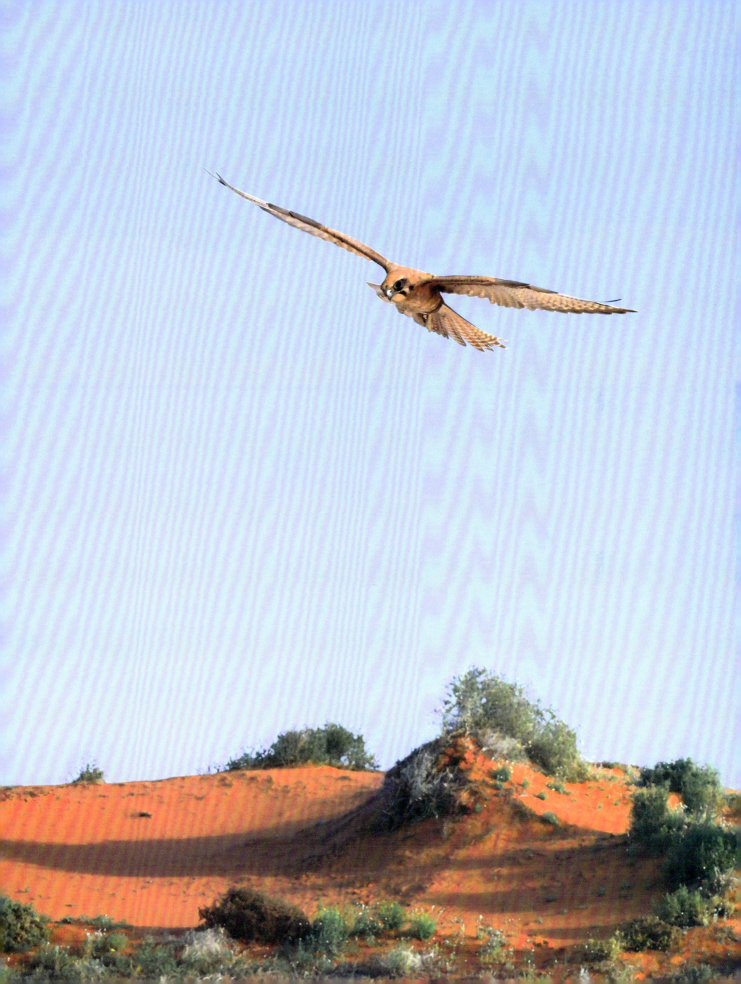

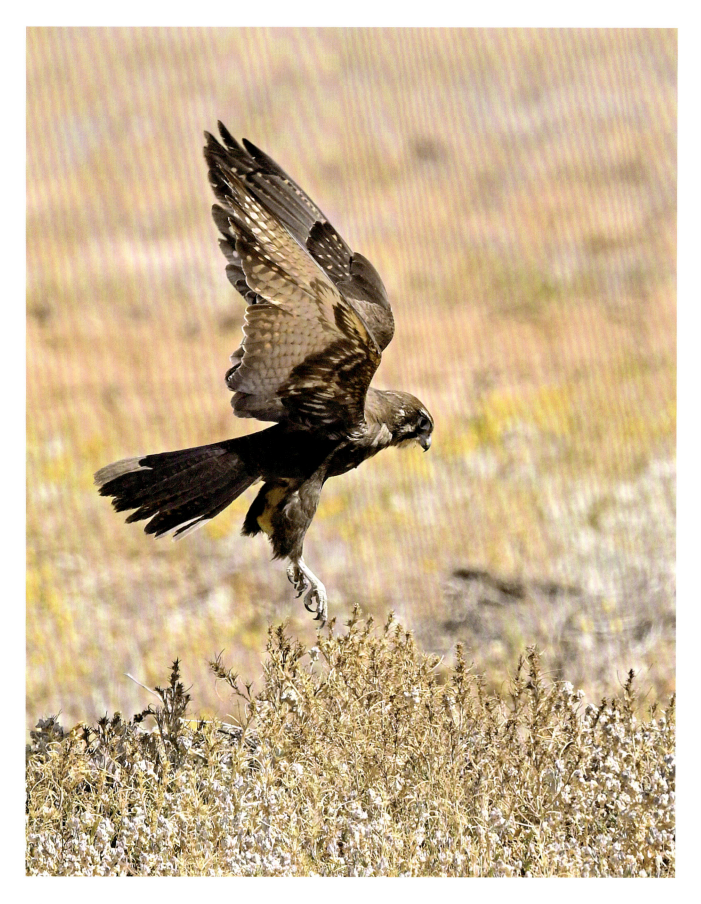

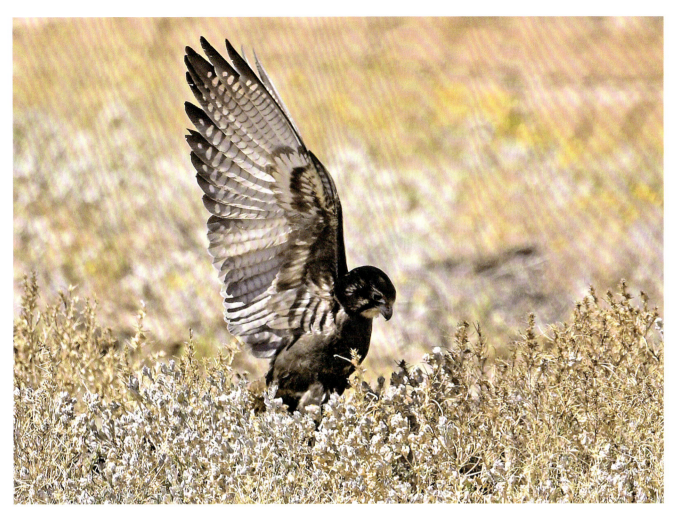

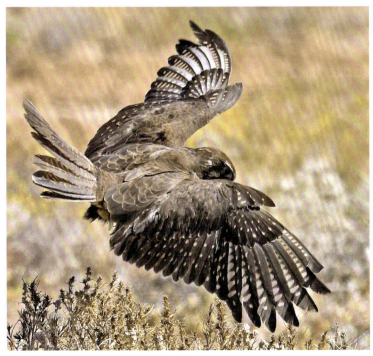

Near Boulia, Qld, we watched this Brown Falcon chasing a lizard. Judging by the buff throat and ear-coverts it looks like a juvenile, which may explain its lack of success on this occasion.

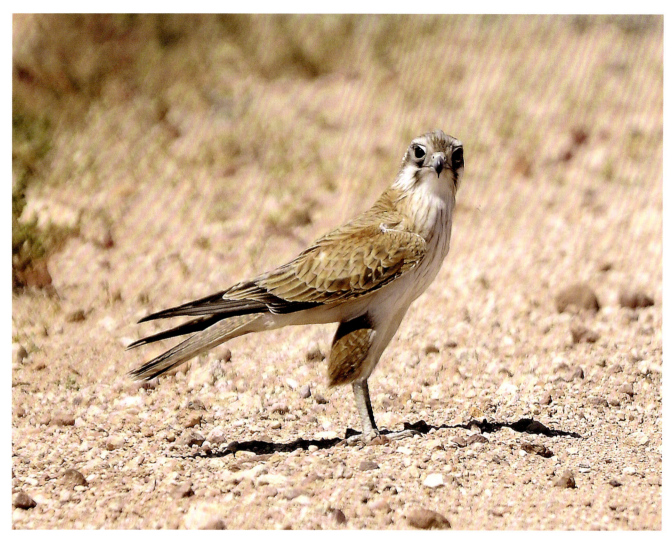
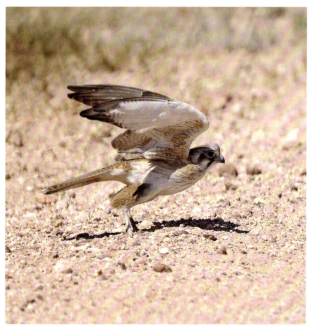

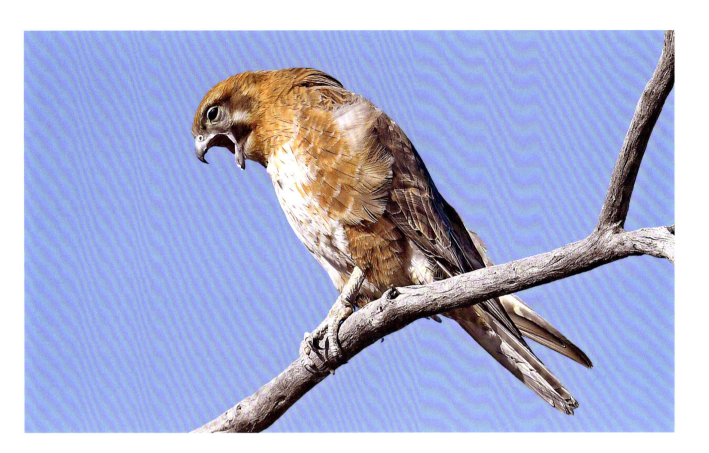

In falcons as well as many other birds, food is accumulated in the crop before passing into the stomach. The crop is essentially an enlargement of the oesophagus. There are suggestions that enzymes begin breaking down the digestible parts of the food while it is in the crop; indigestible items such as feathers, fur, scales and bones are compacted into a pellet, or casting, and are ejected through the mouth. Such castings are essential for the health of the bird, a factor sometimes overlooked by carers of rehabilitated birds. The Brown Falcon shown above is in the process of ejecting a casting; it was photographed in the late afternoon, near Winton, Qld. The bird is a female that had been fed by her mate several times during the day. Usually pellets are cast at the same time each twenty-four-hour period. We saw this elegant little male, left, picking up grit on a road in the Simpson Desert. While we watched, it ran daintily across the road with wings raised and high-stepping gait as if running on hot coals, then it was photographed picking up and swallowing small pieces of grit. Essentially, falcons don't need grit to aid digestion, but old-time falconers believed that sometimes fatty deposits lined the crop, especially after their birds had been rested for moulting, and they fed their birds small stones, called rangles, to clear the problem. The stones were regurgitated later. One account records that stones left near their perches were often picked up and swallowed.

Top: Preparing to eject a pellet.
Above: A pellet.
Opposite: Photographed through the windscreen, this dainty little male was picking up and swallowing pieces of grit.

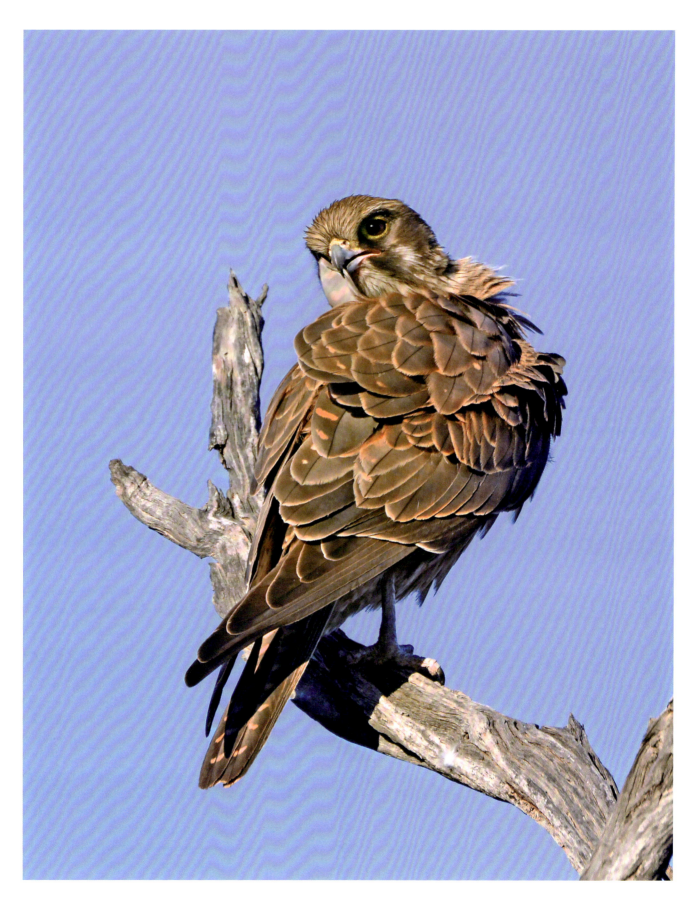

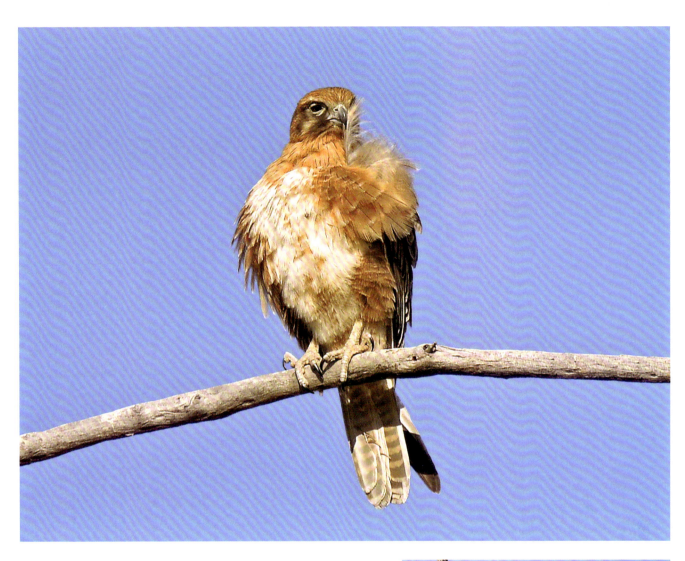

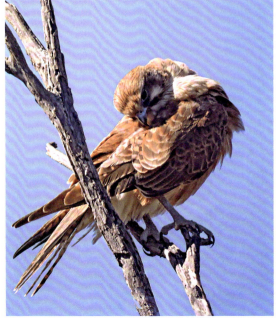

Brown Falcons spend a lot of time each day preening. Feather maintenance is essential for efficient aerial performance, so the wing- and tail-feathers are paid special attention. One female we watched at the Engine Hole in Bladensburg National Park preened off and on during an entire afternoon (right). She was waiting for her mate to arrive with food, so was probably bored. Usually preening sessions last for up to twenty minutes.

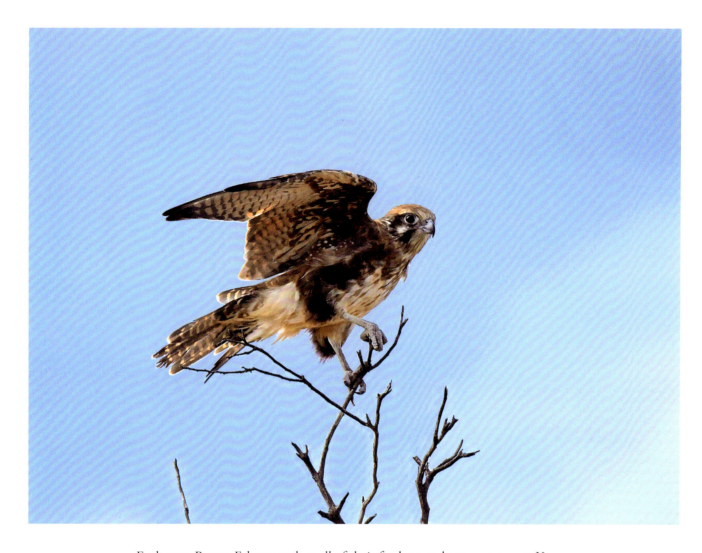

Each year, Brown Falcons replace all of their feathers and grow a new set. Young birds at the end of their first year tend to begin the moult earlier than adults, from September to March, while adults moult from October to April. The bird above, photographed in Victoria on 11 March, is still growing some feathers, and as a result has a rather patchy appearance. In the wing, primary feathers begin replacement with the fourth, proceeding sequentially in both directions, while the secondaries also begin in the middle. New tail- and wing-feathers grow at a rate of four to five millimetres a day, so take up to five weeks to gain full length. Most first-years are dark brown with dark underwing-coverts and in subsequent years become more reddish with increasingly patchy underwing coverts, like the one in the image opposite.

All of the other falcons found in Australia and throughout the world moult directly from juvenile plumage to adult. In most instances the Brown takes four or five years to assume adult plumage, and some males at least continue to lighten throughout their lives, and even have unmarked underwing-coverts. The colours of the unfeathered skin surrounding the eye (orbits) and the cere are blue at first, then slowly turn yellow, the orbits first, more quickly and more brightly in males. The legs at all ages remain blue-grey.

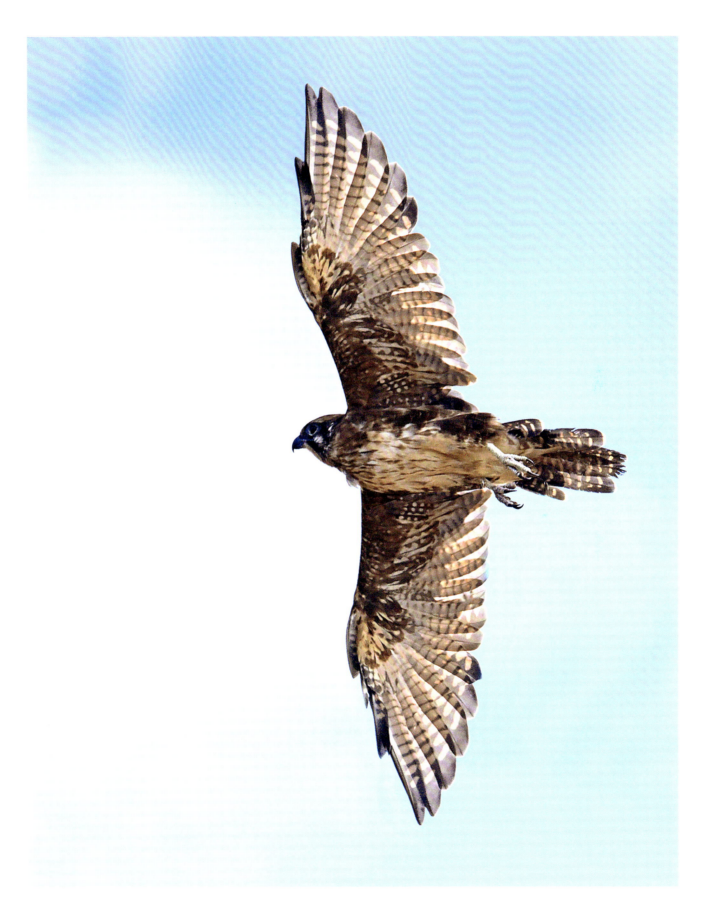

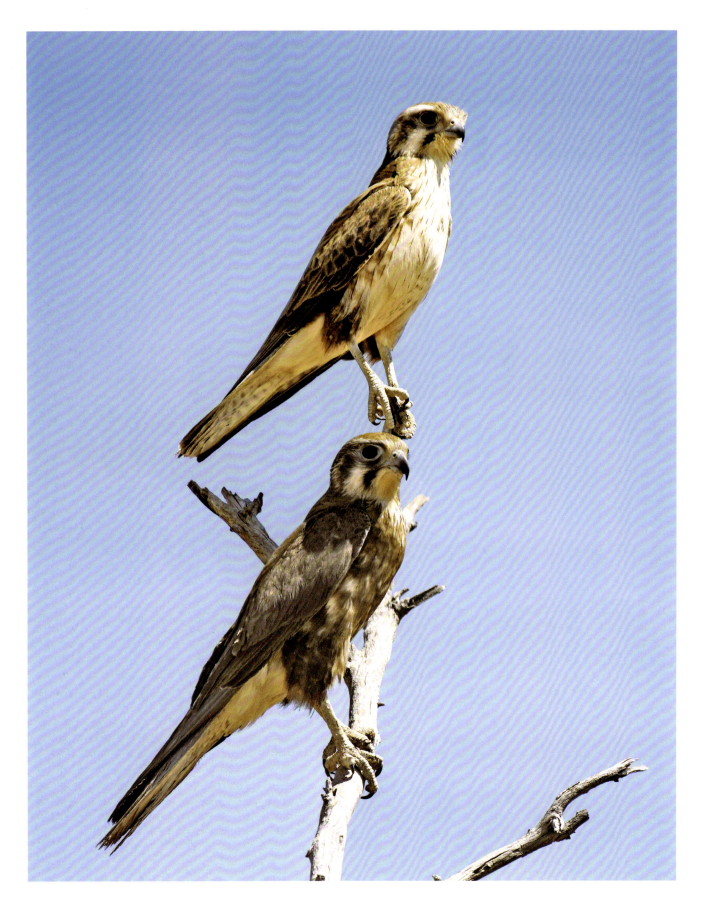

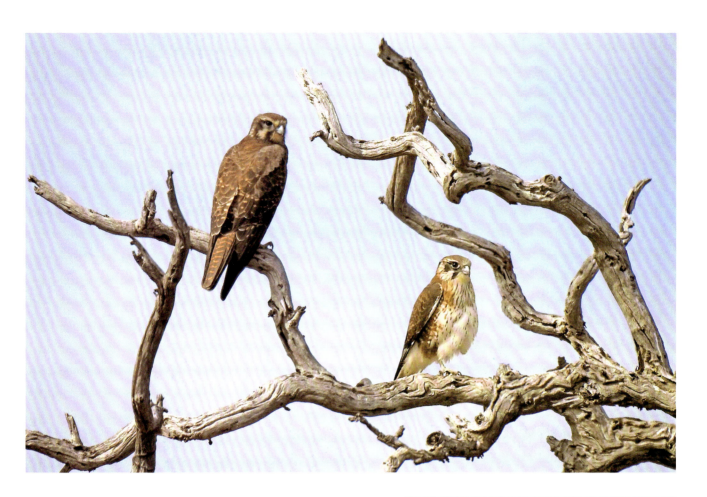

On average, male falcons are visibly smaller than females. The species in which the difference is most pronounced prey principally on birds. There are numerous theories propounded to explain the difference, from sampling different-sized prey in a territory to equalising the aggressiveness between the sexes. The theory I find most convincing was first discussed by Schmidt-Bey in 1913, namely that intra-specific territorial defence favours a smaller agile male. Some support for this idea is presented by the Brown Falcon, which is more of a generalist, preying on insects and reptiles as well as birds, and as a consequence, being probably less agile in the air, shows less size differential: indeed some large males are equal to or larger than some small females. On average the difference is slightly less than 10 per cent. When seeking a mate, small females tend to select small males, while larger birds choose larger mates. There are many exceptions of course. The female on the left, photographed in the Simpson Desert, was substantially bigger than her mate. The pair above were more equal in size, photographed at the Werribee Treatment Plant, Vic, where the density of breeding pairs is probably greater than anywhere else in Australia. On the right is a very large dark female paired with a small pale male. These shots were all taken in September, well into the breeding season.

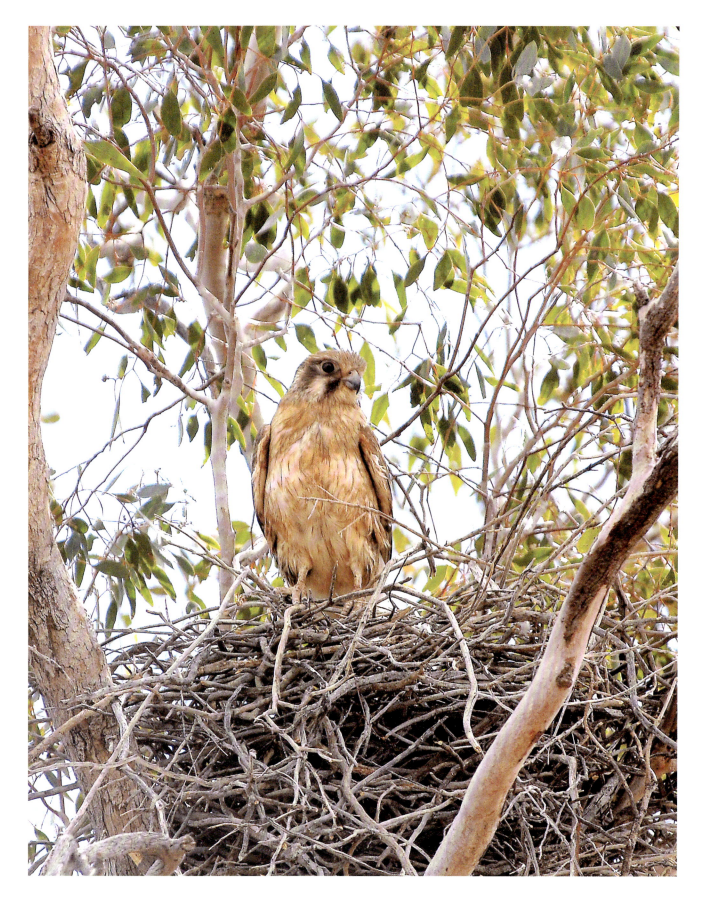

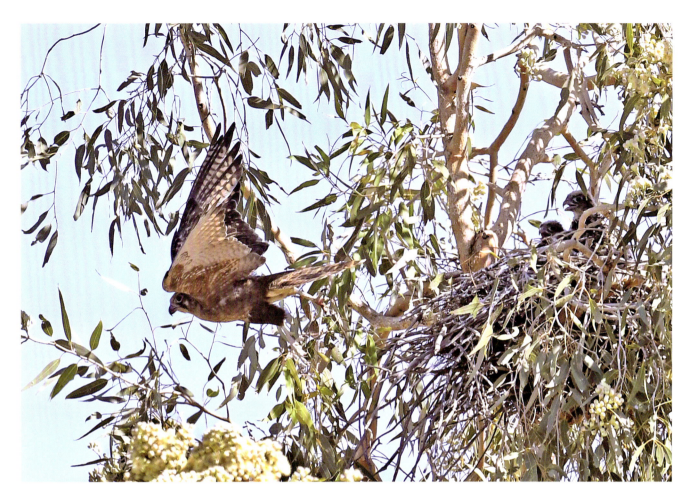

Following the equinox, any pairs that have vacated their territories begin returning, new pairings are made, and displays begin. The one we see most often, but not often enough, is 'side-slipping', in which one or both birds rock from side to side in a shallow swoop, accompanied by loud cackling. We prefer to call this display the 'slalom' because it is reminiscent of downhill ski racing. I remember one occasion in the Simpson Desert when three widely-separated birds from different territories were performing at the same time, all cackling away. It is amazing how far the sound carries.

The focal point of each territory is a nest, usually one previously built by other birds of prey such as kites and eagles, or by crows and ravens. In the Kimberley, thirteen of fourteen nests I found were originally built by Whistling Kites or Black Kites in baobab trees, but elsewhere eucalypts seem to be preferred. For a few weeks before the female begins laying the male provides all of her food. Egg-laying usually begins in September or early October and the typical clutch size is three, but there are of records of nests containing between one and five eggs. The eggs are smeared and spotted with various shades of reddish-brown.

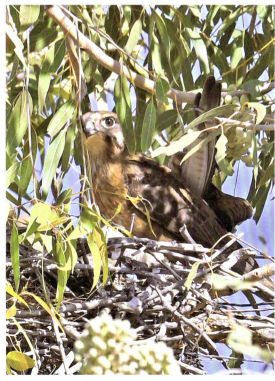

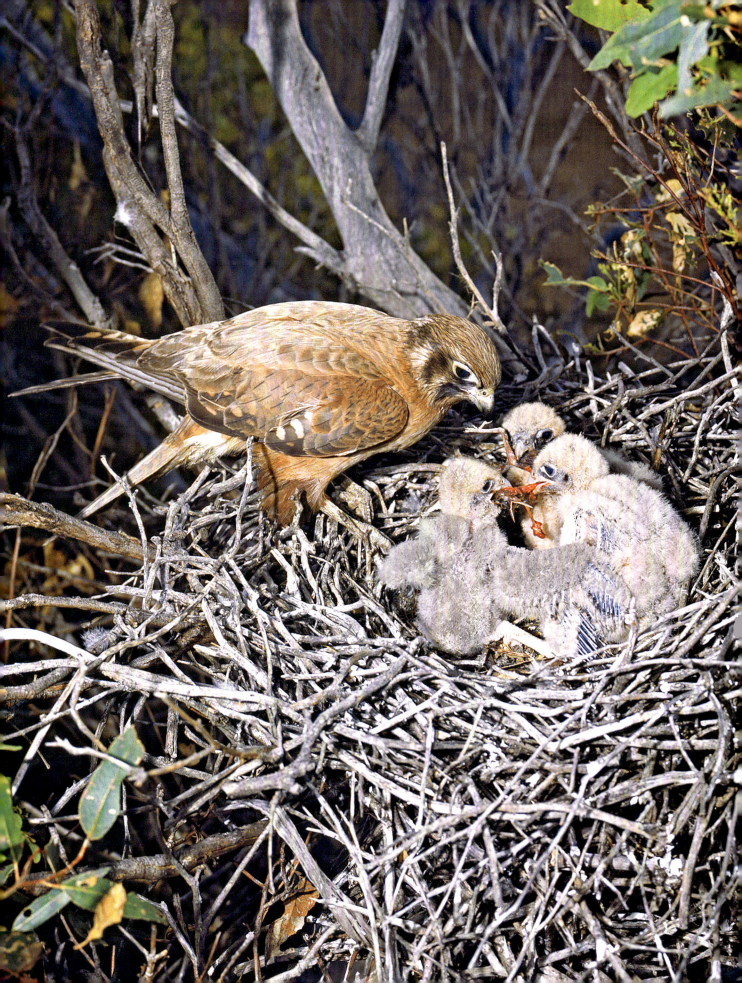

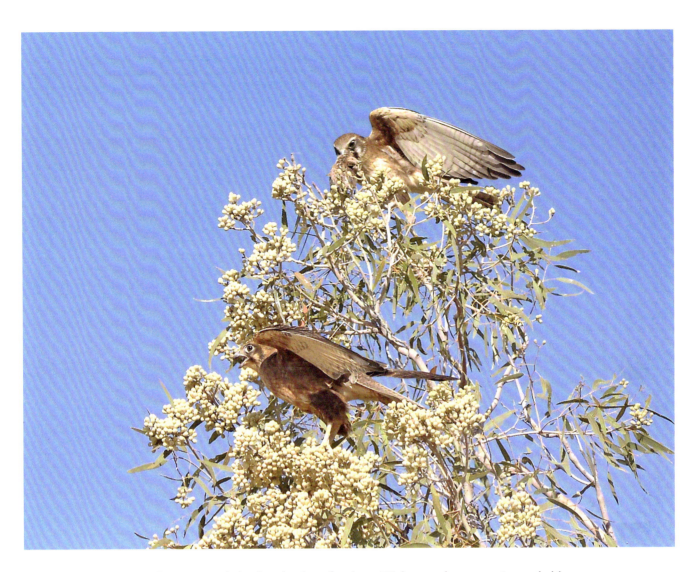

Incubation, mostly by females, lasts for about 35 days; males may assist, probably dependent on the time taken to supply food. Once the chicks hatch, they are fed by the female with food supplied by her mate. Sometimes he carries the food to the nest and leaves it for the female to tear up into small morsels. On other occasions, food is transferred away from the nest. In the photograph above, the transfer was made on top of a bloodwood tree; the offering presented by the male was a Little Buttonquail, a species common in the vicinity at that time. On this occasion the female carried it to a horizontal limb, plucked it then ate some herself before flying to the nest to feed her chicks. At first the young ones are covered in grey down but another coat of more buff-coloured down appears within a fortnight. After about forty days, chicks leave the nest but are still fed for another forty days or so. If there is plenty of available food in a territory young ones may learn to hunt more quickly and become independent sooner. Once they are independent, chicks may be driven from the territory, and move away, sometimes travelling long distances. One banded chick was recovered more than two thousand kilometres away, but the average distance covered by recovered birds is about two hundred and fifty kilometres from the banding site.

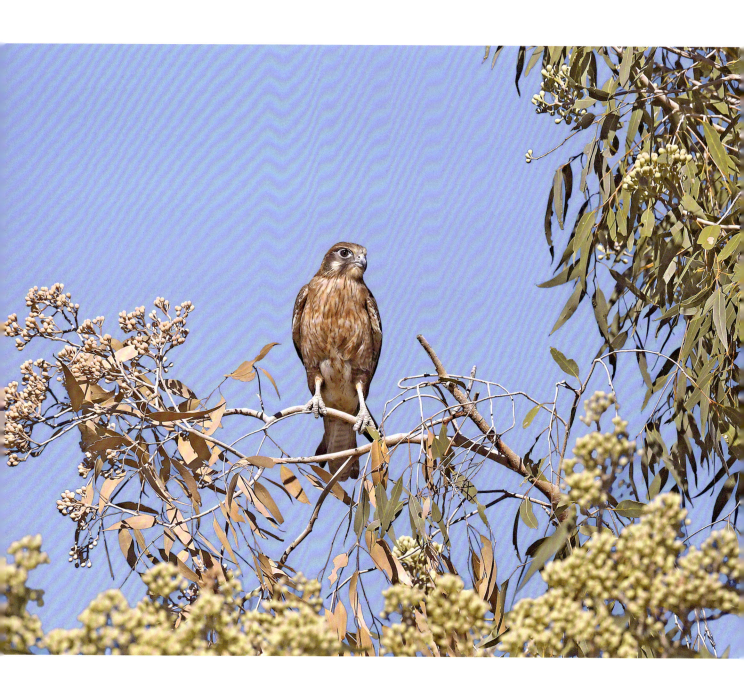

These birds were paired, nesting in an old bloodwood at Jundah, Qld; the female is above and the male is opposite. We returned a fortnight after taking these photos to check how they were going and found the blossoms had opened and the tree was covered with hundreds of bees and woodswallows.

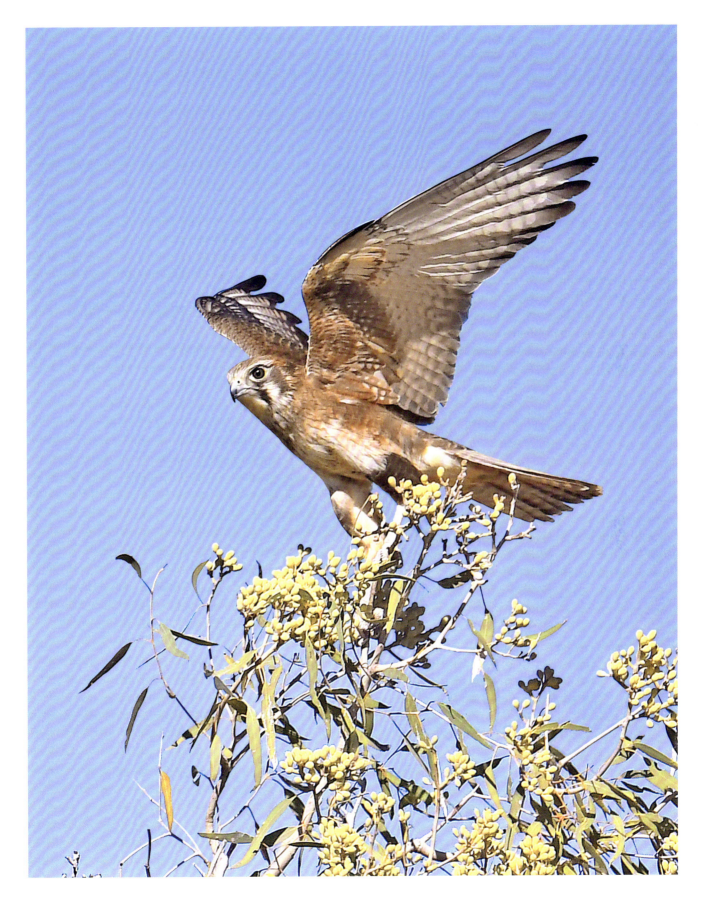

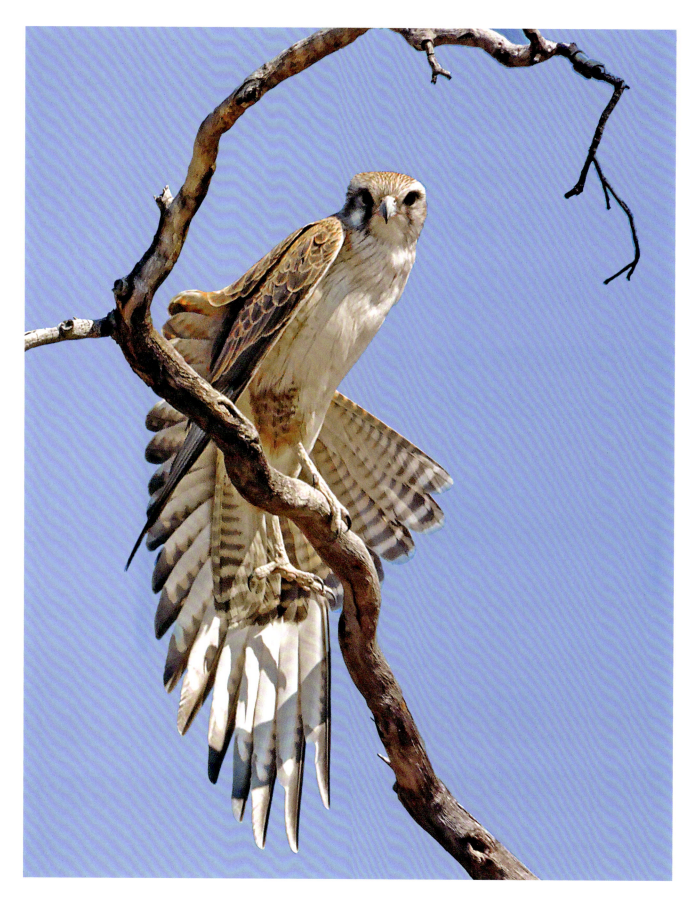

While driving through the outback we regularly see Brown Falcons sitting out in the open on dead emergent branches near or at the tops of trees. The bird in the image opposite is wing-stretching; it was photographed in Bladensburg National Park, Qld. In such a situation at the top of a tree these falcons are very obvious, but down at ground level mature birds match the ground colour of the desert environment, as can be seen in Sally's photos (above and right).

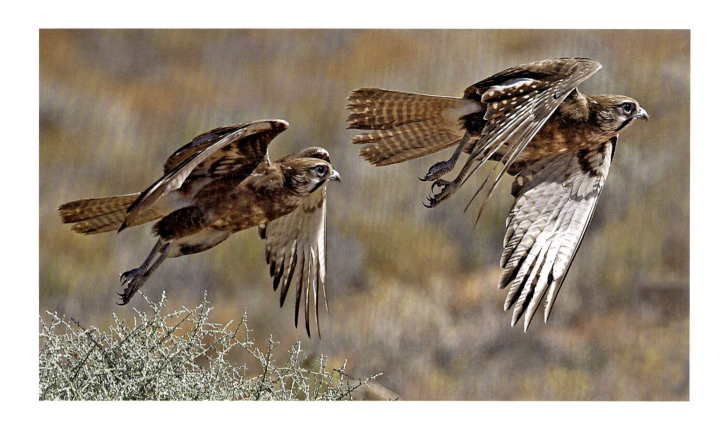

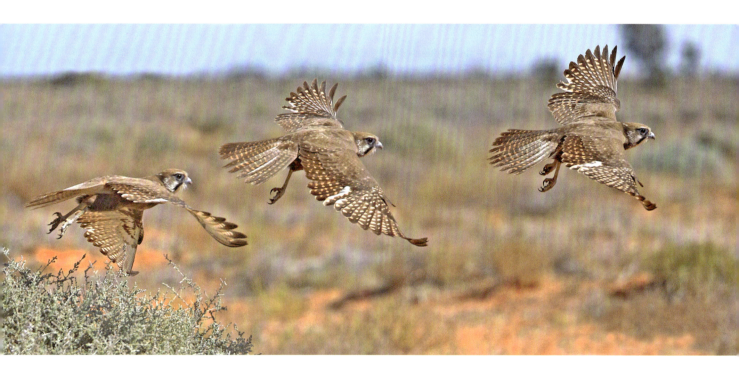

These composite photographs taken in the desert show flight patterns. The Brown Falcon has slower wing-beats than other falcons, with an overarm style that makes them easy to identify at a distance. The wings are held at a high dihedral, unlike other falcons, probably as an aid to slow soaring.

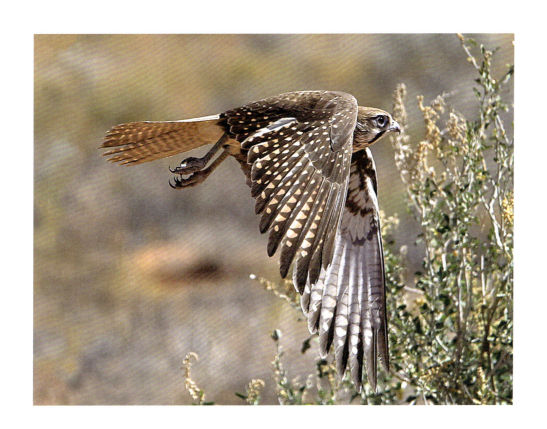
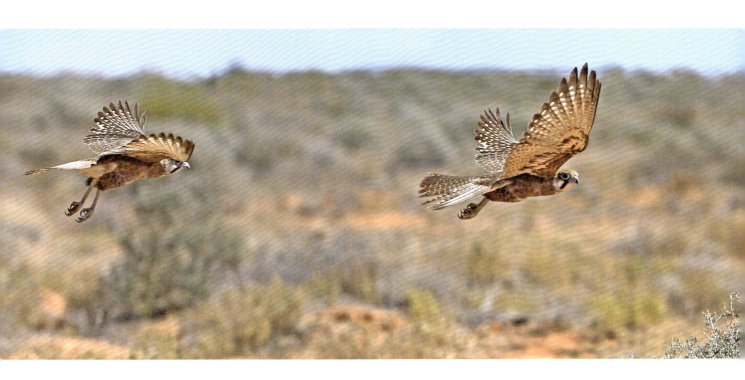

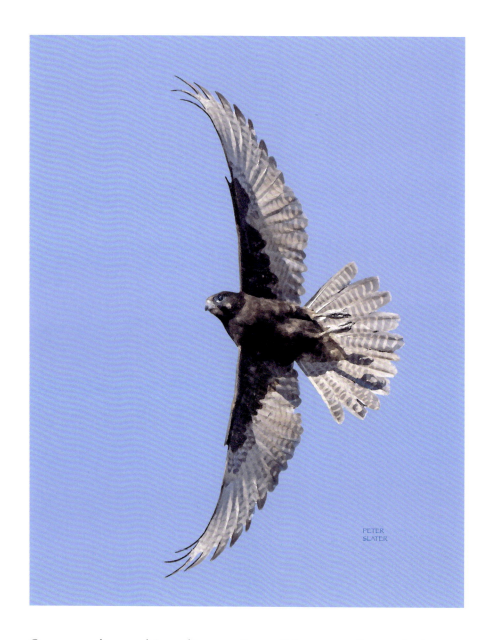

On our travels around Australia we see Brown Falcons more frequently than any other birds of prey except Black Kites and Whistling Kites, and about as often as Nankeen Kestrels. Even though they are so plentiful we still stop to look at each one, and try for a photograph if possible. So I suppose we have photos of some hundreds of individuals. One of the fascinations of the Brown Falcon is the variability of its plumage. No two are exactly alike. Here we show two extremes, dark and pale. We feel, not very strongly, that the dark birds like this one constitute a separate morph (meaning that this plumage is retained for life) from the pale ones. Following the plumage changes of banded birds should settle the matter.

In the following pages we have shown some examples of the variability of the Brown Falcon, from the darkest to the palest.

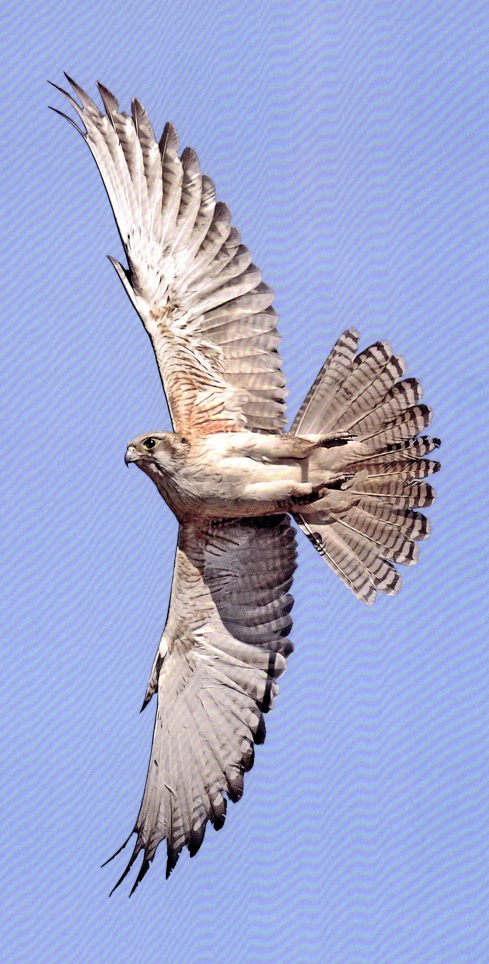

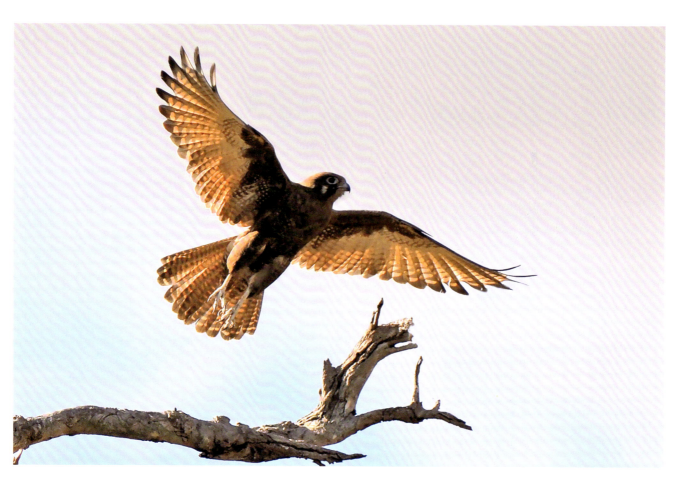
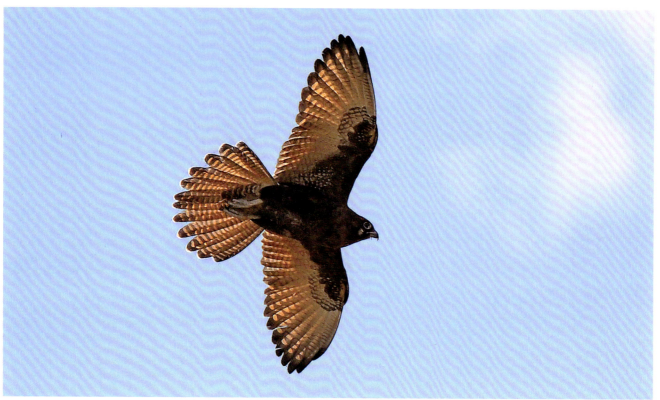

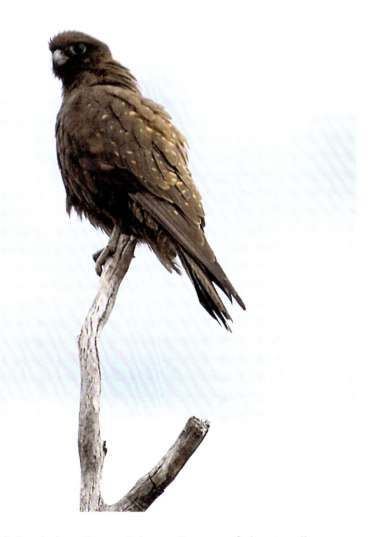

These are examples of the darkest Brown Falcons. Because of the virtually unmarked underwing-coverts and the blue bare parts we suspect they are juveniles. Above is the darkest one we have seen, with only the faintest pale spot on the cheek. Birds like this are sometimes mistaken for Black Falcons. The other two have a larger pale cheek-spot as well as a slightly paler chin. The flying birds show spotting on the axillaries. The plumage is basically chocolate brown although the back-lighting of the photographs makes the birds seem more reddish than they are in life. The paler flight-feathers immediately differentiate them from Black Falcons.

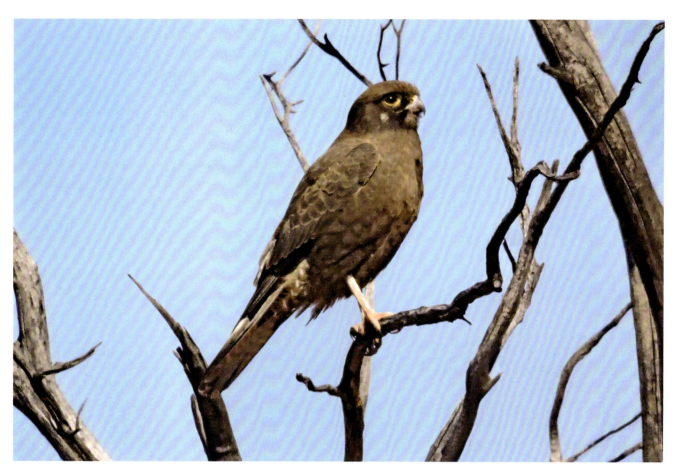
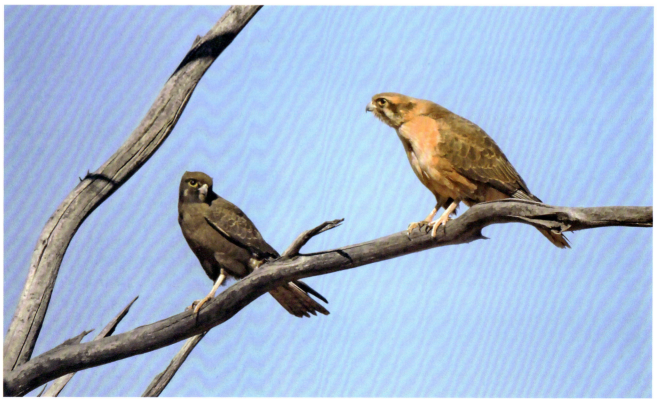

Until we saw this chocolate brown male with its pale mate (opposite, both images) at Yowah, Qld, we were not entirely sure we had ever come across an undoubted dark male in the field, due to the fact that most birds we see are solitary and there is no reliable size reference, apart from a subjective judgement. Due to the bright yellow bare parts, we are confident that this male is not juvenile or immature. Our greatly enlarged photographs were taken from a fair distance away, so are not as sharp as we would wish, but they satisfy our minds that the dark state is not sex-linked. The bird above is a similarly coloured female, also with a pale mate. The blue bare-part colours suggest it is younger than the dark bird opposite.

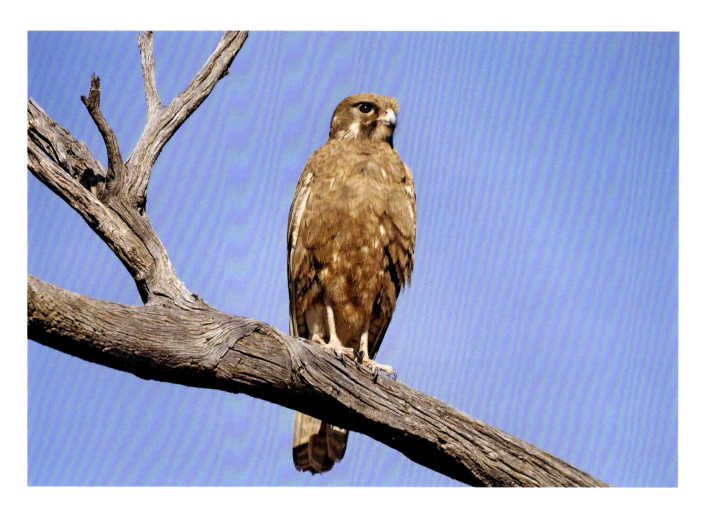

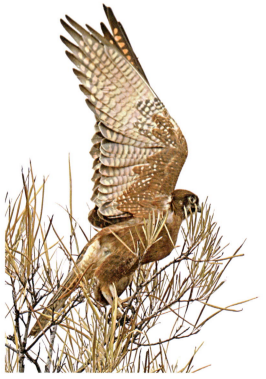

These Brown Falcons are basically dark reddish-brown with pale cheek patches and pale chins. They have some yellow in the orbital rings and pale mottling on the underwing-coverts, indicating that they are possibly adult. The bird opposite has a greyish chin and ear-coverts and also appears to have more reddish plumage.

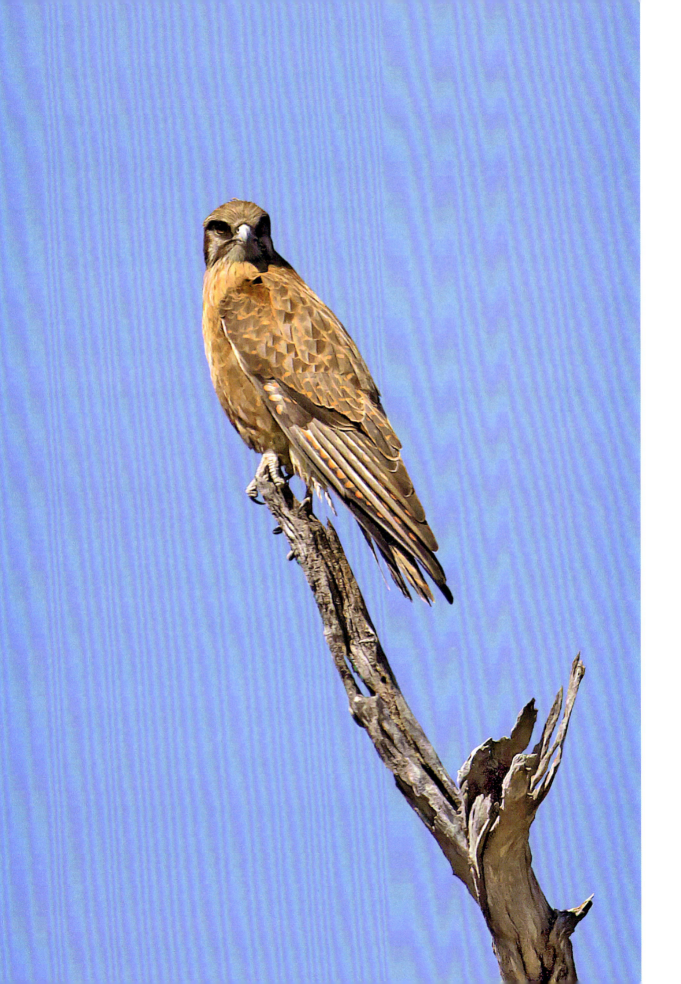

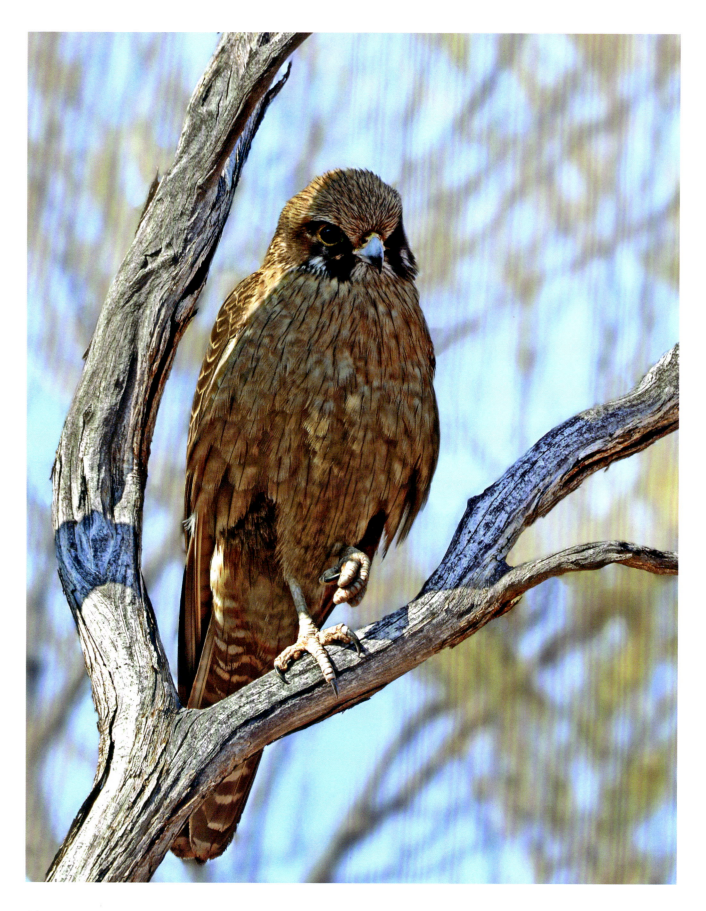

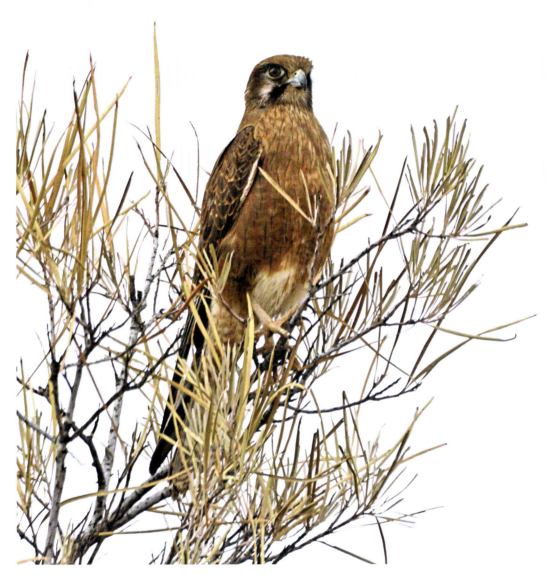

We refer to birds in this plumage as 'sandy-breasted'. Most of them have large dark moustaches and ear-coverts as well as strongly barred undertail-coverts. Bare-part colours on the bird opposite are very bright which suggests it is a male, but I remember it as quite large. *The Australian Bird Guide* by Menkhorst, Rogers and Clarke portrays this plumage as female. It has the belly the same colour as the breast; in the example above the belly is white. It is similar to the bird painted by Richard Weatherly for his paper on Brown Falcon plumage variation, labelled: Adult male 'red' variant (*Emu* 85: 257–260).

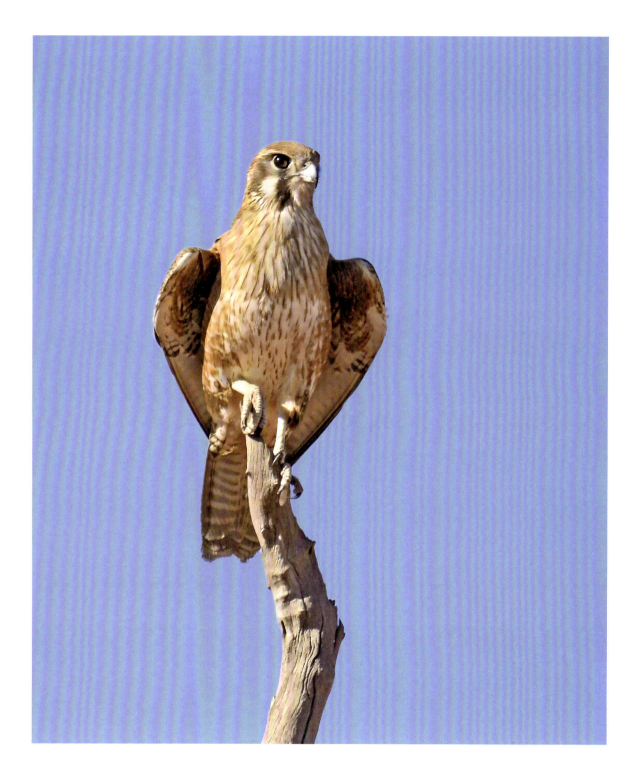

These are variants of paler versions of 'sandy-breasted' Brown Falcons exhibiting different orbit and cere colouration. Above: pale yellow orbit and blue cere. Opposite top: bright yellow orbit and pale yellow cere. Opposite, below right: bright yellow orbit and cere. Opposite, below left: bright yellow orbit and blue cere; this bird also has a smaller moustache.

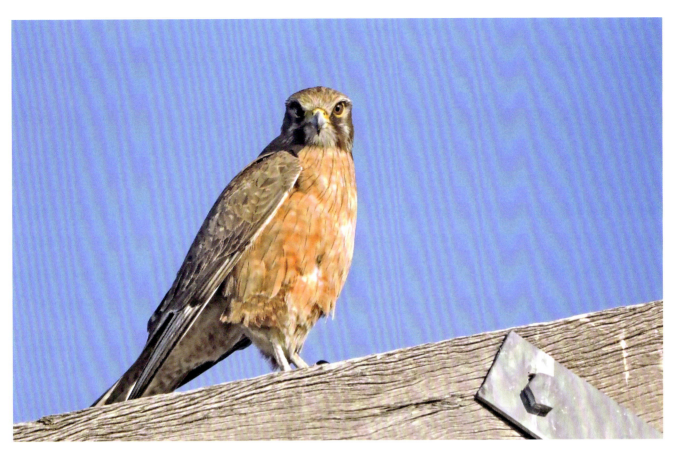
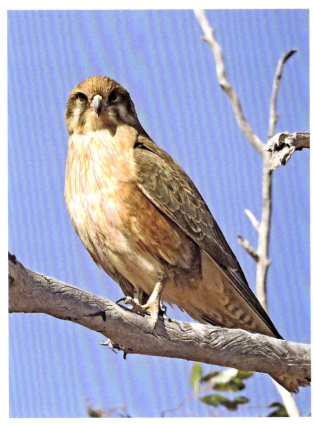
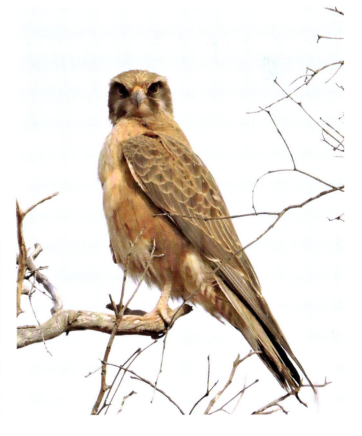

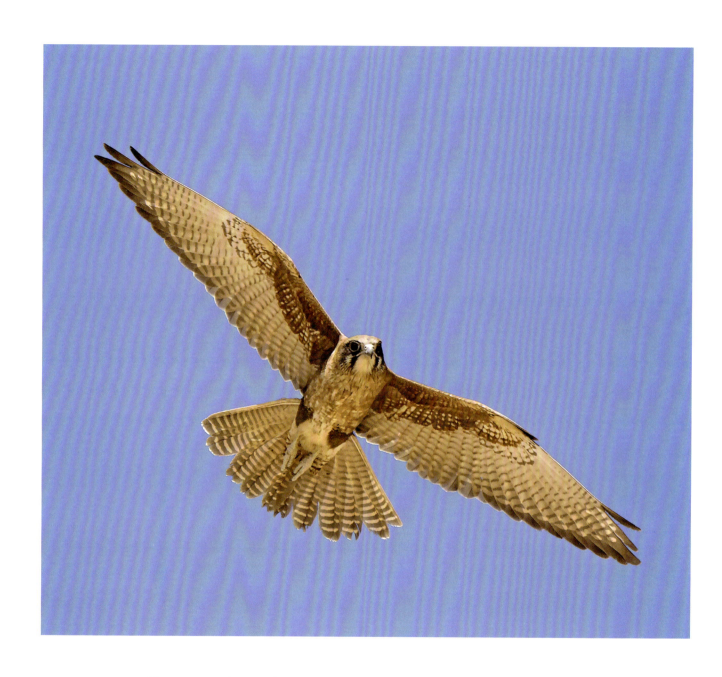

These images show underwing patterns of two different 'sandy-breasted' Brown Falcons. The patchy markings on the breast and abdomen of the bird opposite suggest that it could be moulting into a paler-breasted plumage.

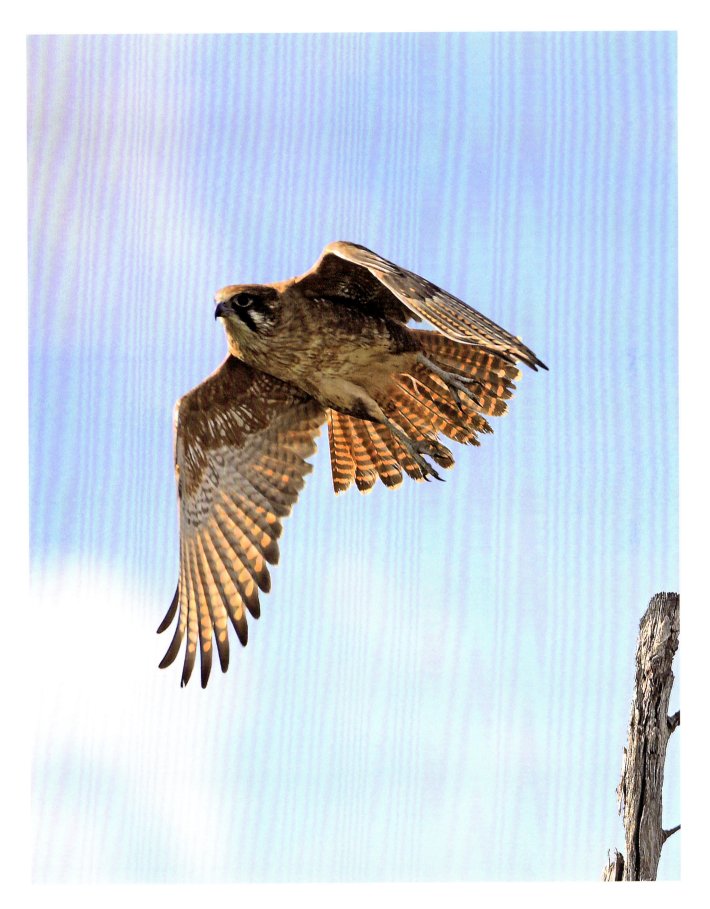

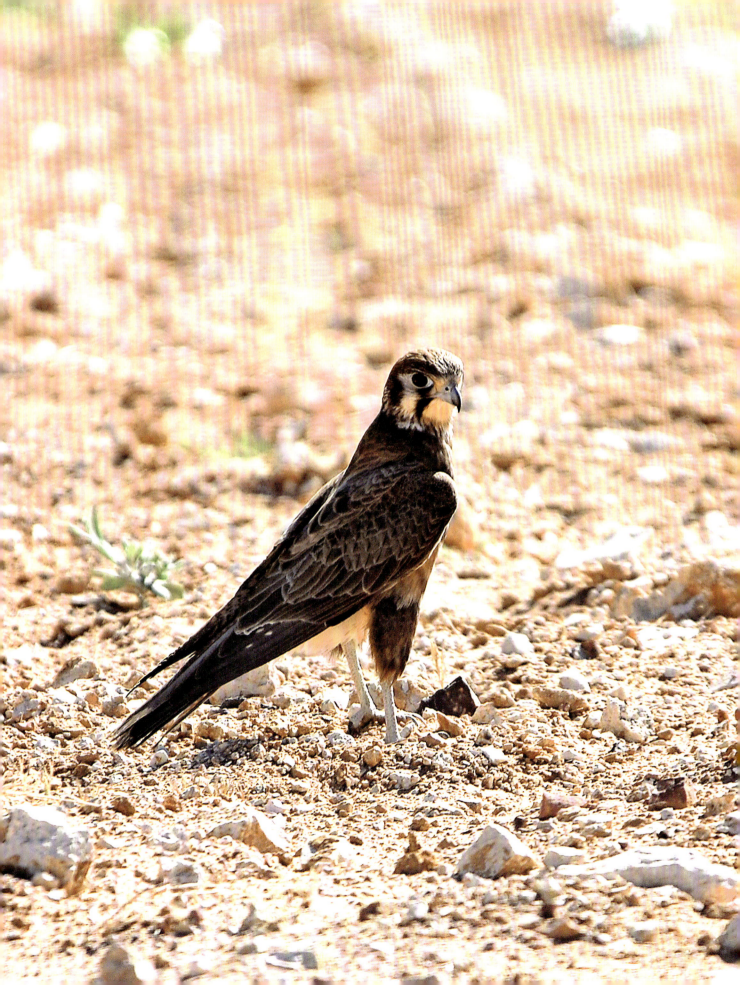

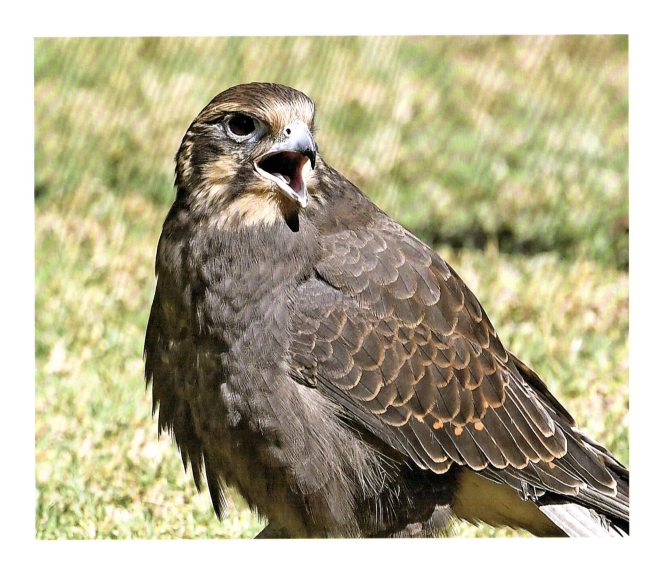

Although these look like dark birds, they are juveniles that will moult into pale-plumaged birds, showing the typical buff colouration on the facial patterns and unbarred undertail-coverts. In the interior most individuals have unbarred undertail-coverts, but that may not be the case in the south-east and Tasmania. Juveniles that eventually become pale-breasted birds can be quite dark on the underparts in their first year, like these, but many have buff markings in the breast. Dark birds have much less pale colouring on the chin and cheeks, and have barred undertail-coverts.

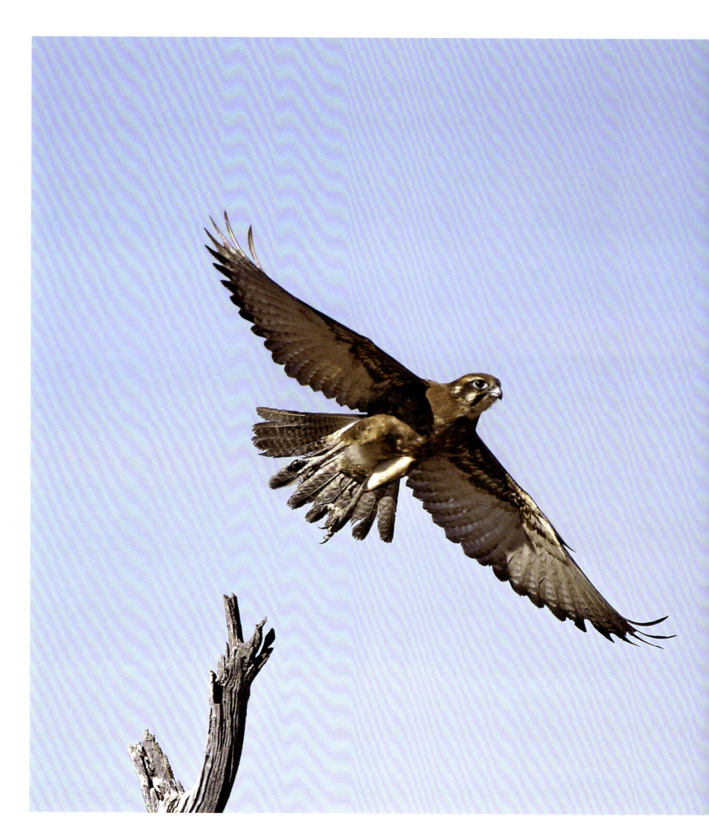

This is a composite photo of an immature inland bird. The lack of buff colouring in the facial pattern and the amount of speckling on the underwing-coverts imply that it is not a juvenile.

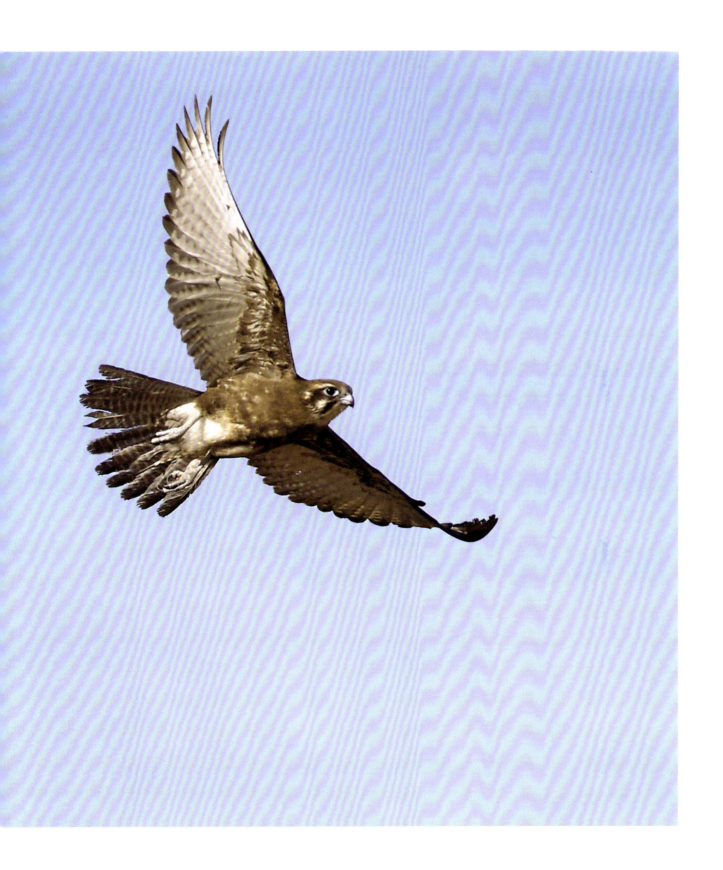

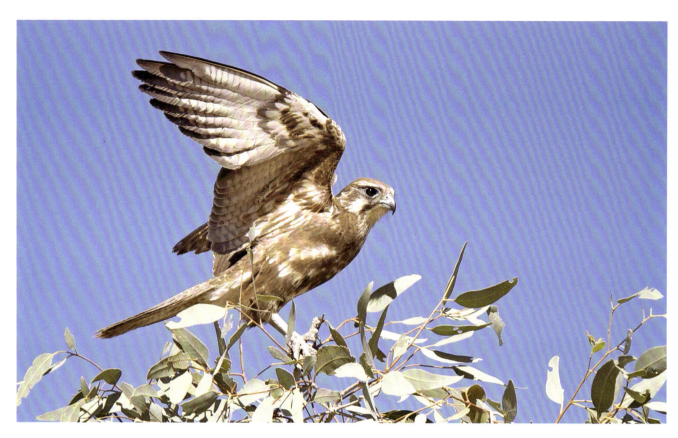
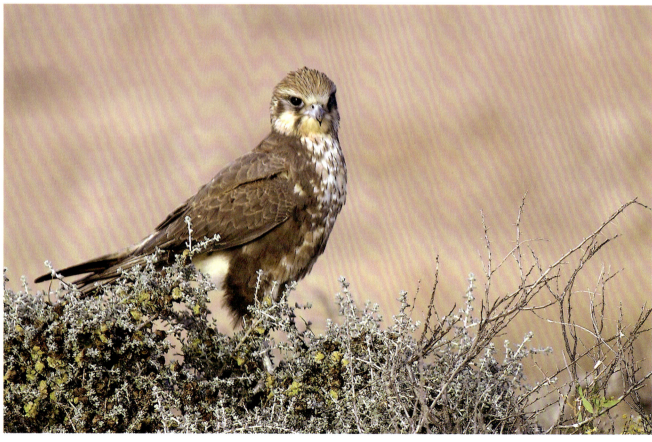

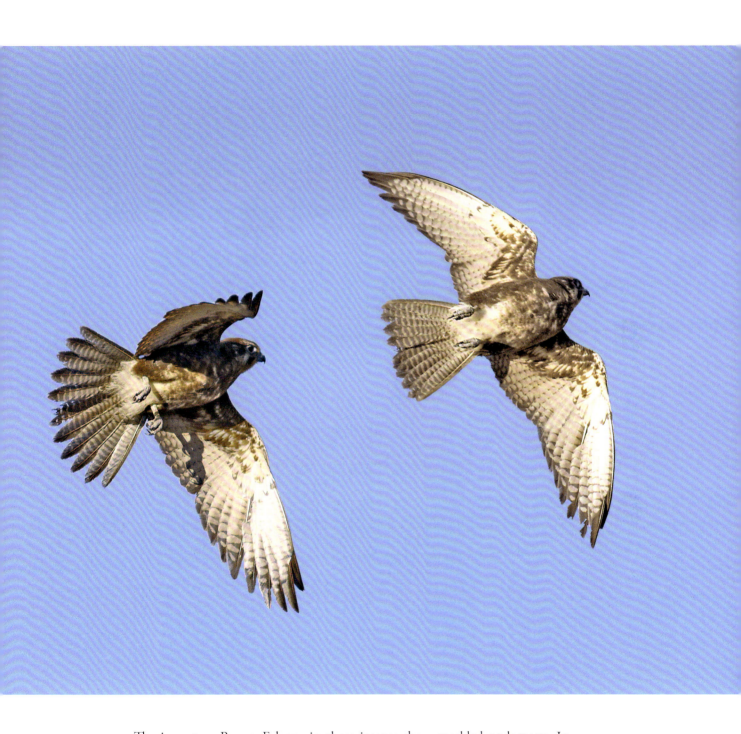

The immature Brown Falcons in these images show speckled underparts. In younger birds (opposite below) the white areas of the underparts are suffused with a paler version of the buff seen in juveniles. In older birds the buff is either absent of faded. As these brown birds get older, the plumage will tend to become more reddish.

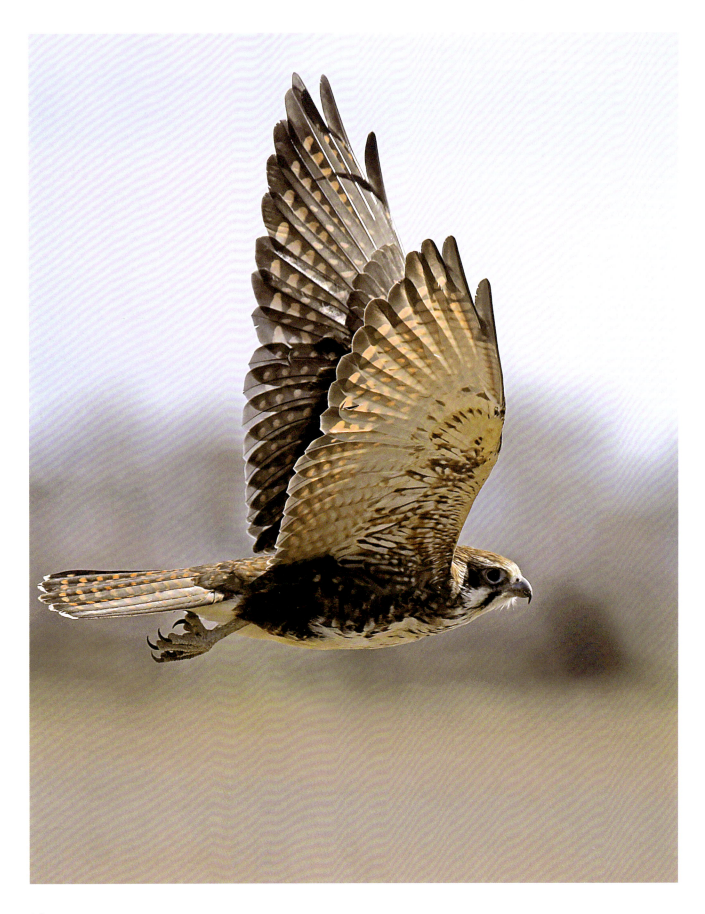

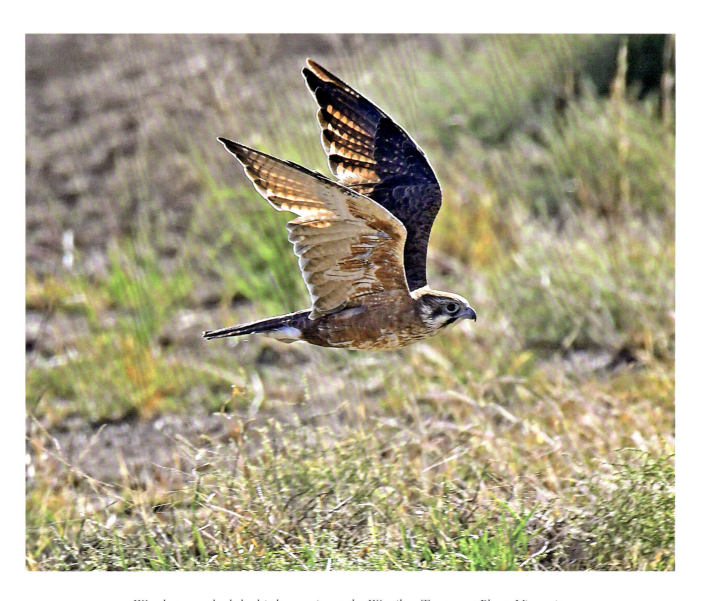

We photographed the bird opposite at the Werribee Treatment Plant, Vic; a site where David Baker-Gabb (in 1982–1983) and Paul MacDonald (in 1999–2002) have conducted classic studies into Brown Falcons. This bird is what in the past has been called a 'brown morph', but MacDonald's studies indicate it is in a transitional plumage. As it ages the orbital ring at least will turn yellow, generally brighter in males, followed later in many cases by the cere.

Above is a more reddish bird, probably older, but still with blue soft parts, and possibly a female. It was photographed near Dunolly, Vic, where my maternal great-grandparents ran a bakery shop and produced nineteen children as well as bread. Great-grandma Hill was the daughter of a convict.

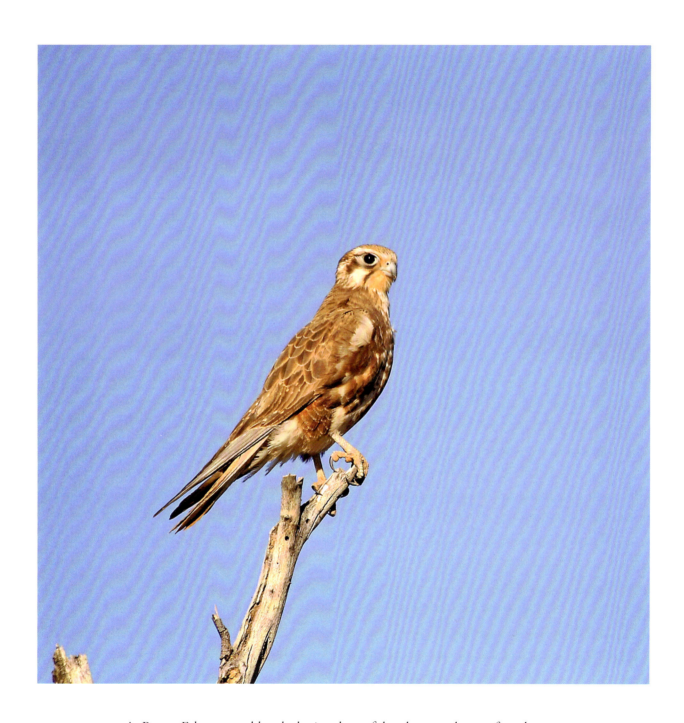

As Brown Falcons get older, the basic colour of the plumage changes from brown to reddish, a progression that may begin in the second or third year, with males probably changing sooner than females. Usually by the fourth or fifth year the adult plumage is attained, although at least some males appear to continue developing into quite a pale, and very attractive, plumage.

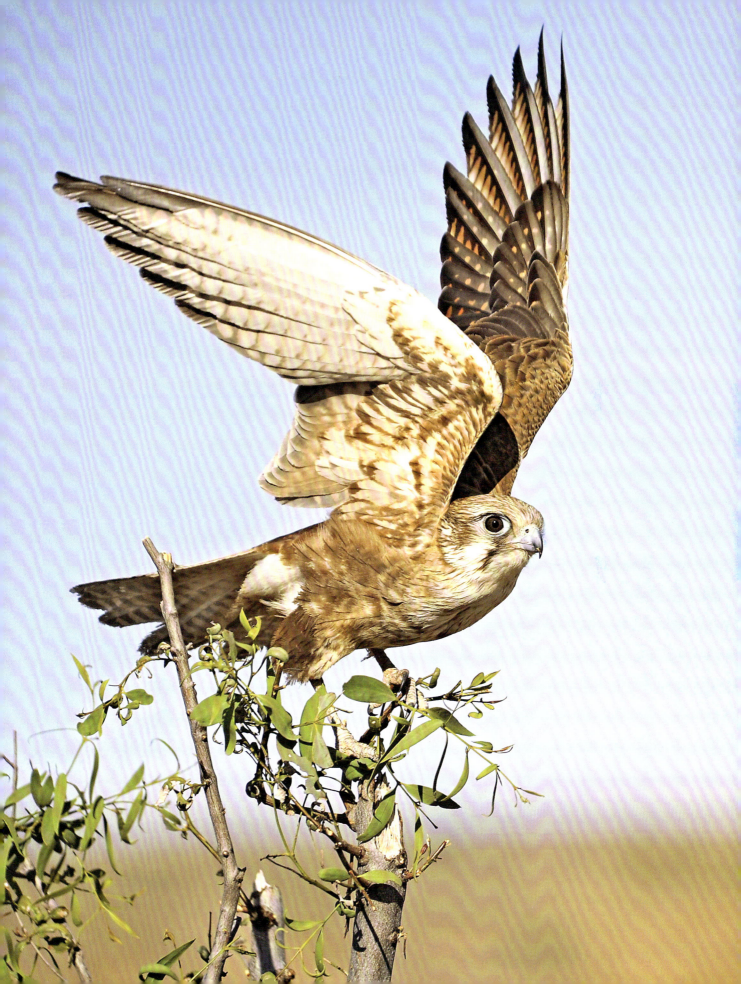

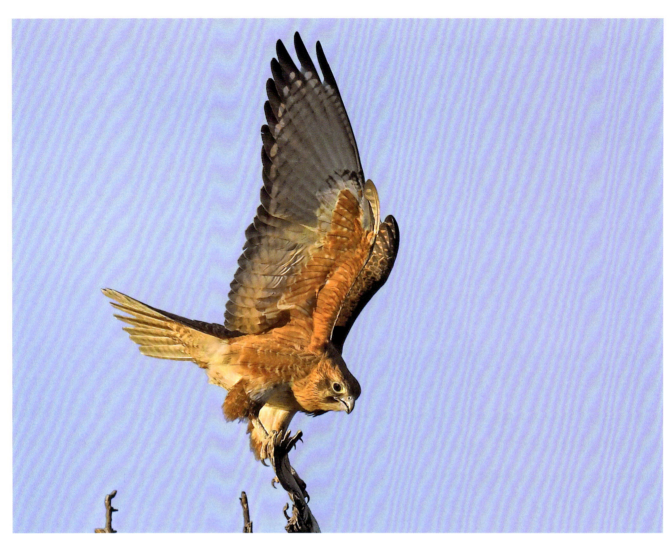
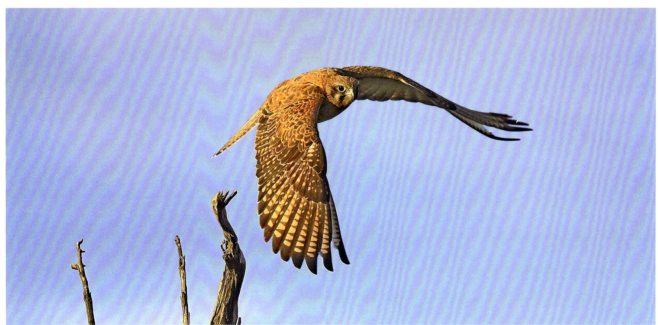

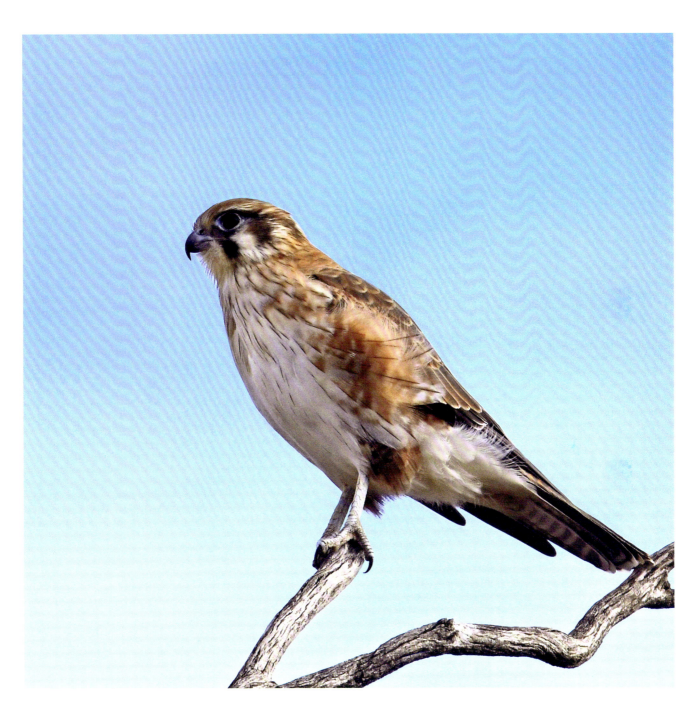

The female opposite was photographed in the last rays of the setting sun as she left her perch for her overnight roost. This perch was occupied for most of the day as she waited to be fed by her mate. The breast-band and flanks are heavily suffused with rusty feathers, pale-tipped in the latter. The bird above, from central Victoria, shows a reduced breast-band and may be a bit older, or perhaps a male.

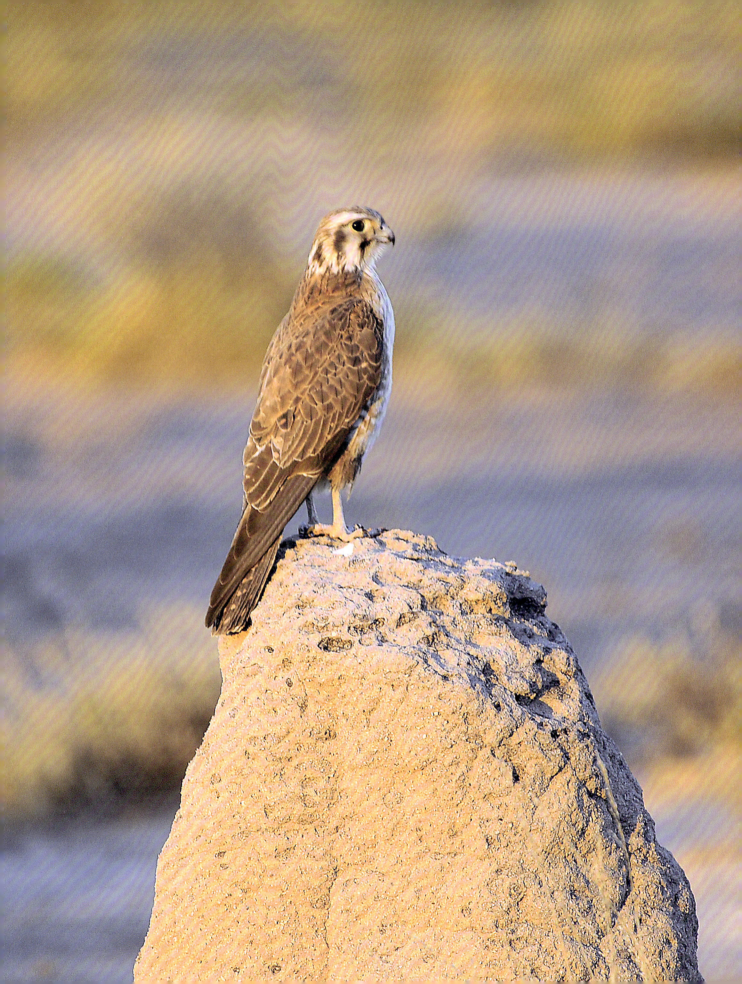

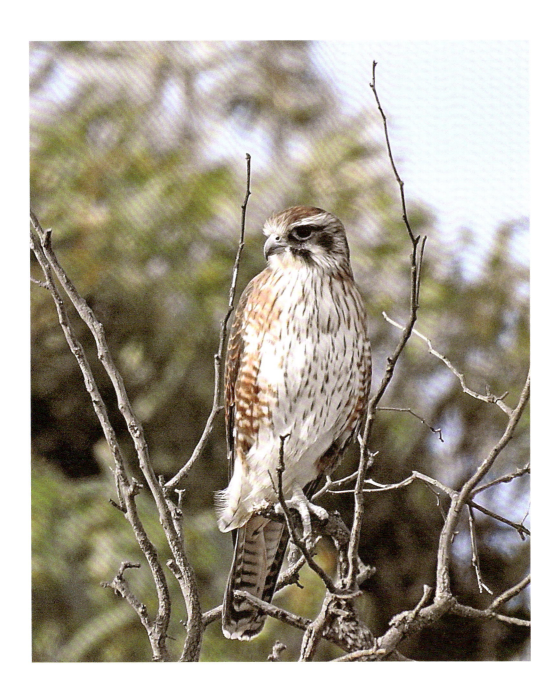

These Brown Falcons have barred flanks and broad eyebrow. We saw the one above at the Werribee Treatment Plant, Vic, and the other out in the desert. Like many in treeless areas of spinifex it is using a termite mound as a vantage point. It has an unusually pale head. Local falconers in the Arabian desert told me their preferred hunting birds were Saker Falcons with pale heads – they'd love this Brown Falcon.

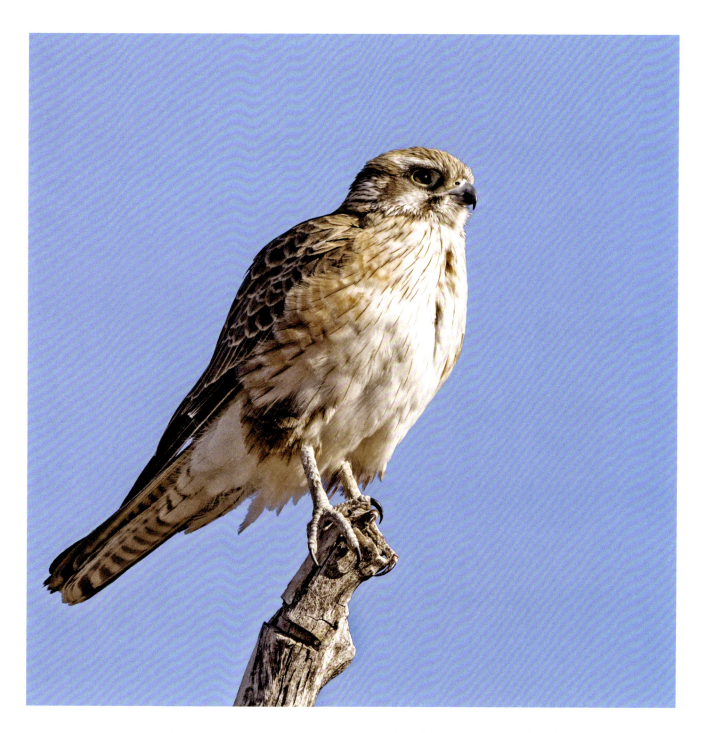

Opposite is a Brown Falcon with barred flanks, broad barring on the tail, and a few bars in the longest undertail-covert. Most of the birds we see in the inland have these coverts unbarred. It appears to have damaged scales on the legs, perhaps due to a tussle with a reptile. Above is a bird with blotched flanks and narrower barring in the tail. Probably at the next moult the blotches will disappear.

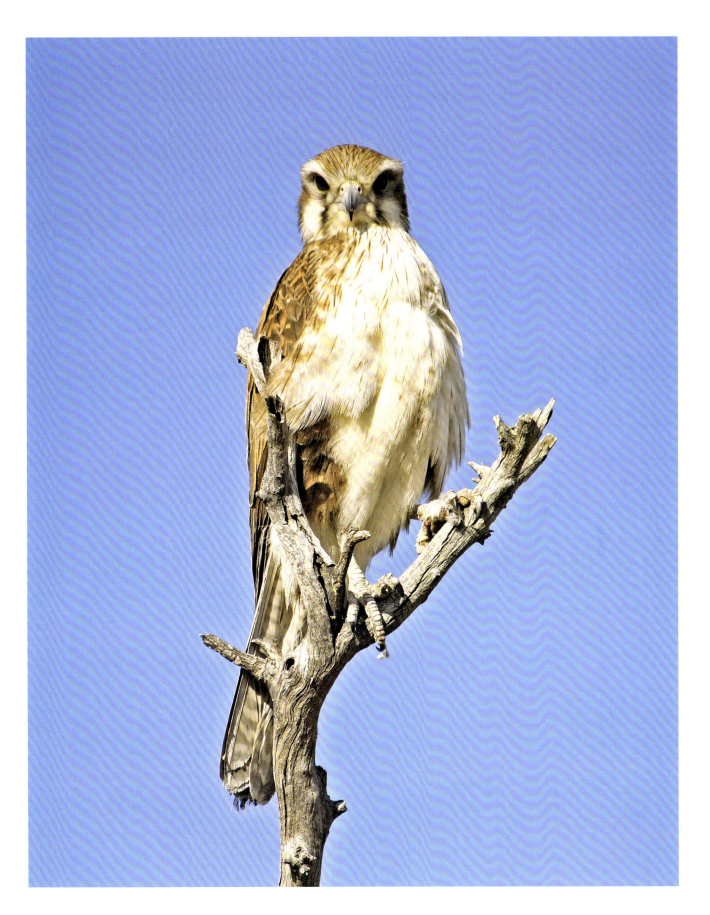

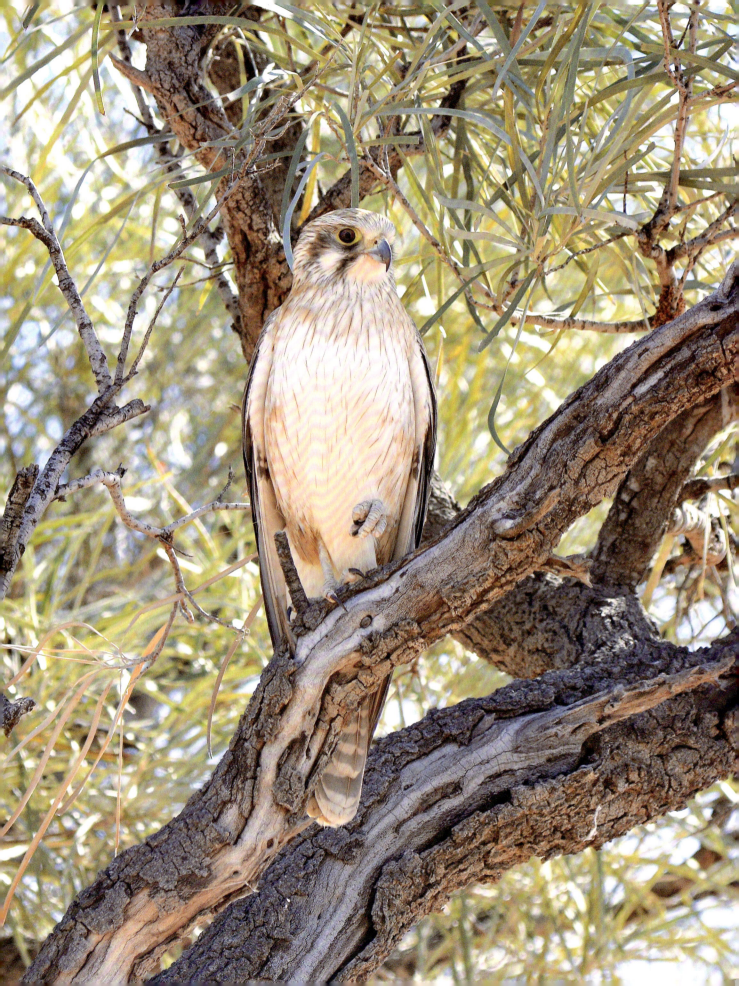

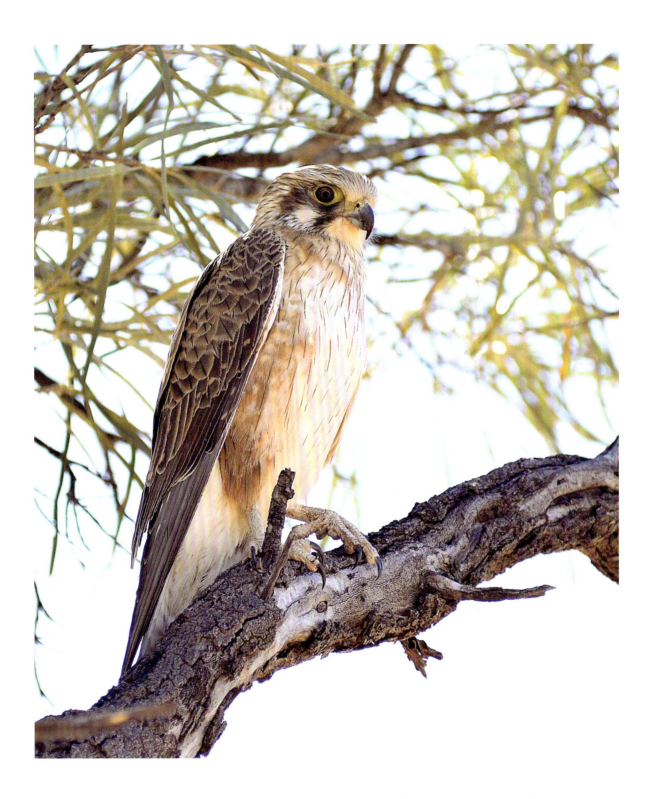

This very tame bird sat unconcerned while Sally walked around it within a few metres to find the best angle to show off the broader-than-usual bars in its tail. Sally first drew my attention to the degree of variability in tail-barring while we were examining birds in the Tasmanian Museum.

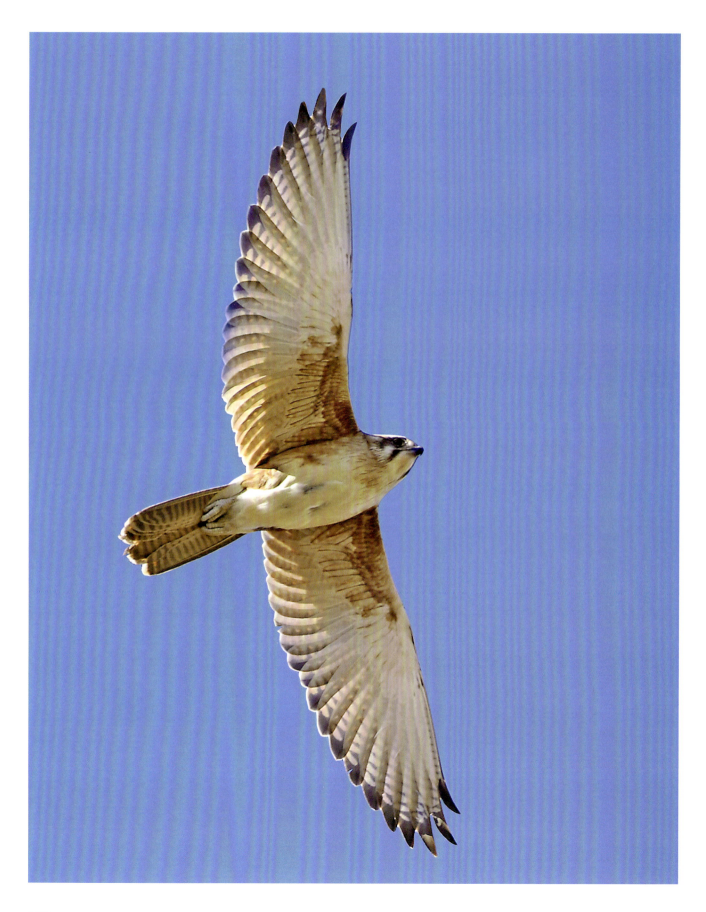

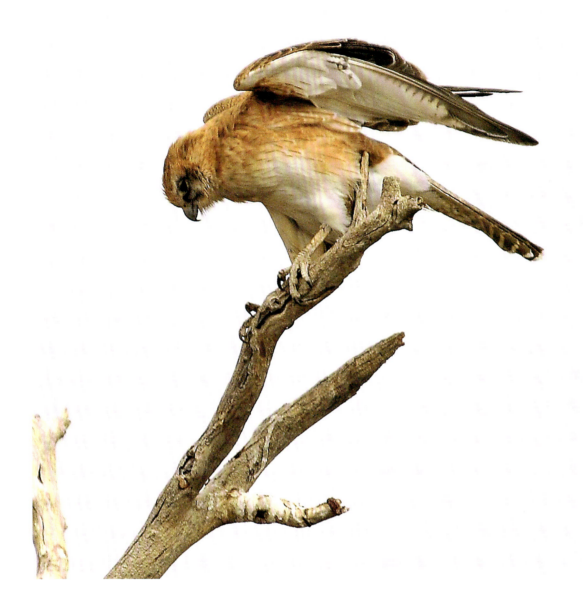

These are older Brown Falcons with different degrees of rusty diffusion on the breast and flanks. A breast-band is often a characteristic of females, so that could be the case with the bird above. We photographed the bird opposite during a courtship flight, so it is probably male.

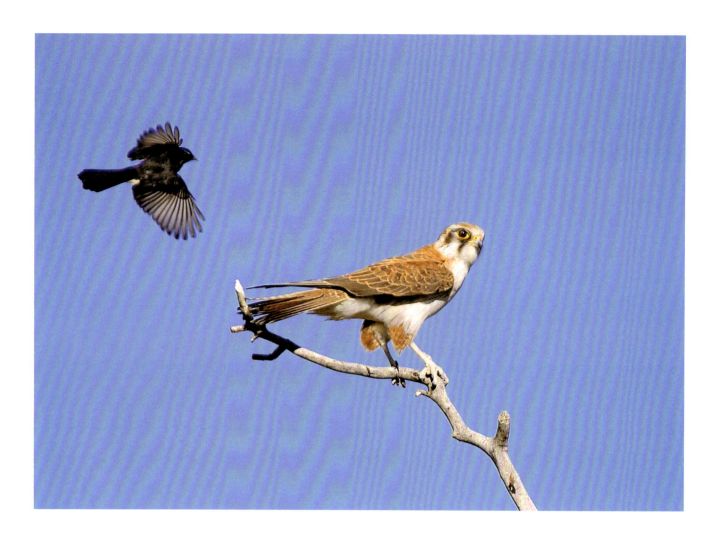

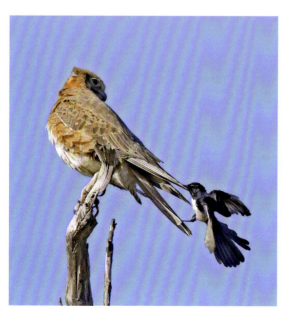

Apart from the long legs, one could be forgiven for thinking this small male (above) had kestrels in its ancestry. It had just delivered a lizard to its mate, and we hoped for more shots, but the Willie Wagtail drove it away. The male opposite ignored the wagtail and me. The other bird being harassed (left) was a female; she remained on this perch throughout much of the time we were there, waiting to be fed by her mate several times a day.

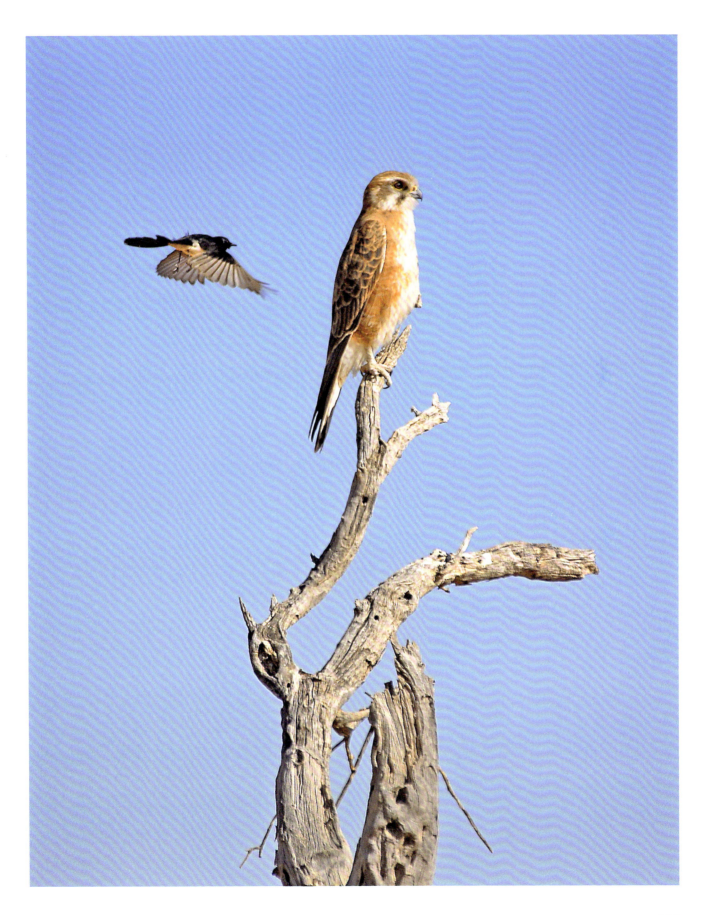

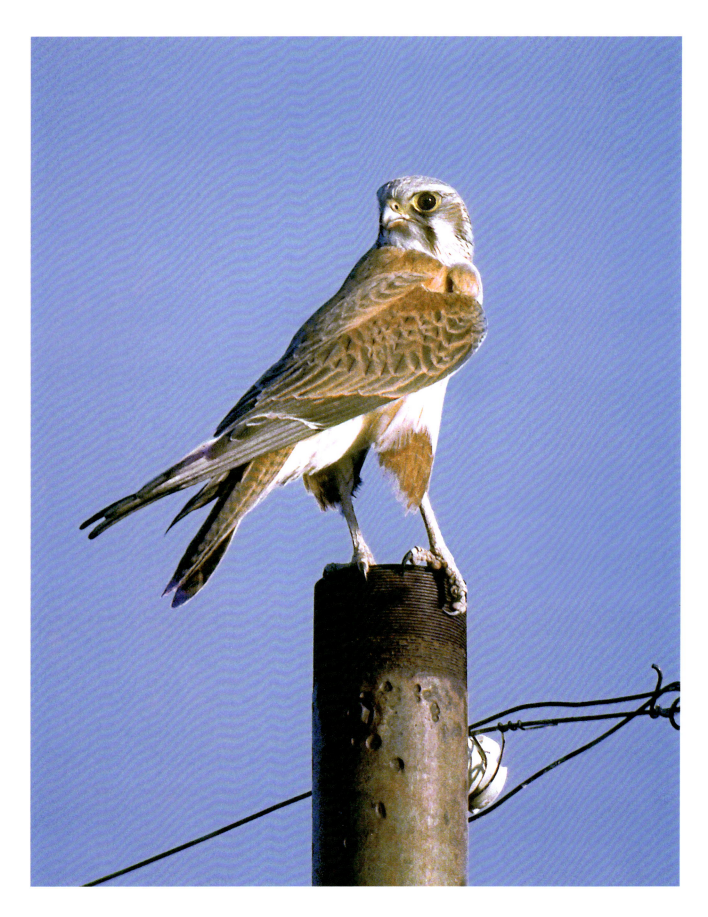

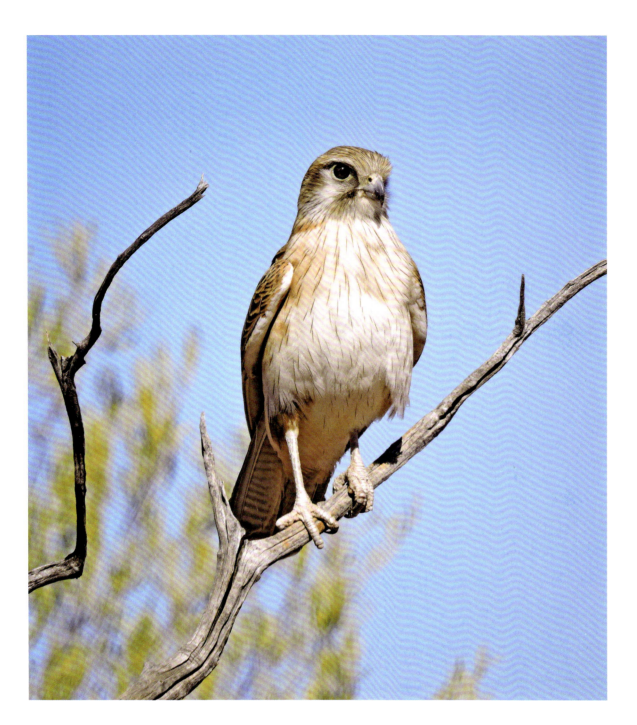

Fifty years ago I saw this Brown Falcon (opposite) west of Windorah, Qld, and photographed it with my old and very heavy 1000 mm Russian mirror lens. It is obviously male, quite old and is one of the most beautifully marked Brown Falcons we have come across. We have seen only a few birds in this plumage; most of the desert birds we see have wispy moustaches like the bird above, which was photographed near Eromanga, Qld. It is probably younger, having muted yellow in the bare parts.

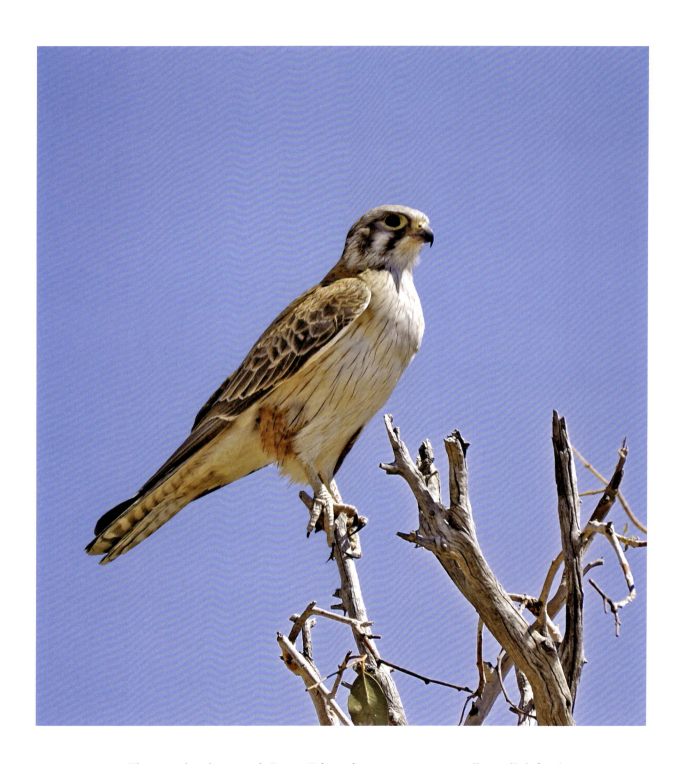

These two handsome male Brown Falcons have grey crowns as well as well-defined moustaches and ear-covert markings. The bird from the Simpson Desert (above and opposite below) appears to be older, with less streaking on the breast and broader barring on the tail. It also had less markings on the underwing-coverts, as revealed in the image opposite. The younger bird (opposite above) was photographed near Opalton, Qld, eight hundred and fifty kilometres from the other.

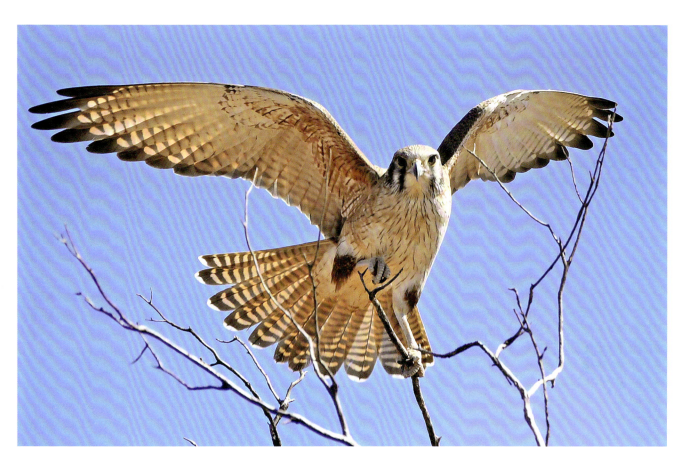
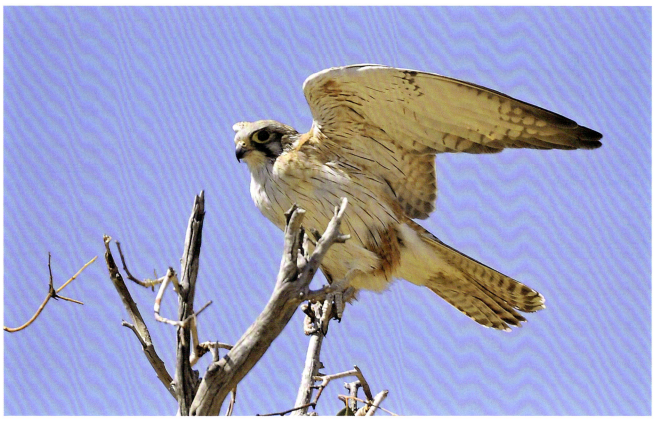

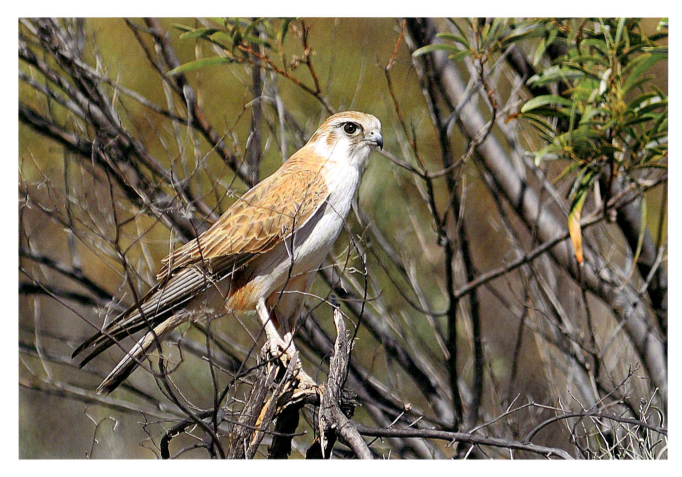
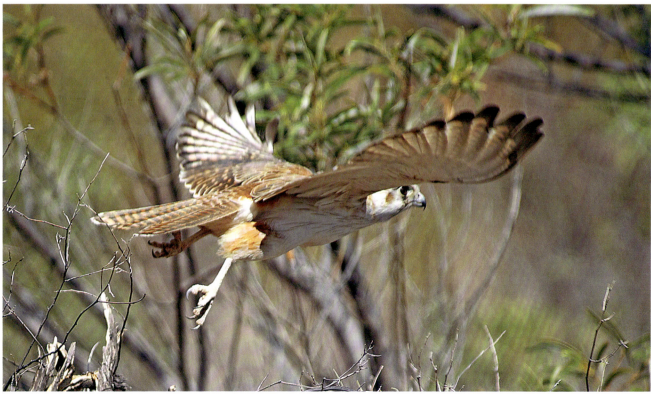

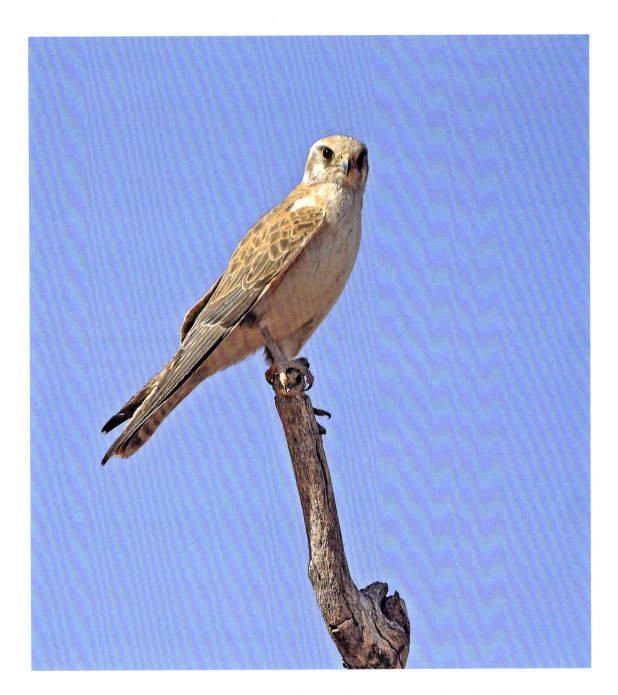

In the Tanami Desert, NT, we found the bird opposite perched on the side of the track; the photos were taken from the car. It is one of only two we have seen with rusty ear-coverts and the only one with orange thighs. It looks like a male but at that time (September) and at that age it should have bright yellow bareparts, so it could be a female. The underwing is lifted just enough to see that the underwing-coverts are completely unmarked. The bird above from Ballera, Qld, is very similar, but a little rustier in plumage and with bright yellow bare parts. The bars in the tail appear to be broader. When it flew it also showed no markings on the underwing-coverts.

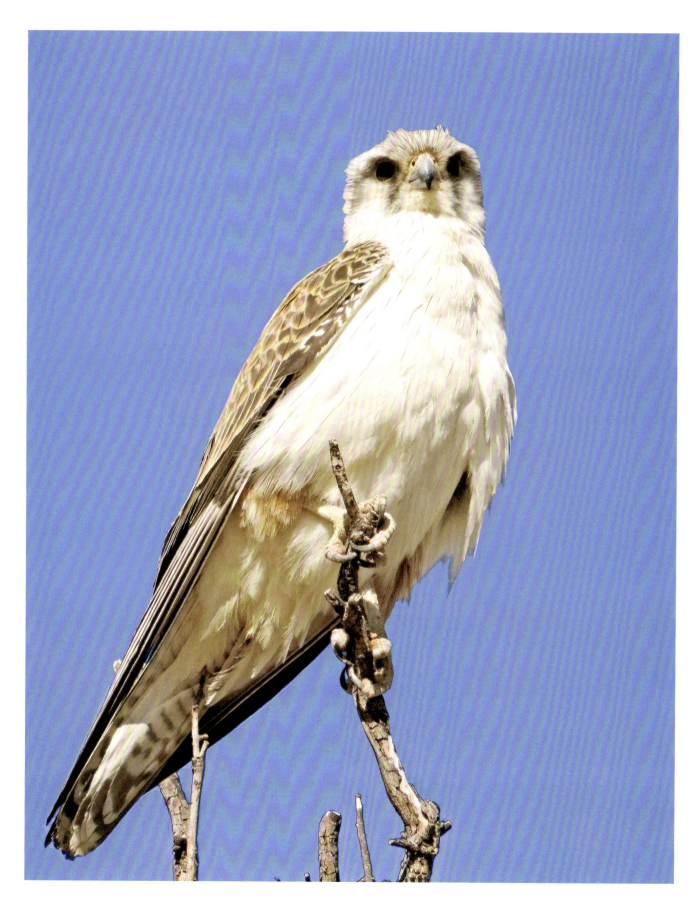

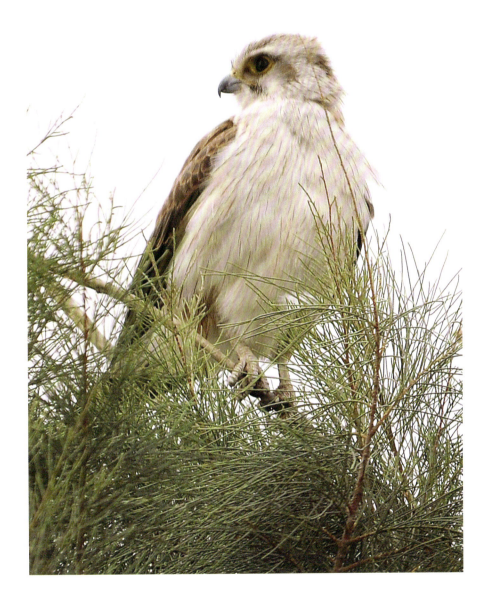

These are two of the palest Brown Falcons we've encountered. The exquisite bird above was found at Mitta Mitta Bore on the Birdsville Track, SA. It has very reduced markings on the head and the crown is almost white. The bird opposite was at the Engine Hole at Bladensburg National Park, Qld. It also had reduced markings on the head, while the bars on the tail were broader than in any other bird we've seen.

The Earth evolved to provide deserts for Brown Falcons to wander.

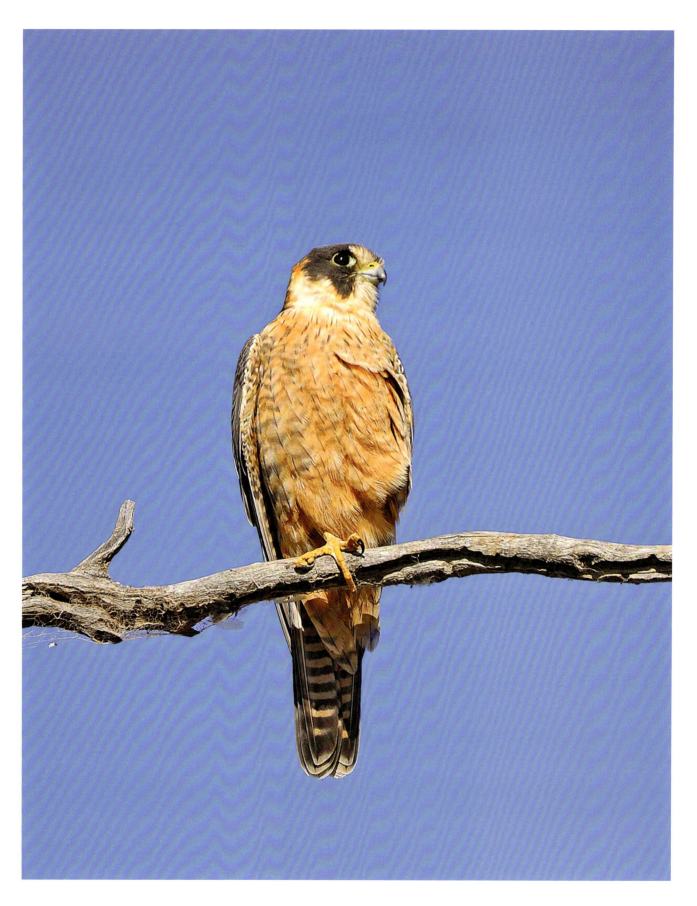

AUSTRALIAN HOBBY
Falco longipennis Swainson 1838

Lunated Falcon Latham, *General Synopsis of Birds*, Supplement, ii, p. 54, 1801.
Falco lunulatus Latham, *Index Ornithologicus*, Supplement, ii, p. xiii, 1801.
Sparvius lunulatus Vieillot, *Nouvelle Dictionaire d'Histoire Naturelle*, x, p. 324, 1817.
Falco longipennis Swainson, *Animals in Menageries*, p. 341, 1 January 1838.
Falco frontatus Gould, *Proceedings of the Zoological Society*, (1837), p. 139, 1838; Gould, *Synopsis of the Birds of Australia*, plate 3, figure I, 1838; Gould, *Birds of Australia*, folio 1, plate 10, 1848; Diggles, *Ornithology of Australia*, part ii, 1869.
Falco subbuteo frontatus, Schlegel, Musee d'histoire naturelle des Pays-Bas, *Falcons*, p.22, 1862.
Falco longipennis apsleyi Mathews, *Austral Avian Record*, 1, p. 33, 1912.
Falco longipennis murchisonianus Mathews, *Novitates Zoologicae*, xviii, p. 252, 1912.
Falco melanotus White and Mellor, *Emu*, xii, p. 164, 1913.
Falco longipennis samueli Mathews, *Birds of Australia*, 5, p. 232, 1916.
Falco longipennis longipennis Swann, *Synopsis of the Accipitres*, p. 189, 1922.

The Australian Hobby was first described in 1801 by Latham as the Lunated Falcon from one of the drawings made by Thomas Watling for surgeon John White. Later in 1801 Latham latinised the name to *Falco lunulatus*; however in the preceding year the same name had been given to a form of the Peregrine Falcon by Daudin, thereby invalidating its use for the hobby, even though various authorities, including Campbell and North, employed the name into the twentieth century. Gould described a bird as *Falco frontatus* at a meeting of the Zoological Society in 1837, but publication was delayed until 1838, by which time Swainson's description had appeared earlier in the year with the currently accepted name, *Falco longipennis*. Gould continued to use *frontatus* in his books, as did Diggles in 1869. In 1862 Schlegel suggested that the Australian Hobby was a form of the Eurasian Hobby, amending its name to *Falco subbuteo frontatus*. Mathews described two subspecies, only one of which, *murchisonianus*, is currently in use. He also suggested Gould's name of *frontatus* should be amended to *rufiventer*. White and Mellor believed they came across a new species of hobby while on a camp-out on Flinders Island, and named it *Falco melanotus*; Mathews proposed a new name for it, *Falco longipennis samueli*, but both are synonyms. Until recently the Australian Hobby was known as the Little Falcon, but that name is not definitive enough as there are several species of 'little' falcons.

I have a vivid memory of standing with Cathy and Henry Nix in their garden while they were living in Canberra. Late evening, ominous dark clouds splashed with orange, crimson and gold, atmosphere electric, the stage set for some apocalyptic event; suddenly a hobby, powering across nature's spectacle, aerodynamic perfection, tiny yet filling the sky, so fast it seemed to beat the lightning's flash. Apocalypses should be so memorable, a fragment of time etched into memory. When I am gone will the memory linger? Probably not but there will always be kindred souls who will live with memories of similar events and marvel like me at the evolutionary fine-tuning that has arrived at a creature with such a flawless profile. Based on the evidence of that evening's flight it would seem that nothing could fly faster, but on other days I have seen other birds out-fly the hobby's pursuit when their survival depended on it. So the hobby's speed is a matter of perception; the long wings lend it a streamlined effect that perhaps overstates their effectiveness. Don't misunderstand me – it is very fast indeed but perhaps not as quick as it looks.

Some observers suggest it is faster than the Peregrine in level flight. I have been lucky enough to have seen both in action at the same time and have no doubt that the Peregrine is superior. It is only necessary to compare the two birds in the hand to be convinced. The female hobby has exactly the same wing area as an adult Peregrine tiercel, yet it is only half the weight; the nostril of the Peregrine is far more complex than that of the hobby, having a system of baffles to facilitate breathing at high speed. But the hobby perfectly fits into its niche as does the Peregrine. In case you are wondering, I would have difficulty in deciding whether the Australian Hobby, Peregrine Falcon, Black Falcon, Spotted Harrier or Collared Sparrowhawk is my favourite bird.

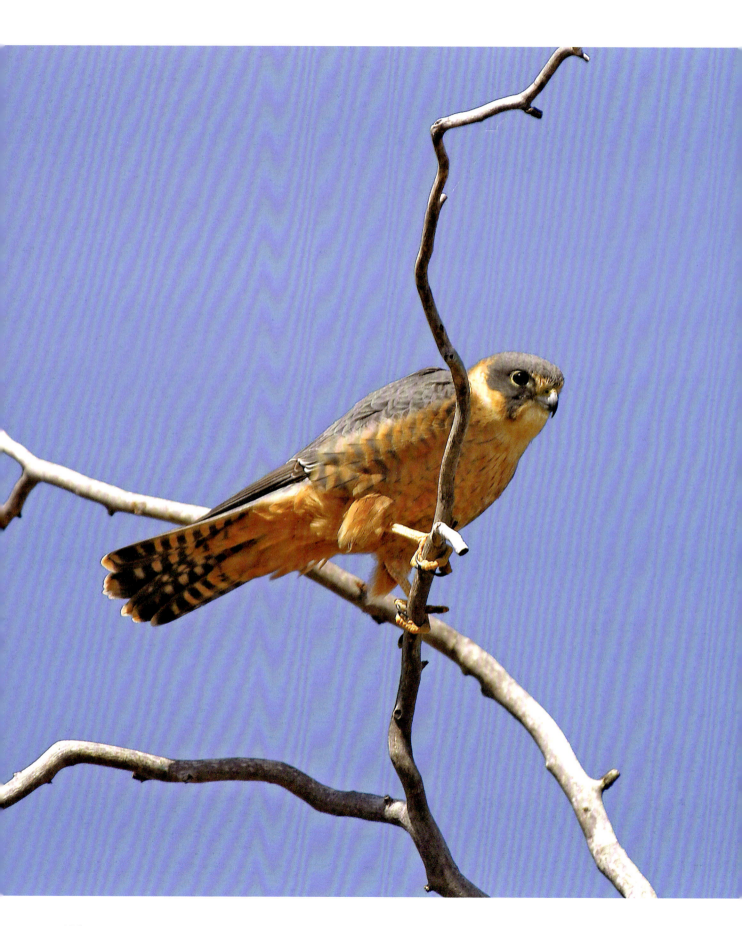

In decades-old memory, I am sitting near an old bridge in south-west Queensland where a huge colony of Fairy Martins lives. A locust-like stream of birds flying past me with beaks full of mud or insects, pausing awhile to plaster mud nests or feed ever-ravenous chicks before leaving to gather the next load. Out to my right stretches Lake Bindegolly. The sky is black and threatening, the lake is dotted with hundreds of Black Swans, the water silver, dead calm before the storm – black sky, black swans sitting on black reflections in a silver mirror.

The old wooden bridge is a much more appealing repository for the martins' bottle-shaped mud nests than the modern structure that will replace it a dozen years hence. I am waiting for the falcon. It has a nest away over the hill, and every hour or so it arrives to sample the banquet. The storm is rolling closer, the air is still, only the sounds of martins fluttering by and their soft pleasant calls. Suddenly a thunderous roar of wings, desperate escalation of panicked churring as a thousand martins take to the air. Out of nowhere the hobby arrives and flicks up onto its favourite perch. It is a male, beautiful and sleek, burnished blue back, black cheeks and tawny breast. It settles, ruffles its feathers and hunches down to watch, one foot up, head turning from side to side as the swarms of birds make height. A minute passes. Two, then three, eternity ticking, head still swivelling. Suddenly, its gaze is fixed, concentrated on one particular bird. I look up but cannot see what the hobby has noticed. With a gaze a dozen times more acute than mine it has picked out among the flying hordes some slight imperfection, some impairment in one individual, or perhaps a youngster just out of the nest, still unsteady in the air. Long wings unfurl and in less than an eye-blink the falcon reaches maximum speed, heading for the unfortunate victim. Desperate attempts to evade: now other martins, secure in the knowledge that it is not their turn, harass the hobby, but it doesn't give up the agile pursuit. Finally, the inevitable strike, feathers float down and alight gently around me. The tiny falcon spreads its wings wide, reaches down and nips its victim behind the nape, the *coup de grace*, turns and heads off, martin loosely dangling, to its plucking perch a kilometre away where it will deplume its prey before delivering the body to its mate. She will eat some morsels then feed the rest to her chicks, satisfying them for an hour or so. The silver water turns grey, sudden riffles skitter across the surface, the storm arrives, the martins dive back under the bridge, I run to my car, the swans retract their necks and disappear behind a watery curtain as the deluge begins.

Next day, on an island at the far end of the lake, we are setting up a hide at a huge nesting colony of swans, when a Black-breasted Buzzard appears, slowly soaring on high-v butterfly wings. So intent is it on the swans and their down-quilted nests that it is startled when it sights us and suddenly reverses course, nearly falling out of the sky, and hurries off over the hill into the hobbies' territory. We see the flicker of wings as the hobby pair rises up, and from half a kilometre's distance we hear their furious kecking as they repeatedly dive-bomb the buzzard, driving it away from the nest and its precious contents. With the intruder gone, they thrill us for too few moments with an exhilarating exhibition of synchronised high-speed aerobatics, sickle-wings splitting the silver sky, then the pair peels off over the hill back towards their nest tree.

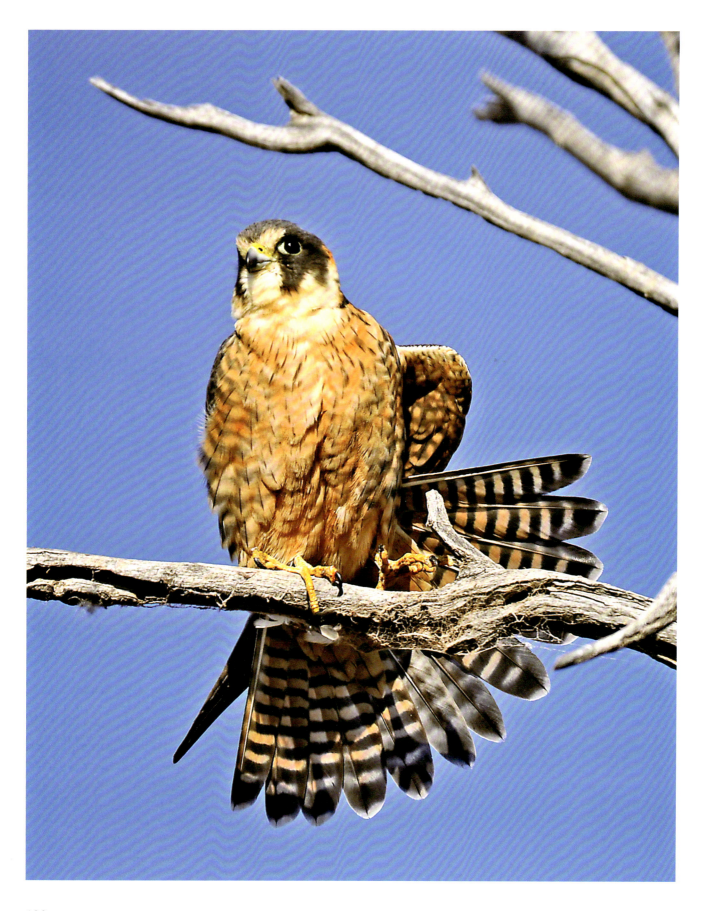

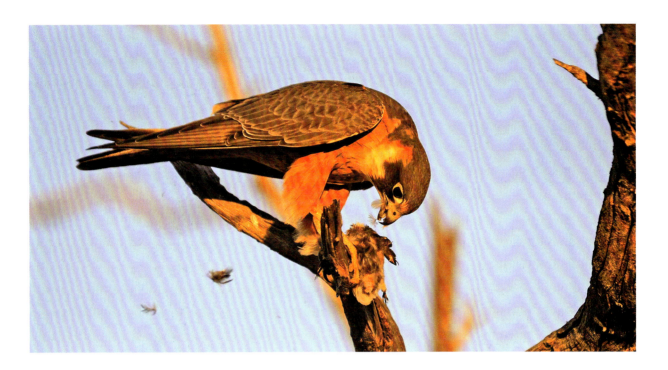

Forty years later, Sally and I were standing near the same spot at Lake Bindegolly when we saw a hobby chasing a dragonfly. With a deft flick of the wings it secured its prey and flew to a dead tree near where we were standing. As it tore up its victim, casting gossamer wings to the wind, I searched my memory and came to the conclusion that this was the same tree used so many years ago by the tiercel that preyed on Fairy Martins nesting under the old bridge. Furthermore, I was convinced we were standing precisely where Ray Garstone had stood in 1973 when a martin, being pursued by a hobby, took refuge between his feet (see p. 140).

As evening approached, the male caught another dragonfly and returned to the same perch, showing no concern at our presence. He stood upright, head bobbing and swivelling, watching martins and dragonflies catching midges in the fading light. Suddenly he took off and headed away across the lake, and we assumed he was flying off to roost somewhere else. I followed through the binoculars as he gained height, alternating rapid wing-beats with soaring, growing smaller and smaller as he drew away. He must have been five hundred metres away and two or three hundred metres high when he peeled off into an electrifying stoop, straight down.

I lost sight of him momentarily so couldn't see whether he had caught anything. Then he reappeared in the binoculars' view, rapidly growing larger, heading straight for us. In seconds he was back on the perch above our heads, a martin held in his claws. He had started to deplume his prey when another hobby landed in the tree, uttering a clucking sound. Obviously his mate, perhaps hoping for a morsel or two. Then the tiercel did a remarkable thing – he flew down to a low branch about three metres from where we watched, and ignoring us completely, made a leisurely meal, finishing as the last rays of sunlight burnished him golden-orange (above).

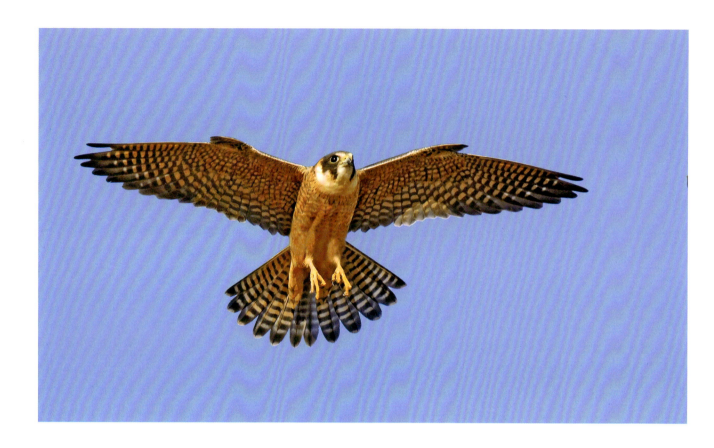

Theoretically there should be no problem in separating Australian Hobby from Peregrine in the field as the former is a smaller, much more slender bird with a longer tail, and lacks bold streaks or bars on the underparts. In practice it is possible to make an incorrect identification; once or twice I have momentarily confused the two, and reading the literature there appear to be examples of confusion, resulting in an erroneous idea of the hobby's hunting ability. One report claimed a hobby took a Grey Teal, which almost certainly involved a Peregrine instead. A J Campbell, in *Nests and Eggs of Australian Birds*, quotes Mr William Bateman, a duck-shooter of twenty year's experience, who "witnessed the [hobby] put on a terrific spurt to overtake flying ducks, then, suddenly making a swoop from behind, deal a duck a blow, apparently with the edge of the wing, that fells it dead. Twice Mr Bateman has seen coots decapitated, and relates how he and his brother procured a bustard [or 'wild turkey'] without spending ammunition. The turkey was seen to rise, well out of range, and was flying away when a Little Hawk was observed coming up at right angles to the Turkey's flight, and, making an exceedingly swift cut, clean scalped the great bird. When the sportsmen picked up the turkey it was quite dead." Another example reads "It always chooses living prey, and will seize and carry off birds exceeding itself in weight, and can overtake and capture the fastest flying lorikeets. During the breeding season they frequently make raids on domestic pigeons (feral Rock Doves) in the centre of our city and carry off the strongest homing Antwerps." These accounts obviously involve the Peregrine; a female hobby weighs about 280 grams and a tiercel 210 grams, compared to about 300 grams for an average-

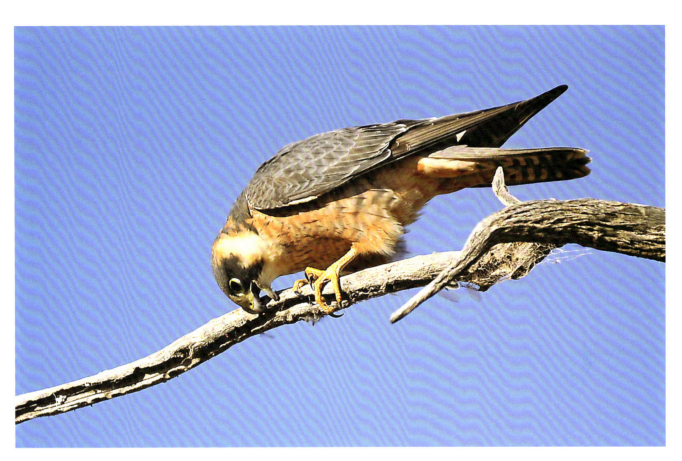
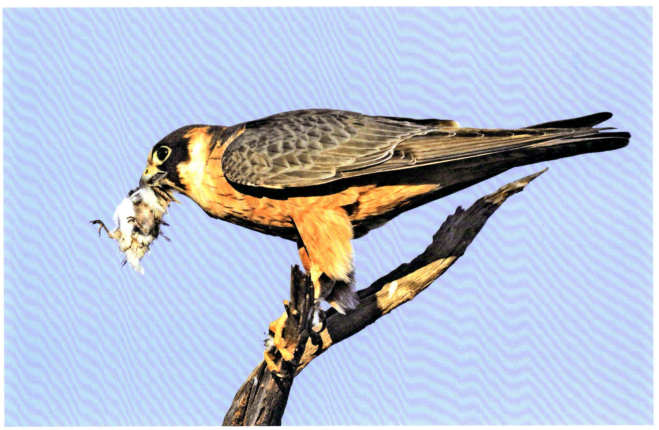

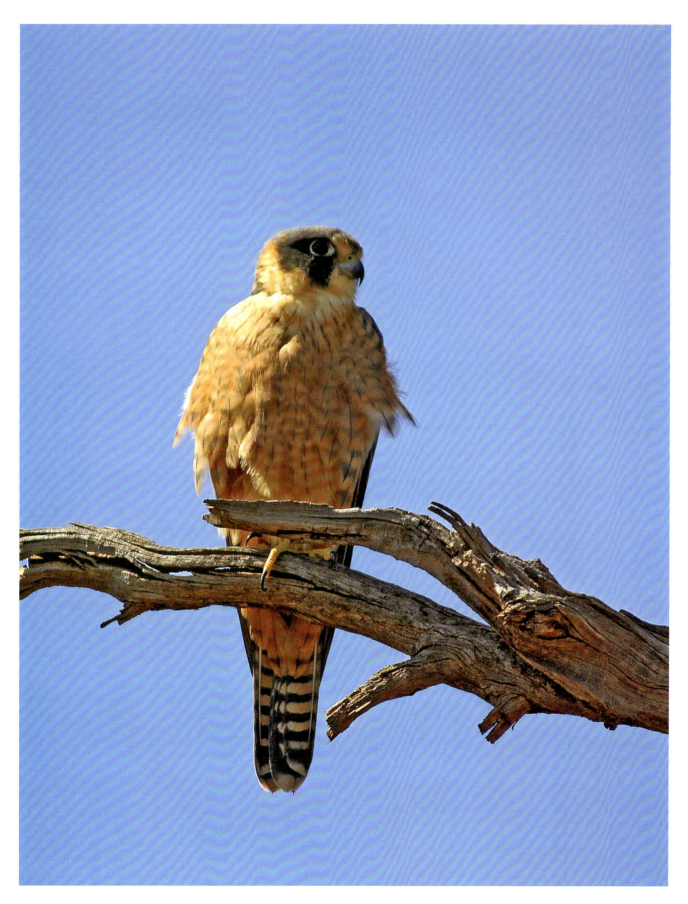

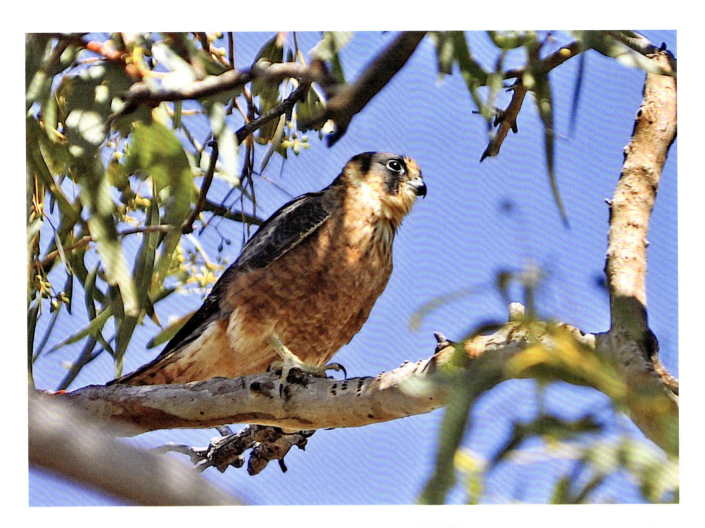

sized Rock Dove, with the cited Antwerp perhaps twice as much. The Rock Dove is included among the prey by various authorities, but I'd like to see a hobby carrying one to be entirely convinced. The Galah is also listed among the prey. Sally and I saw a hobby chasing Galahs and cockatoos at Boulia, Qld. It was obvious, to us anyway, that the hobby and the cockatoos were 'playing,' as there was much to-and-fro activity, with the pursuit alternating between pursuer and pursued. As can be seen from our photos on p. 150–151, the hobby and Galah are about the same size and the cockatoo is much bigger. Monty Schrader and I saw a hobby chasing a Common Bronzewing, which would weigh about 350 grams; the pigeon rapidly drew away so perhaps the little falcon was not really trying, but of course the bronzewing is seriously quick. We have seen a number of other birds exceed the hobby in level flight, among them Common Starling and Stubble Quail. The latter we saw at Werribee, Vic. The quail fairly easily outpaced its pursuer, but then when it thought it was safely out of reach, went to ground and the hobby caught it. It's a different matter entirely if the hobby has a height advantage. In such situations we have seen

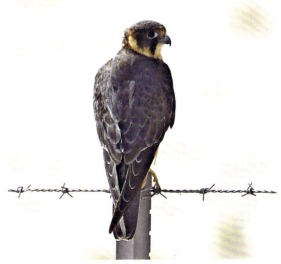

Left: A relaxed male hobby in the Flinders Ranges, SA. Upper: A female with rather dark chestnut underparts, north-west of Dajarra, Queensland, August. Lower: Male at Bool Lagoon, SA, April.

133

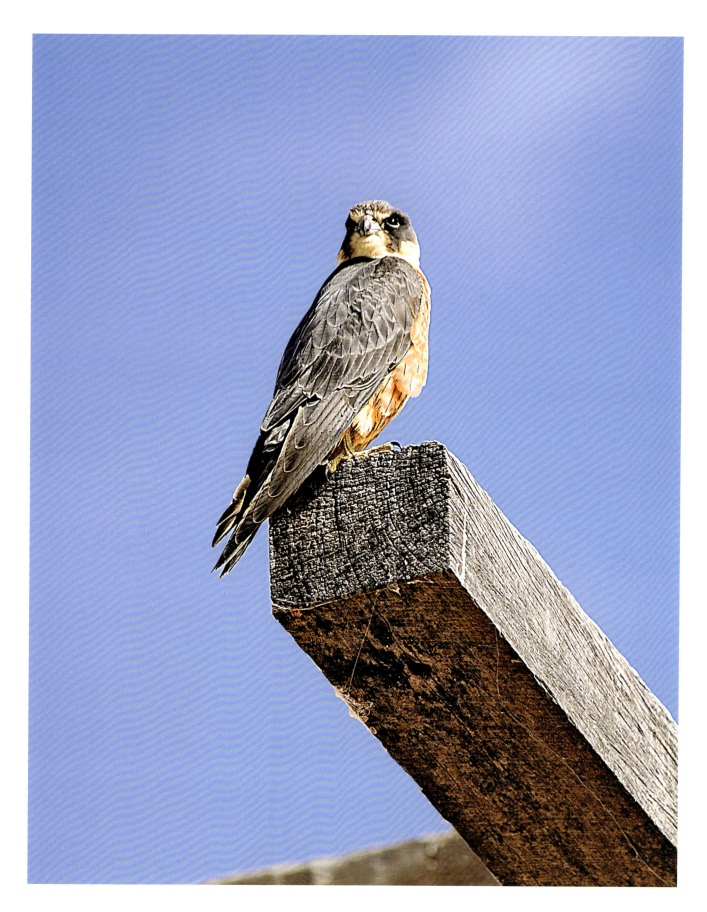

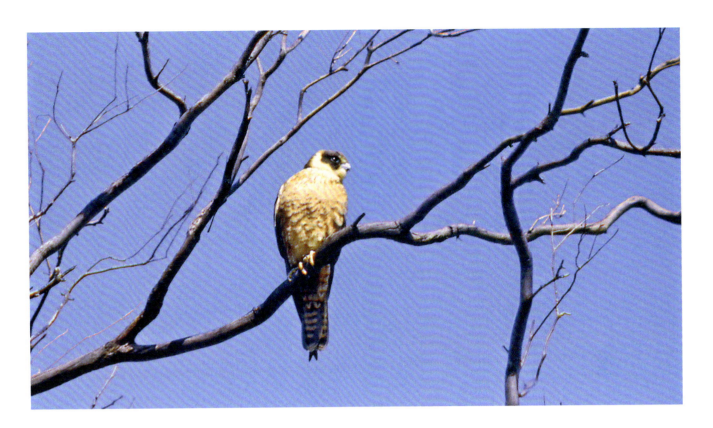

hobbies take doves up to the size of a Laughing Dove, mannikins, quail and a Rufous-throated Honeyeater, as well as dragonflies, flying grasshoppers and bats; one steamy evening on the Ord River, WA, I saw a hobby catching swarming termites alongside swifts, dollarbirds and pratincoles.

The Rufous-throated Honeyeater was captured in an unusual fashion. At Mount Anderson, about a hundred kilometres south-east of Derby, WA, Pat and I observed a Pied Butcherbird and a hobby chasing a honeyeater. Our attention was attracted by the falcon stooping at a bush. The butcherbird was then seen to dive into the bush after the honeyeater, driving it out. The falcon stooped again, missing, and the honeyeater gained shelter in another bush. The two predators perched side by side on top of the bush and after a minute the butcherbird dashed through the branches, startling the honeyeater out. Again, the falcon missed, and the honeyeater returned to the first bush. For about ten minutes the two predators chased the honeyeater between the two refuges. Finally, the victim made a dash for a nearby tree and was taken by the falcon. I imagine that if this pair cooperated regularly, successful outcomes would probably be equally shared. Years later, in our own backyard, we saw how such cooperation might eventuate between two such unlikely partners.

I was given a hobby tiercel to rehabilitate. It had been taken from a nest when a few days old and reared with what must have

Above is a lovely pale bird photographed between Wandoan and Taroom, Qld. When we lived on "Wallace Brae" at Guluguba near Wandoan we saw a number of these pale birds, and a pair nested within sight of our home. Their first attempt was to take over a Ravens' nest, but even though they evicted the Ravens they eventually moved to a Whistling Kite nest in the top of the tallest tree on the property. Another pair nested only a few kilometres away in the township of Guluguba. There appeared at that time (mid 1970s) to be a cluster of these pale birds in the Wandoan/Taroom district and I have also seen a rather similar one at Birdsville, Qld (opposite). They are so pale that they have at times been mistaken for immature Grey Falcons but the dark face, smaller size and slimmer build easily separate them. The intensity of the blue sky and the branches indicates that the bird above is not overexposed in the photograph, and in life is actually even paler than this. I don't have a shot showing its back, but it is a paler grey than the bird opposite. The black face and cheeks seem to be more restricted also.

The bird opposite is rather darker grey on the back. It was in the main street of Birdsville, sitting on a cross-beam that put me in mind of a crucifixion scene.

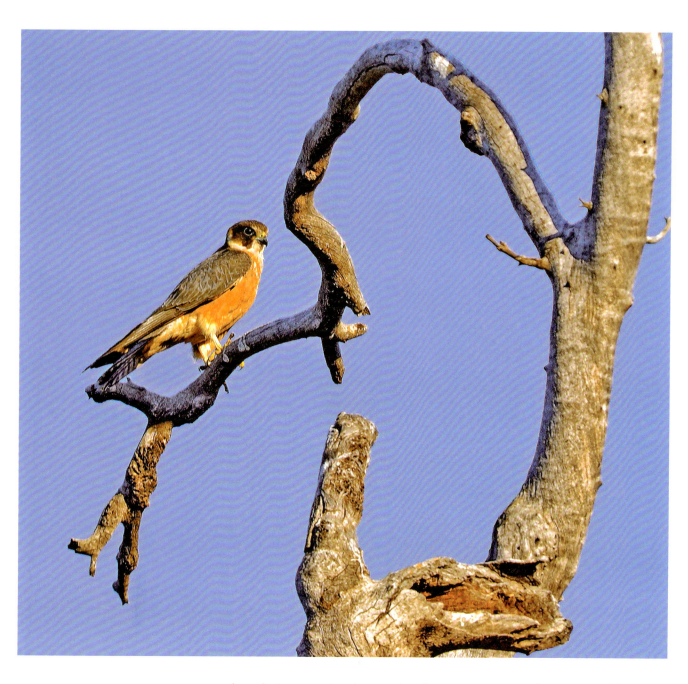

Above: Near Alice Springs we noted a hobby, which I remember as a male, with unusual plumage, lacking any of the streaks and barring obvious in the typical inland bird opposite.

been loving attention because its plumage was immaculate. Regrettably I don't have any photos of it, as I have an unreasonable reluctance to photograph captive birds, but I did paint some portraits. I acquired it when it was about three months old and it stayed with us for about a year. Each morning it was released outside and flew immediately to a favourite perch, an emergent dead branch atop a tall eucalypt. In the evening I would hold up my glove with some food and the hobby flew down to consume the offering and be taken inside for the night. Next morning it would be released again. Whenever a dragonfly passed it would sally forth and with increasing expertise make a capture and return to the perch. Within a few weeks, things started to get interesting. Three or four Pied Butcherbirds shared the backyard and once they realised the hobby was catching

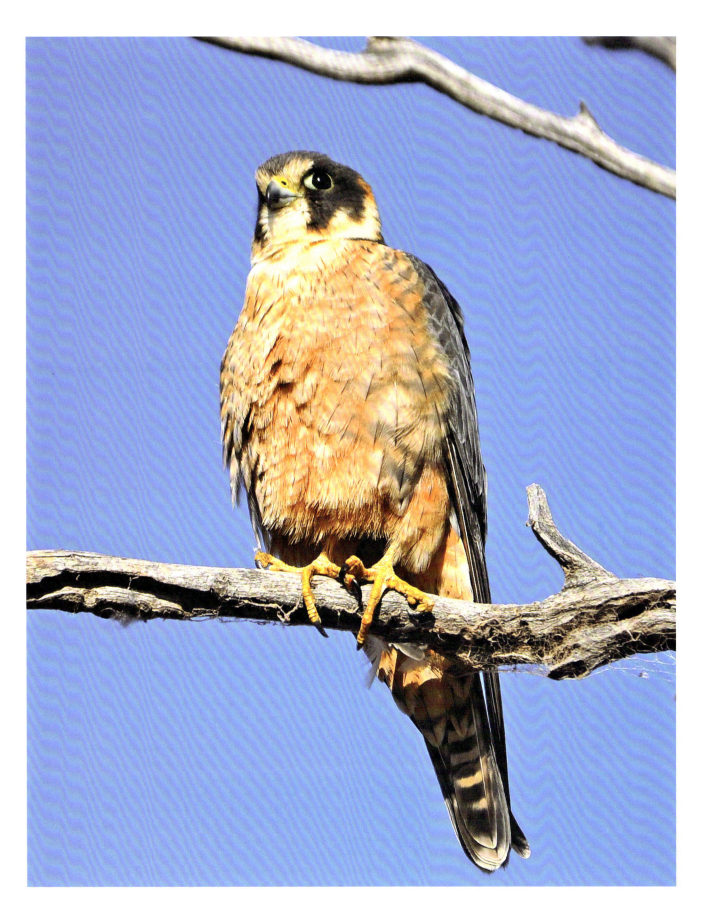

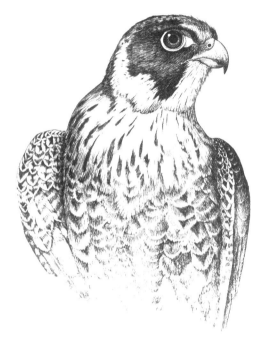

dragonflies, one or the other began landing on the perch, then edging forward to try and steal a morsel. Once the meal was finished the hobby would chase the butcherbirds into a nearby giant fig tree. As soon as the hobby turned back towards its perch the butcherbirds in their turn chased it. This back-and-forth manoeuvring often went on at intervals during the day over a period of months and I have no doubt that it was 'play' on the part of both species. I think it was a few months later that the butcherbirds began coming to my gloved arm in the evening to share the meal. I often had the hobby and at least one butcherbird on my arm at the same time.

Some authorities, including Tom Cade, who is generally regarded as the premier expert on falcons, have suggested that the Australian Hobby is less crepuscular than other hobby species. I am no expert but have regularly seen hobbies hunting well into dusk. The tame hobby was often still chasing flying insects when it was almost too dark for me to see. On one occasion when it was actively hunting, I took a reading of 5.5 foot-candles with a Lunasix light meter. On another occasion I was otherwise occupied one evening and didn't go out with my glove until the light had almost gone. I held the glove aloft anyway, then felt the gentle thwack as the hobby alighted – it was so dark I hadn't even seen it approaching.

Whenever it rained, the young tiercel leaf-bathed by flying onto the wet foliage of the fig tree near its perch, spreading its wings and tail, sometimes hanging upside down, splashing about over the leaves until its feathers were thoroughly soaked. One afternoon a massive storm blew up. When I heard thunder, I raced outside to call it in, just in time to see the branch supporting its perch as well as the bird blown away in a fierce gust of wind. As it disappeared over the hill I feared for its safety, but an hour later it was back on a new perch.

My most vivid memory of our time together was the occasion when it took off after a Brown Goshawk, repeatedly diving at it as the hawk tried to make height. At each attack the goshawk, twice its size, turned on its back, presenting its claws and I just prayed that the little terrier knew enough to keep out of reach. They thermalled higher and higher until almost out of sight, but I could still hear the hobby *kek-kek-kek*-ing as it made its attacks. The goshawk eventually dived away in a steep glide and the hobby turned back, satisfied it had defended its territory. I held up the glove, the hobby closed its wings, and spectacularly zoomed from a fly-speck in the sky to a plummeting thunderbolt, pulling up as it approached the ground at light-speed and alighting on the glove like thistledown, the most exhilarating moment I remember. Obviously, it was time to go; it had finished its moult so without any regrets I took it to Grant Squelch's farm where it headed off over the horizon and was seen no more.

Two distinct forms of the hobby have been described in Australia: a dark one, *longipennis,* in more humid areas, and a pale version, *murchisonianus,* in dry country. There is some intergradation between the two, and we have seen dark birds in nominally pale territory and vice versa. For example, on 7 July, Sally and I came across a moulting dark juvenile sitting on a tuft of grass near Opalton in the arid interior of Queensland. We were surprised to see such a dark bird in the desert and suspect it had wandered in from a more humid region. The old

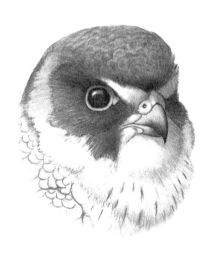

These illustrations depict the little hobby that shared our home and backyard in the early 1970s.

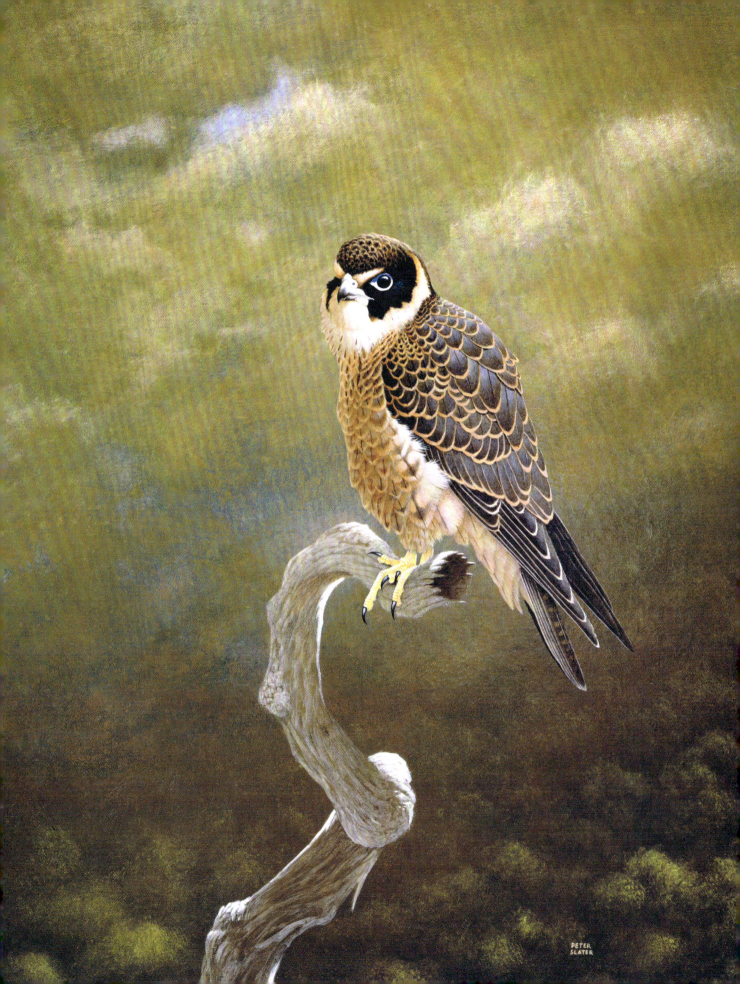

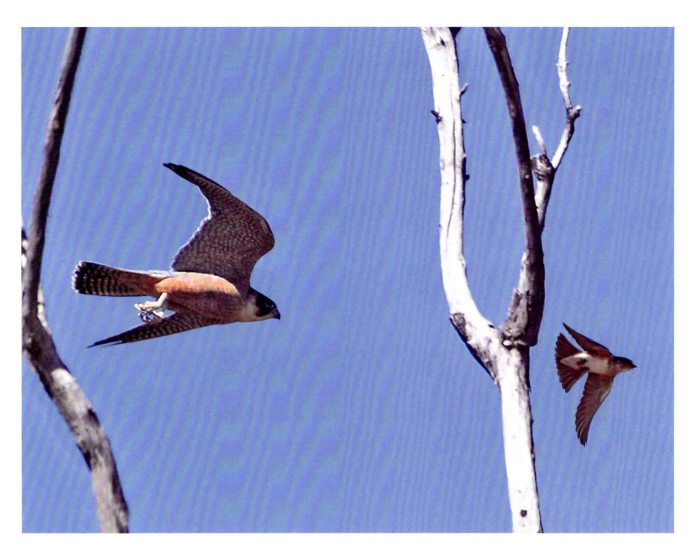

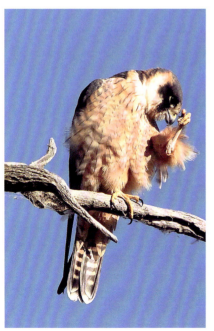

Above: Australian Hobby chasing a Tree Martin, Dajarra, Qld.
Right: Juvenile hobby with Tree Martin. Martins are among the hobby's favoured items of food. I have often come across colonies of Fairy Martins that are regularly preyed upon. When we first moved into our home in Anstead, Qld, we found dozens of occupied mud nests under the eaves of the verandah. It didn't take us long to notice the hobby that zoomed past at irregular intervals, as often as not departing with a victim. I believe every fledged chick over several years was taken by either the hobby, a sparrowhawk or a resident kestrel. On one occasion I was standing on the verandah when the hobby arrived and chased a martin around the house. Eventually the exhausted bird flew towards me and landed between my feet and I was able to pick it up. I told Ray Garstone about it and he said "Oh, yeah" in his usual laconic fashion. A week later we were standing at a colony at Lake Bindegolly, Qld, when the same thing happened, only this time the martin landed between Ray's feet, and he also was able to pick it up. Obviously, humans are preferable to aerial predators.

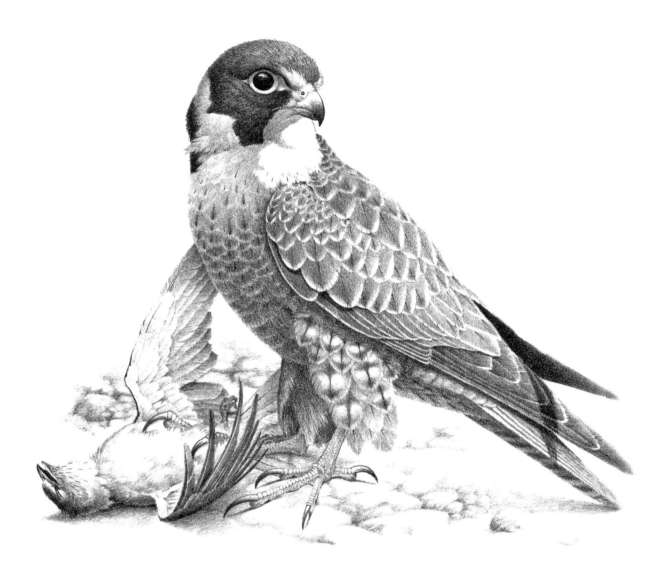

brown feathers showed signs of wear while the new grey feathers on the back were immaculate. It was on a treeless plain where the only available perches were the grasses cropped by cattle, such an unusual situation that we thought the bird might be injured, particularly as it allowed a fairly close approach. Then it yawned, unfurled long wings and headed at great speed for the horizon. July is very early in the year to see moult; assuming it had fledged in late November in the previous year it was only seven or eight months old. Our tame bird began to moult in October, when it was about ten or eleven months old.

The nesting pair photographed in the south-west of WA were mid-way between light and dark. Some desert birds are very pale, such as the bird on page 142, and near Alice Springs, NT, we came across an aberrant one without any markings on the pale rufous underparts. One I saw near Innisfail, Qld, was almost black on the back and deep chestnut below, so unlike others I have seen that I thought it might be an Oriental Hobby, which occurs in New Guinea, but subsequently

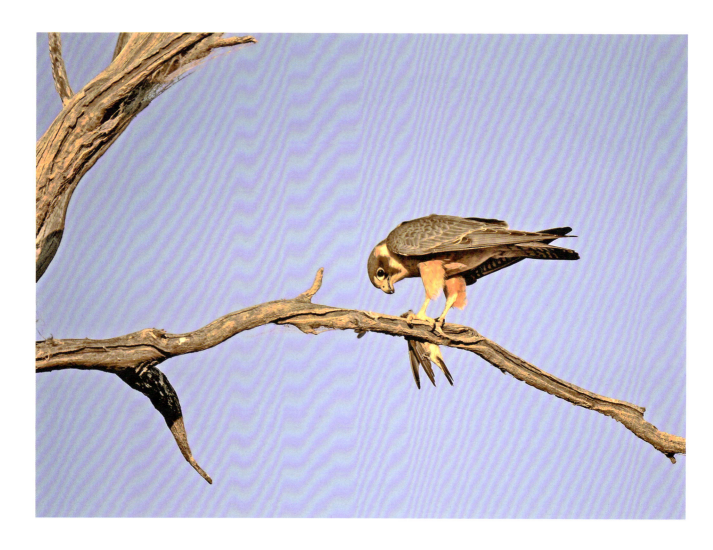

Above: A pale male hobby, typical of birds found in the arid interior. Right: A very dark juvenile on an unusual perch near Winton in central Queensland. Note the new grey feathers on its back.

I saw a specimen, undoubtedly an Australian Hobby, in similar plumage among the skins at the Queensland Museum. The adult Oriental Hobby lacks barring on the wings and tail; eventually someone will see one on Saibai or Boigu Island and add it to the Australian list, but care will need to be taken with the identification because some Australian Hobbies head north to New Guinea in winter. Some of our hobbies migrate to the Sundas where there is a smaller resident subspecies. I'm not sure where these migrants come from, because hobbies were present in every month in WA at Derby and the Kimberley Research Station during the five years I spent there with no apparent diminution of numbers.

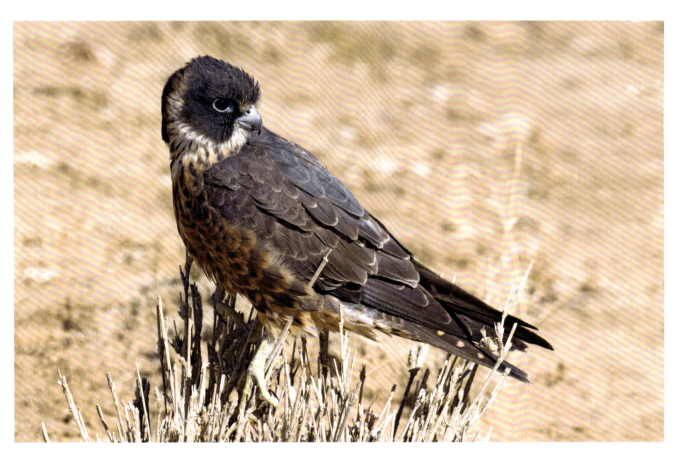
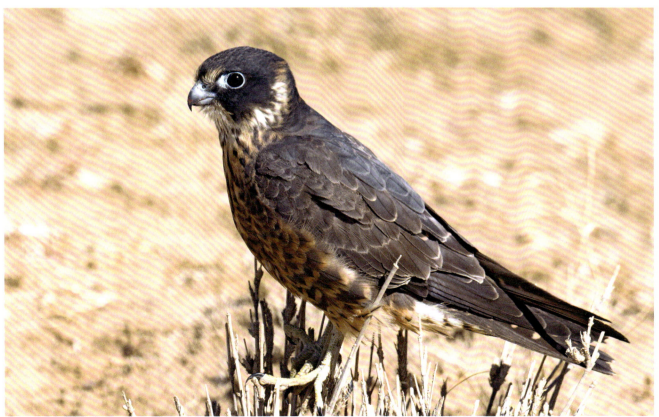

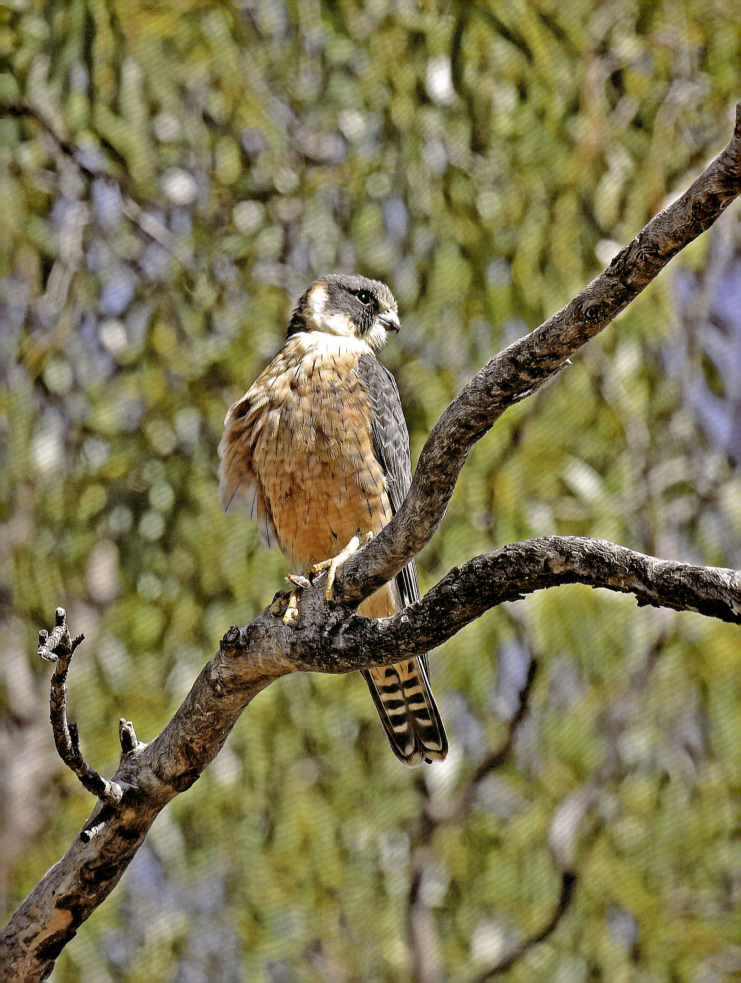

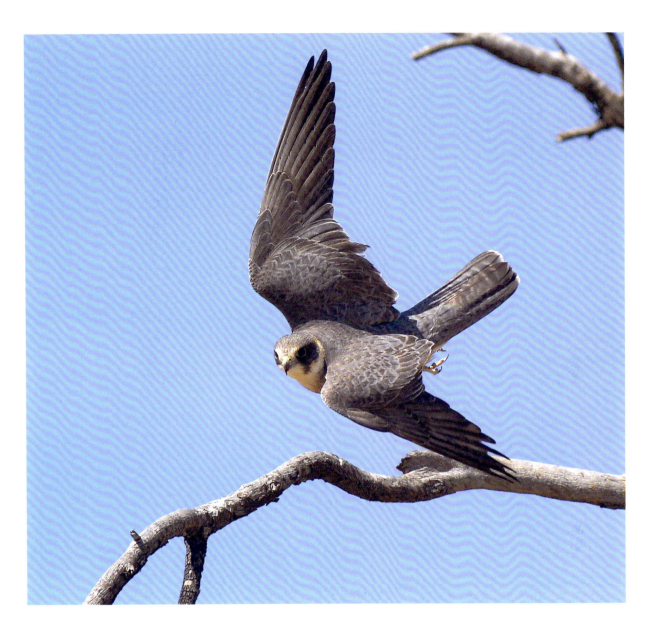

We usually stop to examine bird roadkills on our travels. On one occasion we picked up a freshly dead Fairy Martin on a road in western Queensland, typically near a culvert, obviously a victim of a collision with a vehicle. A short time later we noticed a hobby perched alongside the road. Hobbies often stay put so we got out of the car to take some photos for our collection, because it had less rufous colouring on the head than usual. It looked like a male and was more curious about us than alarmed. I had a sudden thought: it might like a free meal, so while Sally focused on the hobby, I tossed the martin up. The reaction was instantaneous: down he came, plucked up the offering, waggled his wings to say thank you and headed off, hopefully to share it with his mate. Sally managed two shots and when we examined them, we noticed the central tail-feather looked older, and more brown than the others. Our conclusion was that it was a first-year bird that had just finished its first moult, with only that feather still to be replaced. So it probably didn't have a mate anyway.

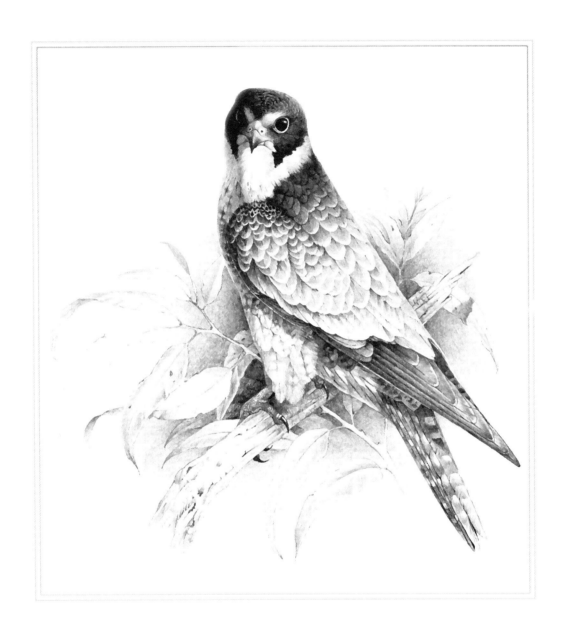

Above is the drawing of an Australian Hobby that attracted the attention of renowned bird photographer Eric Hosking when he visited our home, described on p. 159.

I photographed the bird opposite in September 2010, near Dajarra in north-western Queensland. It was a male performing a courtship flight during which it whistled past our heads several times at great speed, allowing me to fluke a few shots. When I viewed the results later at home, the position of the tiercel in one of the photos seemed familiar, so I dug out some images of old paintings, and found the one above, painted about 1972 in an almost identical position. I recall it was modelled on a bird given to me by our neighbour, Julie, who had picked it up alive in her backyard. She told me it was flying past and suddenly tumbled to the ground. When I took it out of the box it went into convulsions with back arched and wings quivering, reminding me of a condition known as 'twirling' I had seen in some local Red-browed Finches, which inevitably proves fatal. Possibly it had preyed on one of the infected finches and acquired the twirling virus. As I held the bird it convulsively grabbed my hand with needle-like talons, and, as it died, I shared the pain of its passing. I laid it out on my easel and with bloodied hand sadly set to work on painting its immaculate plumage.

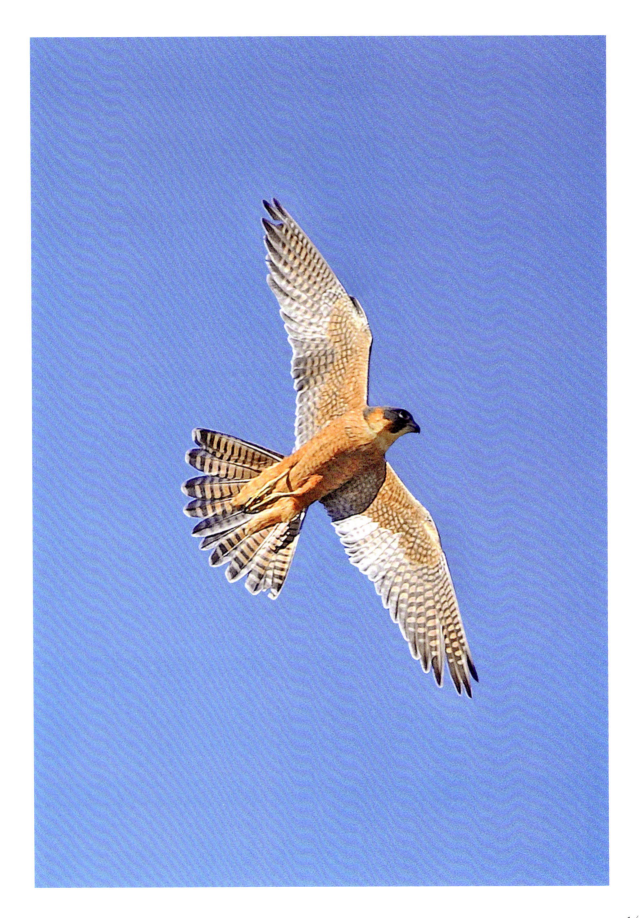

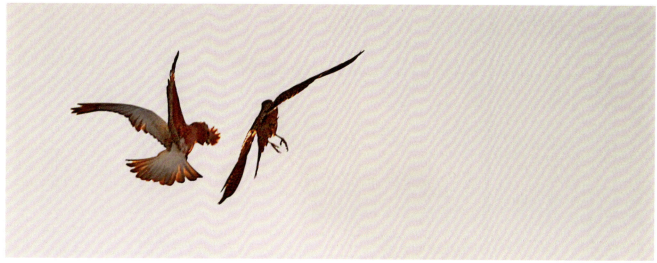

As Sally and I drove out of Bedourie, Qld, just before sunrise on a clear-skied August morning we noticed a hobby chasing cockatoos around the top of the telecommunications aerial in the main street, including a number of Galahs and Little Corellas. It was soon obvious that the hobby was not aiming to catch one, rather it seemed to us that all participants were 'playing.' There was much back and forth, particularly with the corellas. The hobby would chase one, then it in turn was chased. All participants regularly returned to the aerial, then took off again to resume their play. This exhilarating exhibition of aerobatics continued for at least five minutes as the sun rose, and the first rays gave us enough light to snap a few rather fuzzy pictures. Eventually the cockatoos settled on the aerial, and the hobby sped off, very fast, over the rooftops and beyond. We were in and around Bedourie for a month, checking the tower each morning, but never saw the interaction again.

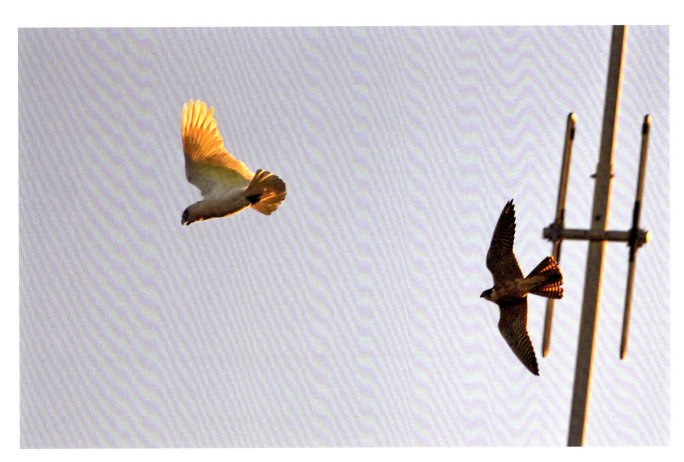
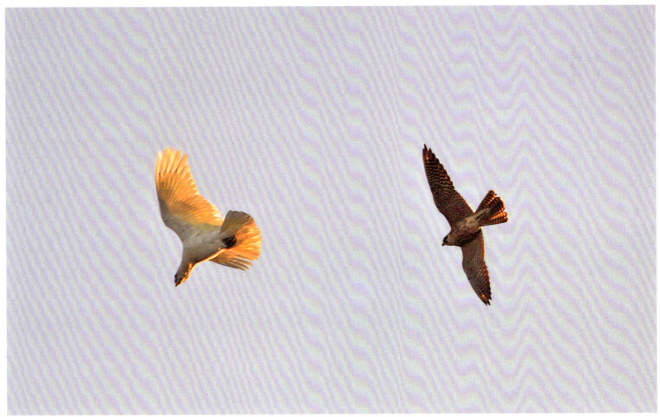

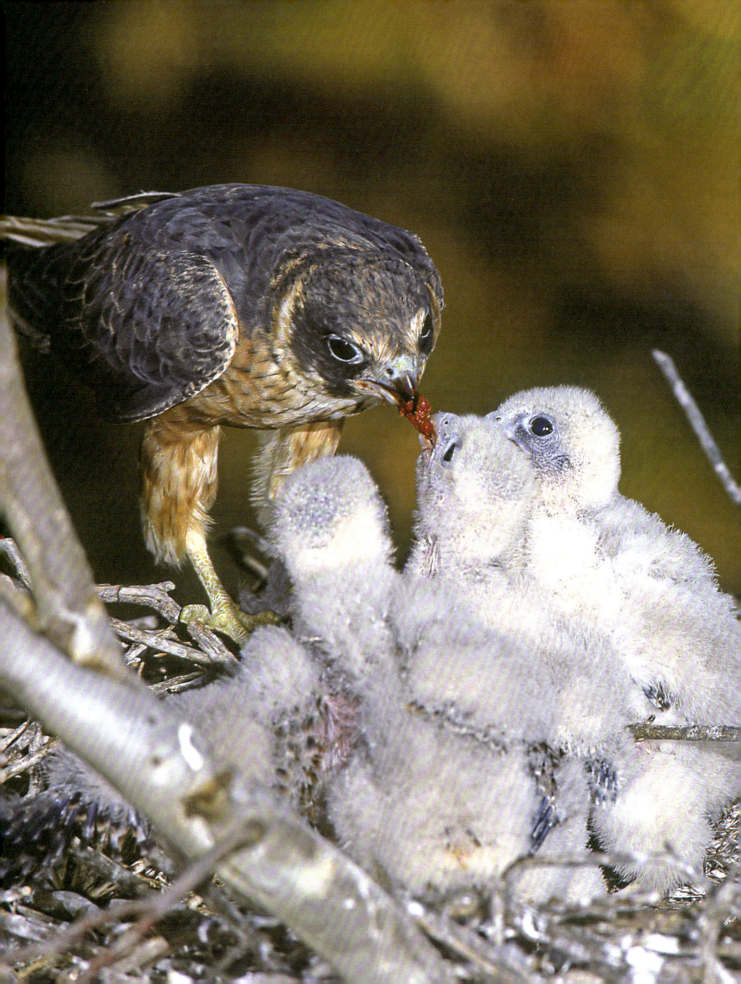

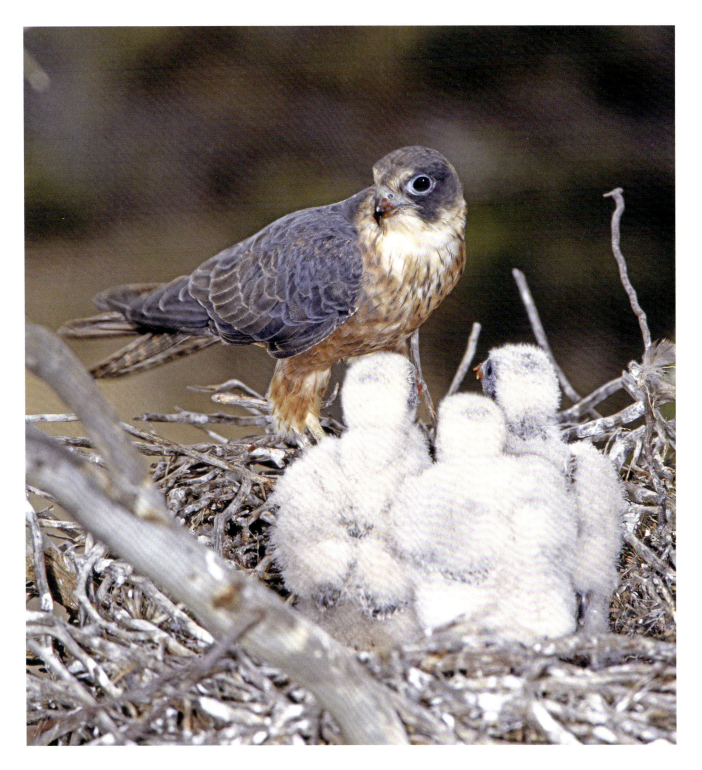

Hobbies utilise other birds' nests, usually the large stick constructions of corvids and other raptors, preferring those placed high among outer branches. I have only come across about twenty nests, those in the south mostly later in the year than other raptors. These photos, for example, were taken in December. Four nests I noted in the Kimberley, WA, were earlier – one had eggs in August, two in September and one in October.

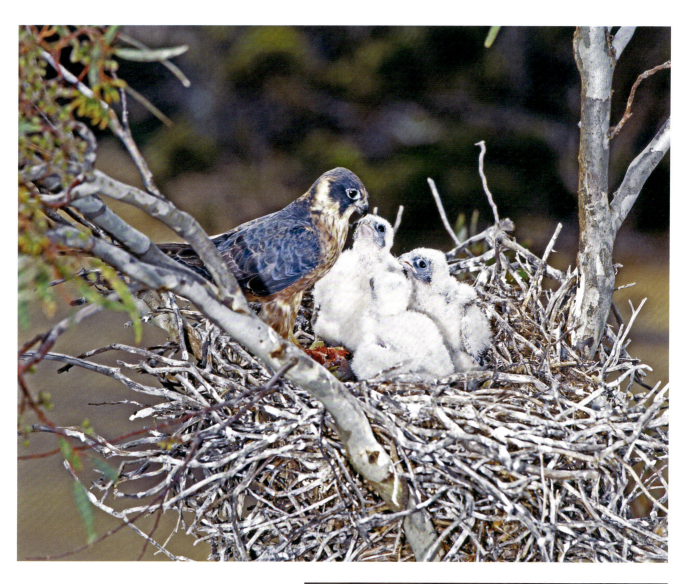

Above: An Australian Hobby feeding chicks on a Purple-crowned Lorikeet, their last meal of the day, late in the evening.
Right and opposite: The prey is a Tree Martin. At this nest in WA the chicks were fed predominately on small birds. Because the quarry is plucked before being carried to the nest, it is not always possible to make a positive identification, but sufficient feathers remained to identify three items of prey as a Tree Martin, a Purple-crowned Lorikeet and probably a Gilbert's Honeyeater.

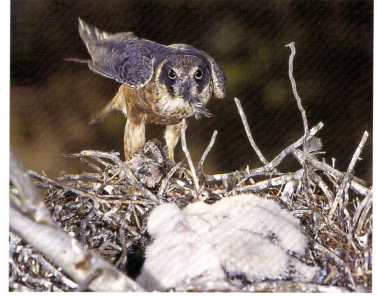

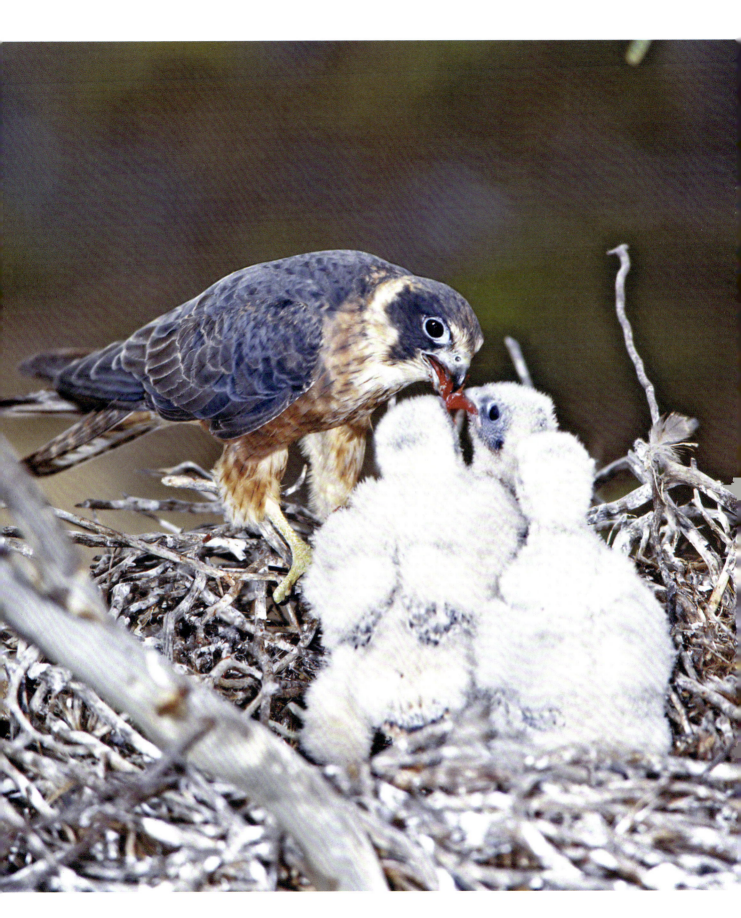

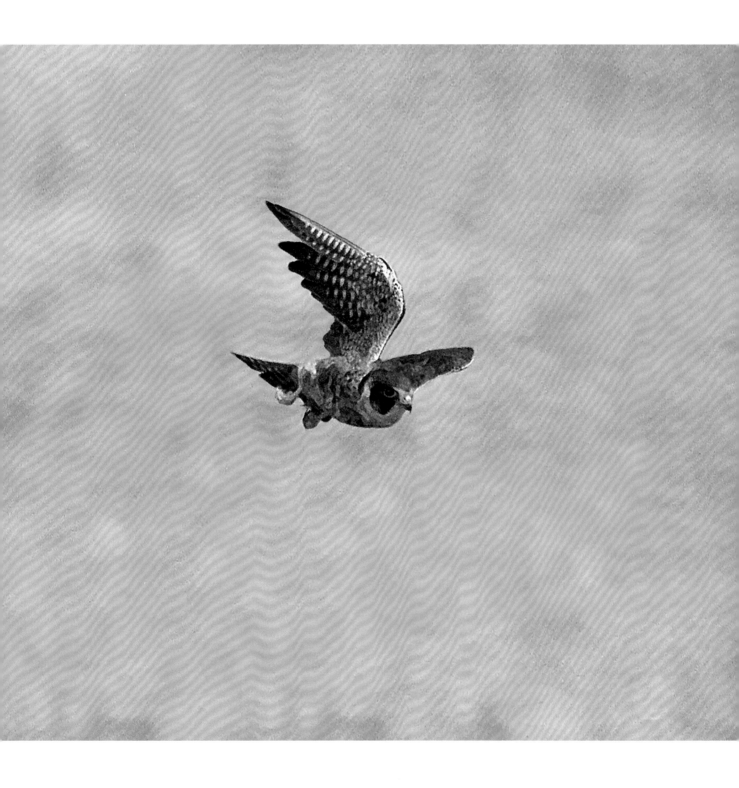

*Australian Hobby
hustling over the stubble
hoping to flush quail*

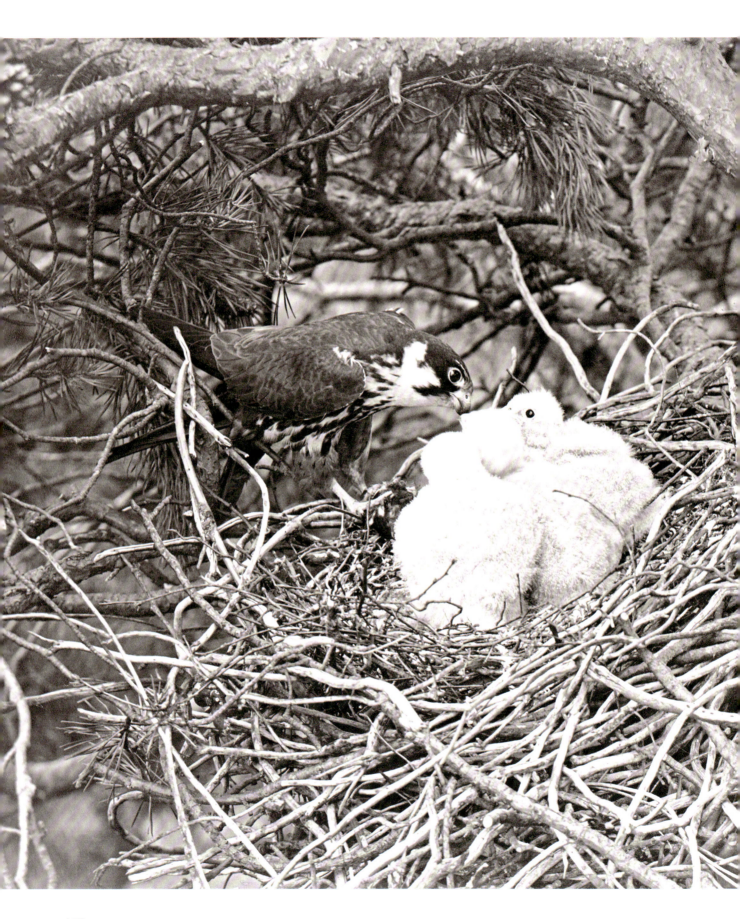

EURASIAN HOBBY
Falco subbuteo Linnaeus 1758

The Hobby Albin, *A Natural History of Birds*, i, p. 6, plate 6, 1738.
Le Hobreau Brisson, *Ornithologie*, p. 375, 1760.
Falco subbuteo Linnaeus, *Systema Naturae*, 10th Edition, i, pp. 89–90, 1758.
Falco barletta Daudin, *Traite elementaire et complet d'ornithologie*, ii, p. 129, 1800.
Hypotriorchis subbuteo Boie, *Isis*, p. 796, 1826.
Falco hirundinum Brehm, *Vogel Deutschland*, p. 65, 1831.
Falco arboreus Brehm, *Vogelfang*, p. 27, 1855.
Hypotriorchus cuvieri Gray, *A Hand-list of the Genera and Species of Birds*, i. p. 20, 1869.

The Eurasian Hobby has been sighted on only a few occasions in our region: Cocos (Keeling) Islands, Christmas Island, Swain Reef, at sea near Scott's Reef and at South Lake near Perth. It is a migratory species so not unlikely, particularly in WA in the north-west Kimberley north of Derby. I have seen only one, in the desert near Abu Dhabi in the United Arab Emirates. To me it looked longer-winged than our hobby, more compact, and I suspect, from this very limited experience, faster. But that is subjective; they are both masters of what they do, that is, catching flying insects, particularly dragonflies, small birds and bats.

I had the rare privilege of driving legendary bird photographer Eric Hosking around while he was in Queensland, looking for subjects for his Olympus cameras. When we stopped at my place one day for a cuppa he saw my framed pencil drawing of an Australian Hobby on the wall, and said he would love to have something similar in paint for his collection. I suggested a swap: one painting for some black-and-white prints of his justly renowned raptor photographs. We settled on the Eurasian Hobby, Merlin, Western Marsh Harrier and Montagu's Harrier. At the time they were taken, in the 1930s, these pictures were major achievements in the annals of bird photography. Four beautifully printed 16x20 inch signed masterpieces duly arrived, and I sent off a painting to Eric, an acrylic version of the drawing on page 147. After Eric died, some of his collection was dispersed and I discovered my painting in a Sotheby's catalogue, listed as a Peregrine Falcon, where at auction it realised a much better reward than I would have expected in Australia back then. Anyway, I contacted Eric's son David, and he was quite happy for me to reproduce the Eurasian Hobby photo here. If you see a Eurasian Hobby in your travels, rejoice; it's a beauty!

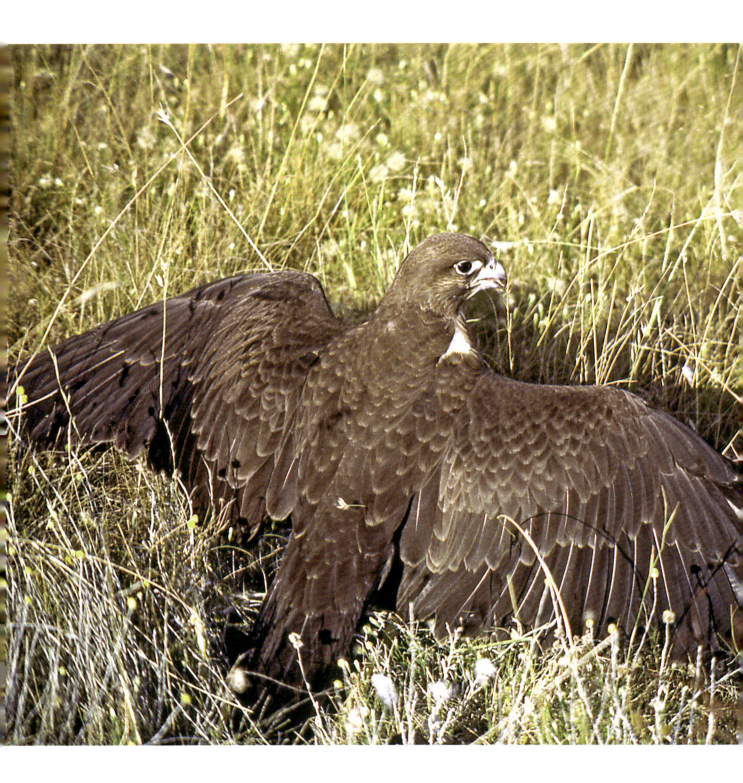

BLACK FALCON
Falco subniger Gray 1843

Falco subniger Gray, Annals and Magazine of Natural History, xi, p. 371, 1843.
Falco subniger Gray, Genera of Birds, i, p. 19, plate viii, 1844.
Hierofalco subniger Kaup, Contributions to Ornithology, p. 56, 1850.
Notofalco subniger minnie Mathews, Austral Avian Record, ii, p. 127, 1915.
Falco subniger minnie Swann, Synopsis of the Accipitridae, p. 198, 1922.

The Black Falcon was the last Australian bird of prey to be discovered and described, three years after the Grey Falcon and Black-breasted Buzzard. In describing it in 1843, George Gray wrote: "This bird has the form of the Peregrine Falcon but is larger in all its proportions; judging from its plumage, it appears to be an immature specimen of a species not hitherto described. Its locality is unknown but is supposed to be an Australian species."

According to the list of birds in the British Museum compiled by Gray, the specimen in the museum came "from Mr Warwick's collection." Gray's book *Genera of Birds*, 1844, contains a fine lithograph of the Black Falcon by David W Mitchell, rather better than Richter's illustration, delineated in 1848 for Gould's *Birds of Australia*, or Diggles' depiction in *Ornithology of Australia*. All three err in showing the cere, orbital rings and legs yellow.

David W Mitchell's lithograph from Gray's Genera of Birds, *1844. The feet are too big, but the short outer tail-feather is shown.*

Henry Richter's lithograph from Gould's Birds of Australia, 1848.

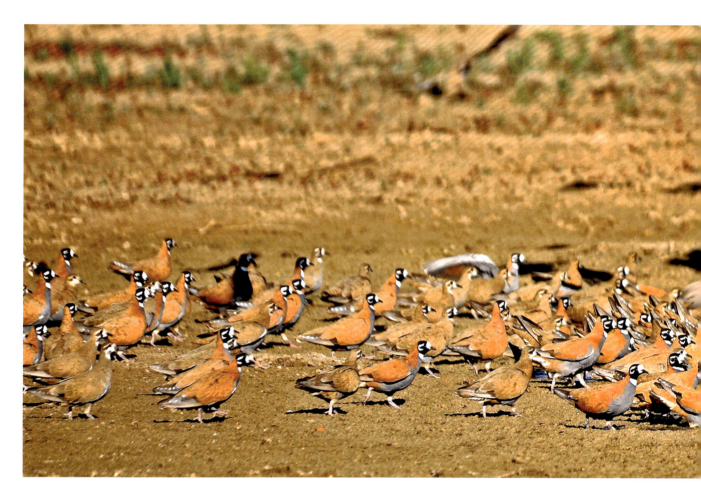
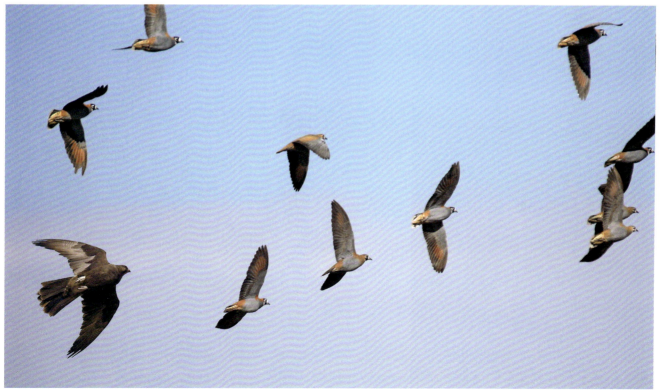

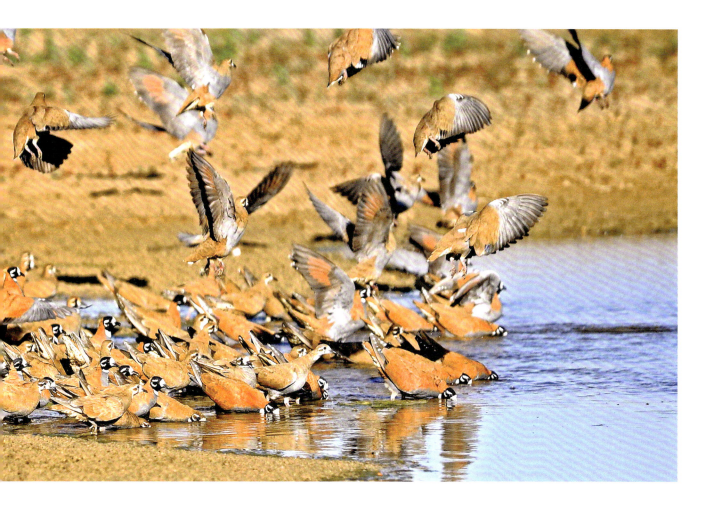

Picture the scene. A hot day on the edge of the Simpson Desert. Shimmering dunes in the distance. A sky without pity. An unexpected stretch of water, more than a puddle, less than a pond, all that is left of a recent flood that has germinated desert ephemeral plants all around. A good place to wait. In the far distance we see clouds of birds, landing in the legumes, repeatedly taking off and settling again. A whirr of wings passing over our heads. Flock Bronzewings, hundreds of them. They bank in unison, giving momentary glints of purple and green in the wings, and head back, making more circuits. Then, like a wave crashing, the leaders hit the shore, suck up a cropful of water in a few seconds, and hurriedly take off, their places quickly taken by the next wave. In a few minutes all have drunk their fill and leave. It's midday; the bronzewings are supposed to drink at sunset. We wait and are rewarded when another flock wheels in. They haven't read the books. This time they land near the water and run down like clockwork toys. Suddenly all take off – a Black Falcon arrives. How did they miss seeing its approach, just a metre above the ground, wings flickering. Perhaps they feel secure in their numbers. The falcon misses whichever bird it had selected, and continues on, content that there are so many on the plain that it won't be long… The bronzewings settle in the grass near the water. After half an hour they start to head down for a drink, a few at first, then a rush. Another Black Falcon hurtles in, selects one and chases it; they head for the horizon; the last we see

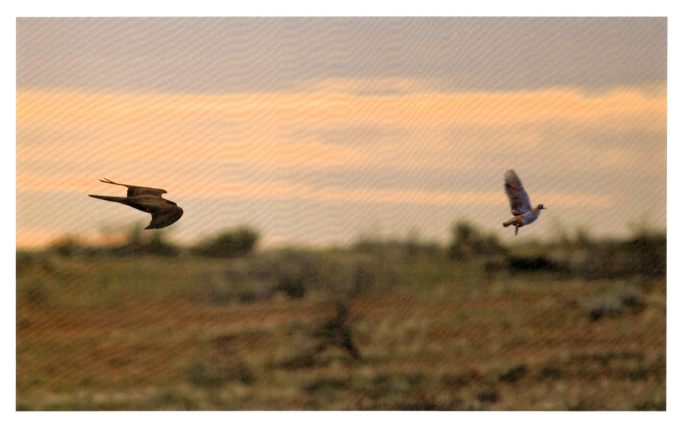

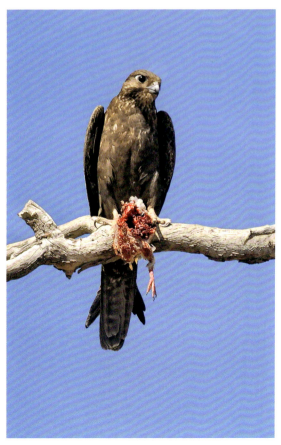

of them they are small specks rapidly disappearing. Next day, we see a Brown Falcon on the ground near the pool, feeding on a bronzewing; did he catch it or did he dispossess a Black Falcon?

Later, on the Diamantina River near Birdsville, we see another Black Falcon chasing a solitary bronzewing. The pigeon is trying to get to the ground and the falcon flies just behind, trying to force it up. They are flying incredibly fast; I keep thinking the falcon will be outpaced by the bronzewing, but it has no trouble keeping up. Despite the falcon's efforts to keep its quarry airborne they lose height. About ten metres above the ground the falcon catches up in a sudden burst, a snowflake puff of feathers and they go to ground, bound together. We had taken a few shots as the pair passed, but we want more, so marked where we thought they had landed several hundred metres away on the other side of the river. By the time we locate a place to cross we find no sign, just some drifting feathers. Oh well, another day. Anyway, I am very impressed by the speed of both birds. Someone recently timed a flock of bronzewings that flew alongside his vehicle at about a hundred kph. Sally and I were lucky enough to have a similar experience with a Black Falcon near Boulia, Qld. It kept pace with us for several hundred metres at just under seventy kph. That was why I am surprised the falcon had no trouble taking the bronzewing. When I think about it, the Black Falcon occasionally has a rather lazy gait, but is capable of great

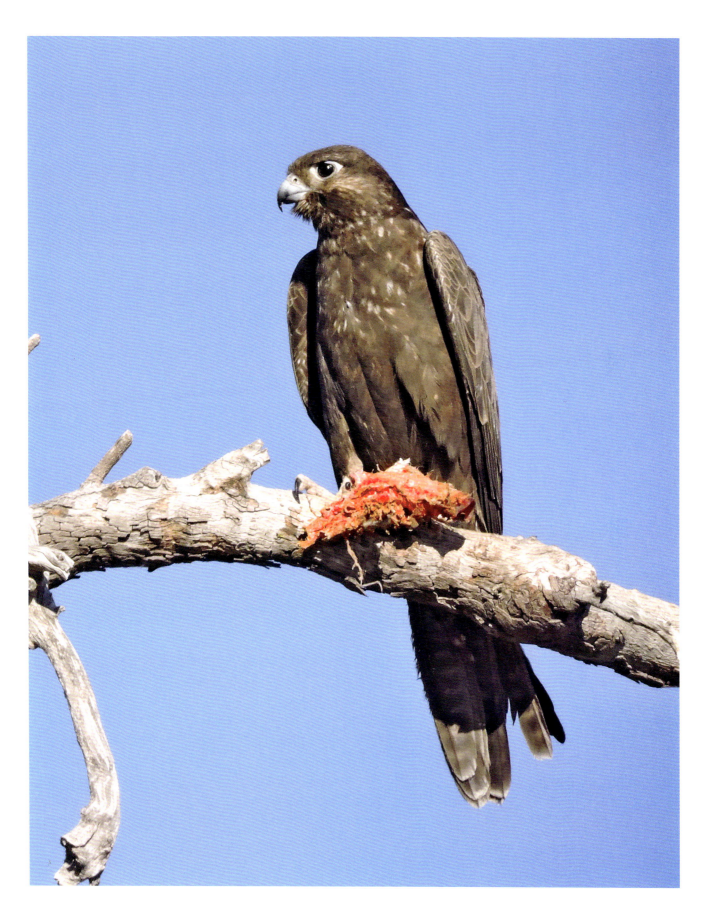

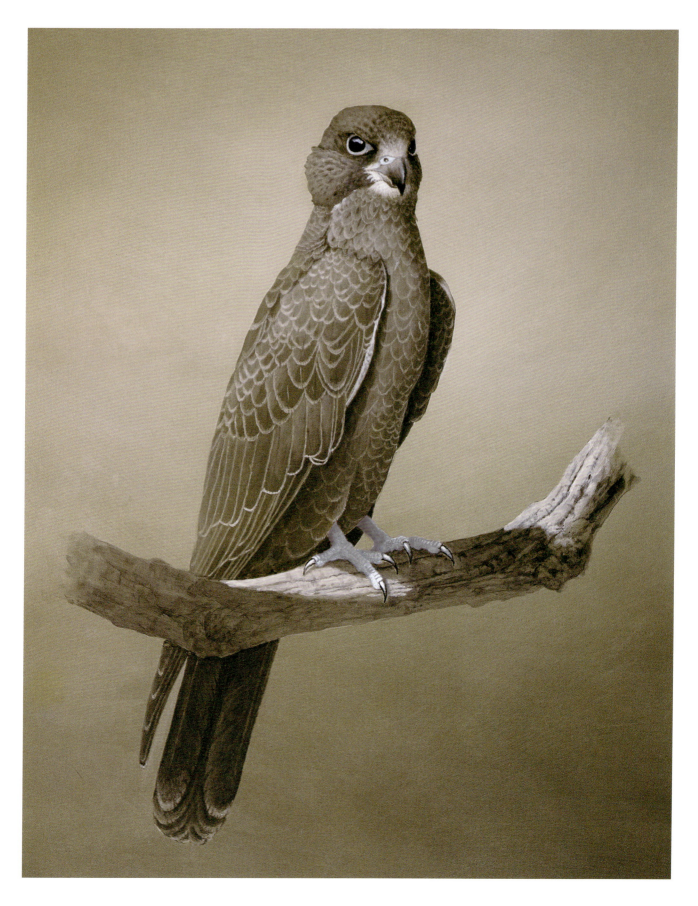

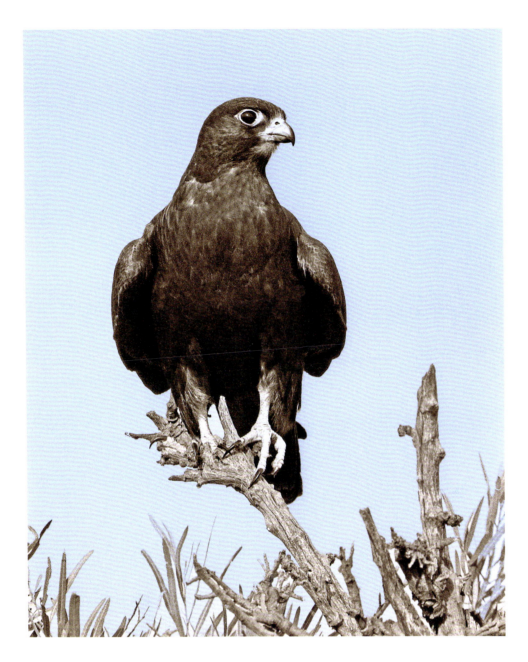

speed with much quicker wingbeats when required. I have seen a few dramatic stoops at prey, but think both the Grey Falcon and Peregrine are faster. Fred Smith, doyen of Australian birdwatchers, told me he saw a Black stooping and believed it was much quicker than the Peregrine. I pointed out some features of each bird: the Black has rather soft, flexible feathers and fairly simple nostrils; it has a much bigger sail area than the Peregrine and longer wings and tail with much the same bodyweight. The Peregrine has tight feathers and complex baffles in the nostrils to facilitate breathing at high speed. Also, a friend of mine saw a Peregrine catch and kill a Black Falcon. Fred remained adamant that the Black was faster. Not that it matters, such perceptions are very subjective. Both birds are magnificent, each perfect in its own way. But the Peregrine of course is the most perfect thing on the planet.

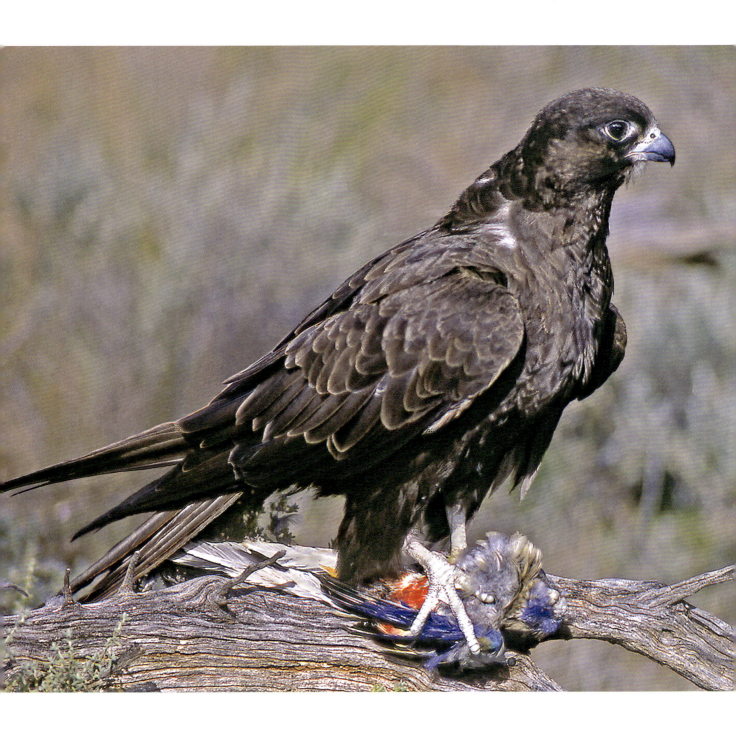

The Black Falcon is an efficient and persistent hunter of birds, but we have occasionally observed less successful situations. Grant Squelch and I were once at the Wandoan airfield and were lucky enough to see a pair of Black Falcons following a harvester reaping a wheat crop in a nearby paddock. We followed them in our binoculars as they soared in tight circles, about thirty to forty metres above the reaper. The farmer had started on the outside of the paddock and was working around the periphery, getting closer to the centre with each circuit. Every now and then a quail, presumably a Stubble Quail, would be flushed and one or both of the falcons would stoop. On each occasion the quail dropped back into the crop, which was too dense for the predator to follow. I can't remember how long it took the harvester to clear the paddock, but it would have been more than an hour, maybe two. All that time the pair followed, stooping at each quail as it flushed. As the tractor drew closer to the centre of the paddock, more and more quail were bursting out, but the falcons remained unsuccessful. Grant and I decided to get closer to see the final swathe reaped, when the quail would have nowhere to hide, but by the time we got there, tractor, quail and falcons had gone. We both marvelled at the patience shown by the Black Falcons and hoped they had at last managed a meal. In western Queensland, I have seen Black Falcons following cattle on the stock route, but can't remember seeing one catch anything that was flushed out. Another friend, John Murray, told me he watched Black Falcons following his herd of cattle when he was moving them, but didn't see them catch anything either. I'm sure they do or they wouldn't persist.

On other days I have seen Black Falcons in devastating mood, none more so than a pair at Munkejarra near Derby, WA. It is an extremely hot November Day. I've been hotter at Wyndham on the other side of the Kimberley, reputedly the world's second-hottest town, but not by much. The water is drying up and thousands of doves are coming down to drink. Pat and I sit under a paperbark near the water. The roar of wings is so loud we can't communicate. During the day we see all species of Australian falcons hunting; the doves don't respond with the usual panic when a raptor arrives. A pair of Black Falcons appears. One circles high, the other dashes through the hordes, leaving several doves, probably Diamonds, fluttering on the ground. Kites swoop in to pick them up. The Black Falcon, which I assume is a male, flies through again, leaving more doves on the ground as food for the kites. I can't believe it as it whistles through again and again with the same result. Is this some sort of macabre display for his mate circling above? On one occasion a Brown Falcon beats a kite and snatches up a stricken dove. I stand up and dash down to the water's edge with my camera. It's 1950s technology, useless in this situation. Doves all around me. The Black Falcon dives through again and this time grabs a dove in front of my face, carries it a few metres then, I swear, lets it go. The dove continues on. I am stunned. On its next pass the falcon finally holds onto a dove and thermals up to its mate. They keep ascending and at last I can take a shot; pinpricks against the sky, surrounded by kites.

In 1974 Ray Garstone and I spent some time at a Letter-winged Kite colony west of Windorah, Qld, during a plague of Long-haired Rats. There were plenty

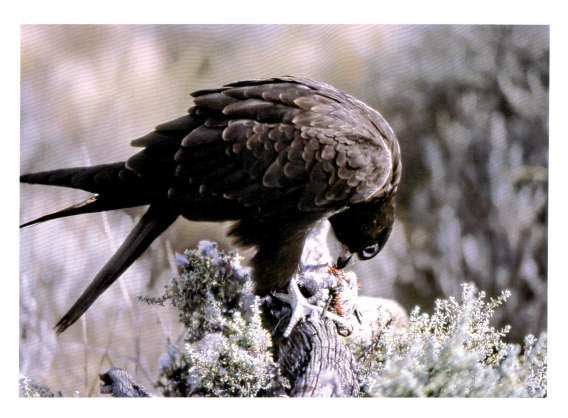

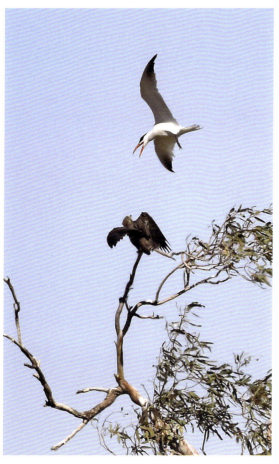

of Black Falcons there, along tree-lined Morney Creek, which runs through an otherwise treeless plain. One day we saw a Black Kite sitting in an isolated bush. A Black Falcon was winging its way over the plain just above the ground, heading from A to B when it saw the kite, so deviated, whistled past within a few centimetres and resumed its steady course to B somewhere over the horizon, chuckling to itself. While we were watching a Letter-winged Kite, we saw a Black Falcon dive-bomb it as it sat on a dry branch above its nest. I have seen similar events elsewhere; apparently a Black Falcon can't resist making a pass at another perched raptor. On Eyre Creek we saw the tables turned when a Caspian Tern several times attacked a Black (left). There were many Black-faced Woodswallows in the Morney Creek colony, and one group often clustered in a small bush. Once, when a Black Falcon approached, they seemed to freeze, and the falcon simply plucked one like picking an apple off a tree as it went past; usually woodswallows are very aggressive towards birds of prey. On the way home from the colony Ray and I counted twenty-six Black Falcons between Morney Station and Windorah, a distance of about one hundred kilometres. Most of them were young birds; the plenitude of rats probably led to a high proportion of chicks fledging.

On another occasion near Windorah, a pair of Black Falcons chased a Crested Pigeon and after a relentless pursuit one bound to the pigeon, and began to deplume it on the ground. The other

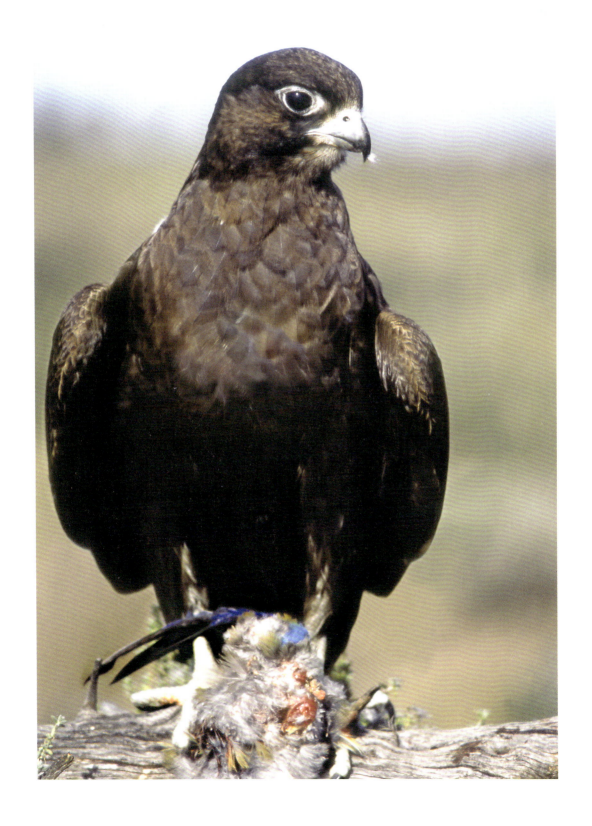

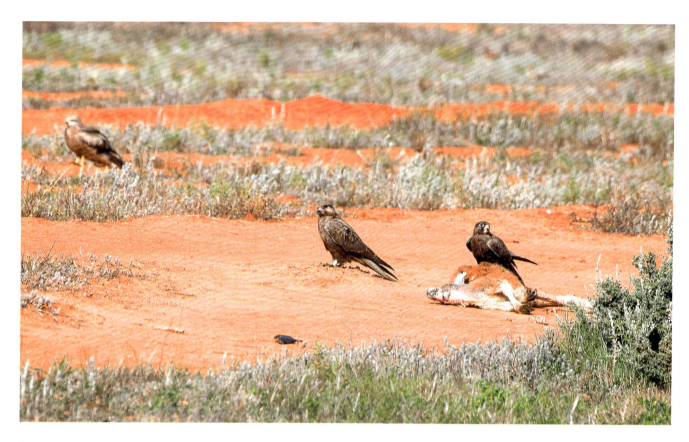
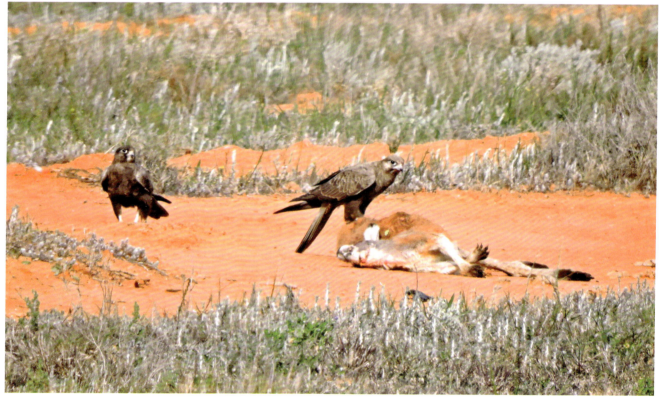

Black Falcon pair feeding on a dead kangaroo.

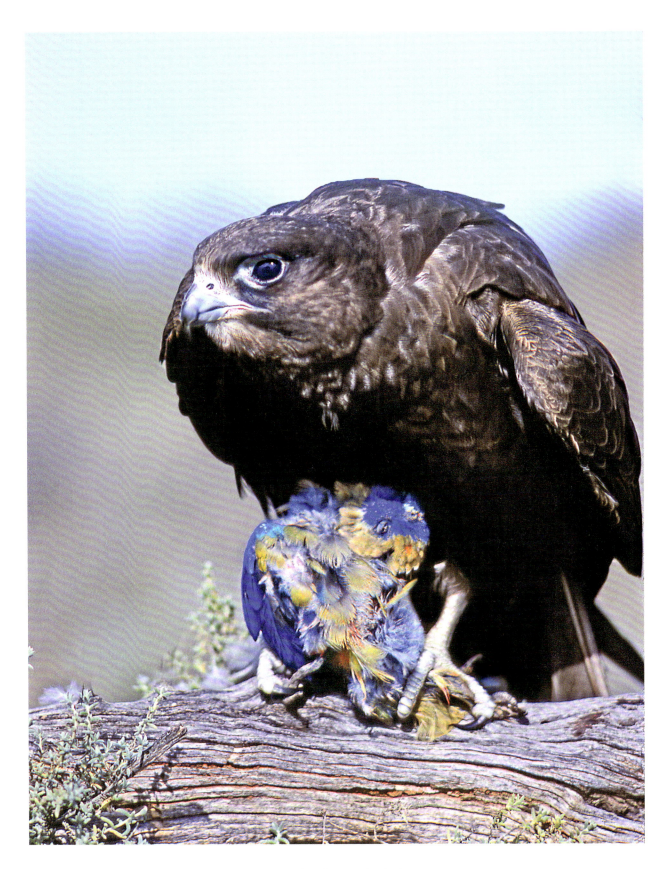
Female Black Falcon with Bluebonnet prey.

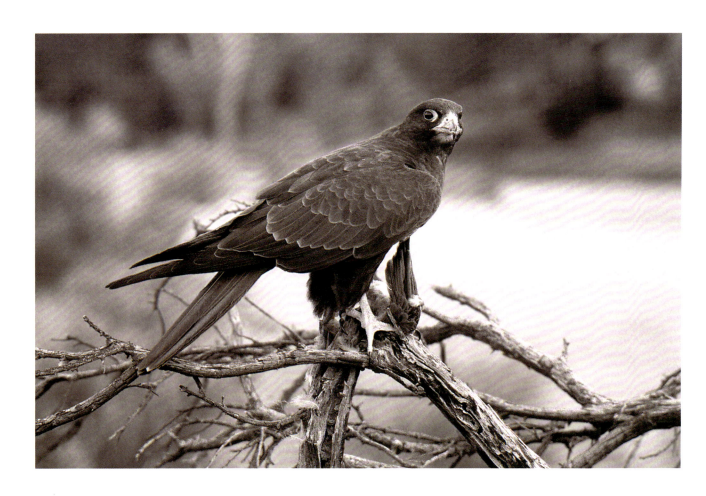

bird, probably its mate, landed alongside and the first bird stood aside while the other began feeding, not resuming until it had finished. There were a number of Black Falcons around that line of sandhills just west of the town. One I watched lying on the ground in mid-day heat, not even panting; I wondered then and wonder still why the species has 'black' plumage, a colour antithetic to thermoregulation. Actually, it's not really black, as the specific name *subniger* suggests, translated as 'less than black', or 'almost black'. A better description would be dark slaty-brown, but still unsuited, one would think, to the devastating heat of summers in the inland. Birds that we assume are very old acquire pale feathering on the cheeks and breast. A few we have seen have also had extensive barring in the flight feathers, undertail-coverts and tail, very like a juvenile Laggar Falcon from India (p. 185). One Sally photographed near Boulia being harassed by a juvenile, had barring in the secondaries as well as the primaries. A few days later we saw a similar bird at Cuttaburra Crossing on Eyre Creek, about two hundred kilometres south. Younger birds have the barring in the primaries generally restricted to the outer feathers and rarely if ever have barring in the tail, although at least a few have barred or spotted undertail-coverts. The Black Falcons are mislabelled in

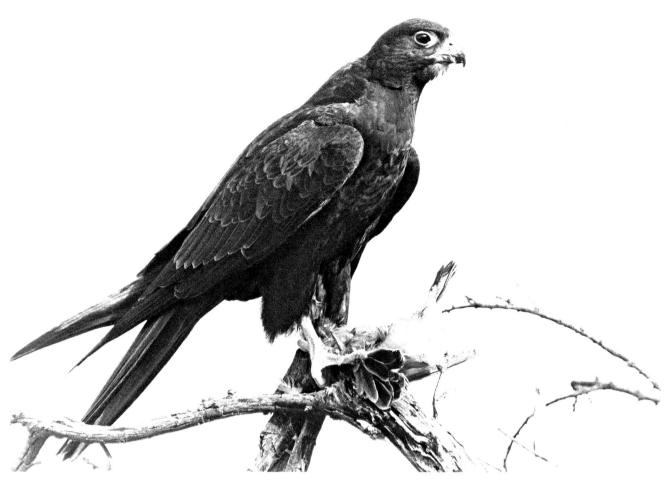
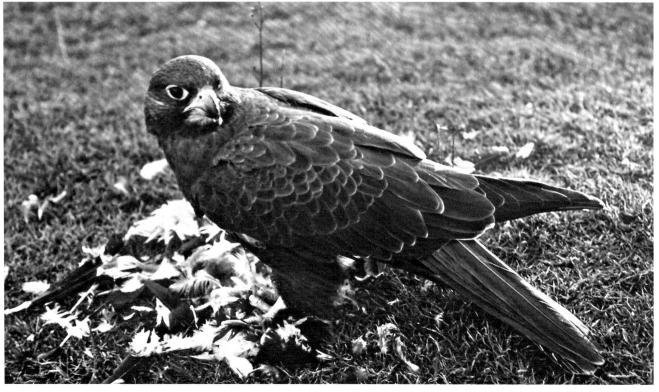

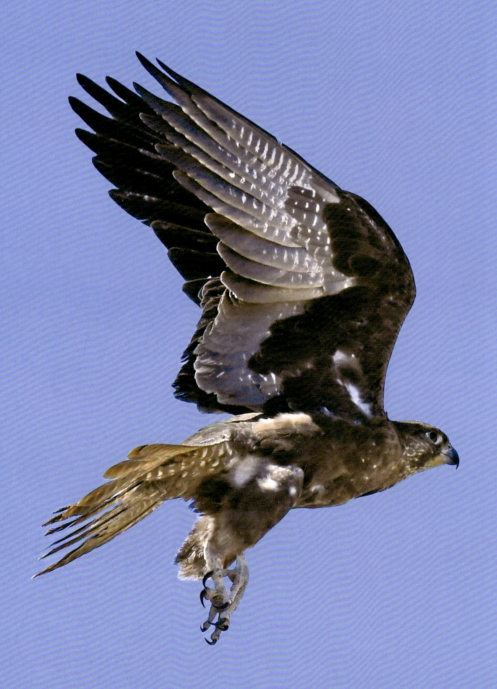

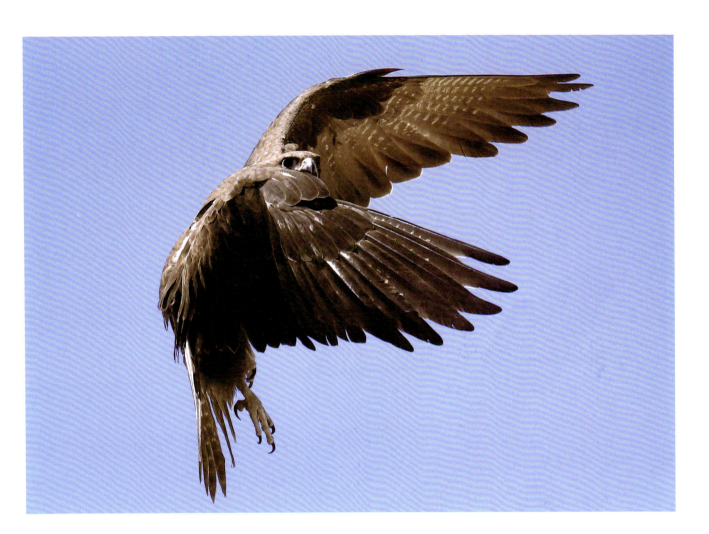

J C Harrison's painting in Amadon and Brown's *Eagles, Hawks and Falcons of the World*; the juvenile is labelled an adult and vice versa.

In the desert in South Australia, Sally and I came across a pair of Black Falcons feeding on a dead kangaroo (p. 172) – the only occasion we have seen any at carrion. The female had just finished when we arrived, her beak and breast covered with blood. The male stood on the very large male Red Kangaroo to feed, a rather unusual sight. A number of Black Kites were standing around, waiting patiently for their turn.

For twelve years Pat and I looked after a Black Falcon with a wing so badly damaged it couldn't be repaired. A large female, she had a perch on a wicker chair in the living room. Each morning she headed out through the hallway, past the dog in its basket, down the back stairs and into the back paddock, where she would wander around during the day. Towards sunset she would return, jump up the back stairs one at the time, wander down the hallway to her chair, then sit eating her evening meal of mice and anything edible we picked up on the road. Several times when she was in the backyard I heard her making an unusual call which I recorded at the time as a 'strange indrawn screaming;' each time when I checked there was a harrier standing near her, usually a Swamp Harrier, but once a Spotted, one of only two I have seen in our paddock – in South Australia

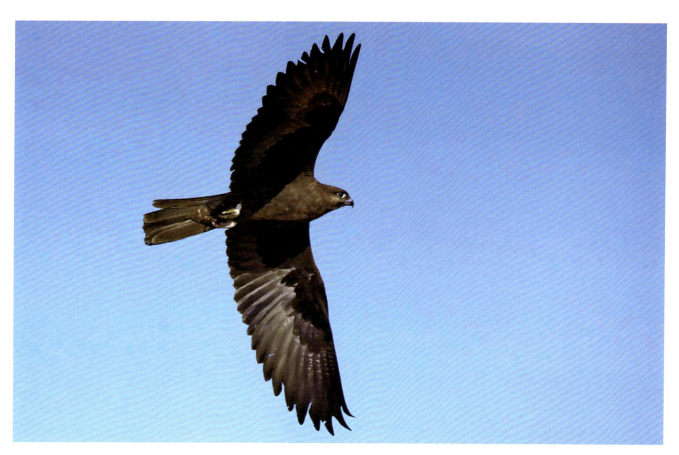
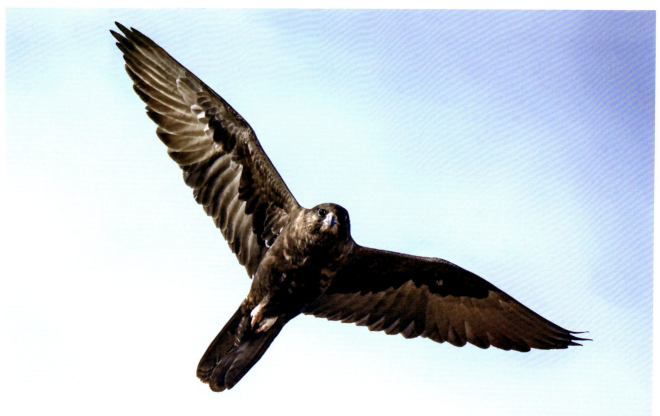

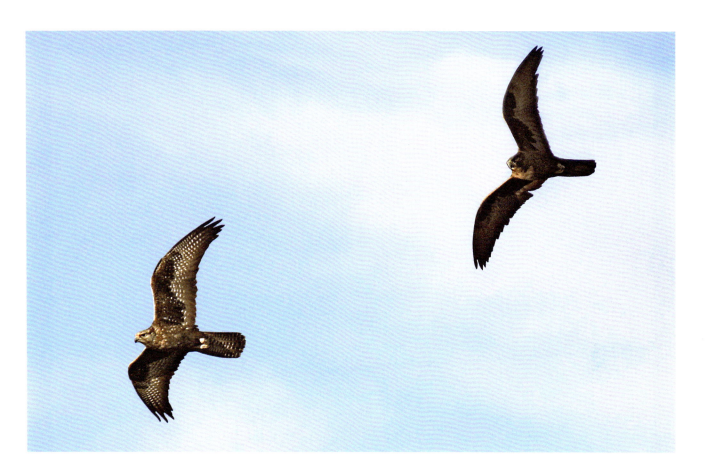

I once saw Black Falcon following a Spotted Harrier, obviously hoping for flushed quarry. One year we were given a sackful of frozen rats from a laboratory, which the falcon enjoyed. I think it was in July or August she started spending time under the dining room table, often squatting down, and standing in front of my feet with her head bowed, and making a clucking sound. One morning I was very surprised to see she was sitting on an egg under the table. I surrounded her with sticks and was interested to note she nibbled them, shredding bits of bark which she dropped around her breast. Only one egg was laid; it didn't last long, and she gave up sitting.

When Raoul was small, he often played with the Black Falcon; if he lowered his head, she would preen his hair. Occasionally she wandered down to the front paddock and one day she disappeared, and I suspected someone passing might have picked her up. So I put an ad in the paper: Lost, large black bird, with locality and contact details. It was a slim chance, but I received a phone call next day with good news, and went to pick her up. There she was in a cocky cage surrounded by dead mice and sporting a bulging crop. The kind folk were sorry to see her go. She lived with us for twelve years and left a hole in our lives when, after she died, she went to her final resting place in the Queensland Museum.

When recently fledged young are compared to their parents,

Above: What appears to be a very old Black Falcon being chased by one of its chicks in mid-August near Boulia, Qld. The old bird has extensive pale feathering on the head and breast, and extensive barring on the primaries, secondaries and tail. Its cere appears to be yellow. A week later and two hundred kilometres further south we saw a similar bird at Cuttaburra Crossing on Eyre Creek. The youngster's wings and tail are unbarred. Opposite: These two birds were a mated pair. The female (below) has unbarred wings and tail, although the undertail-coverts are barred. The male (above) has some barring in the outer primaries.

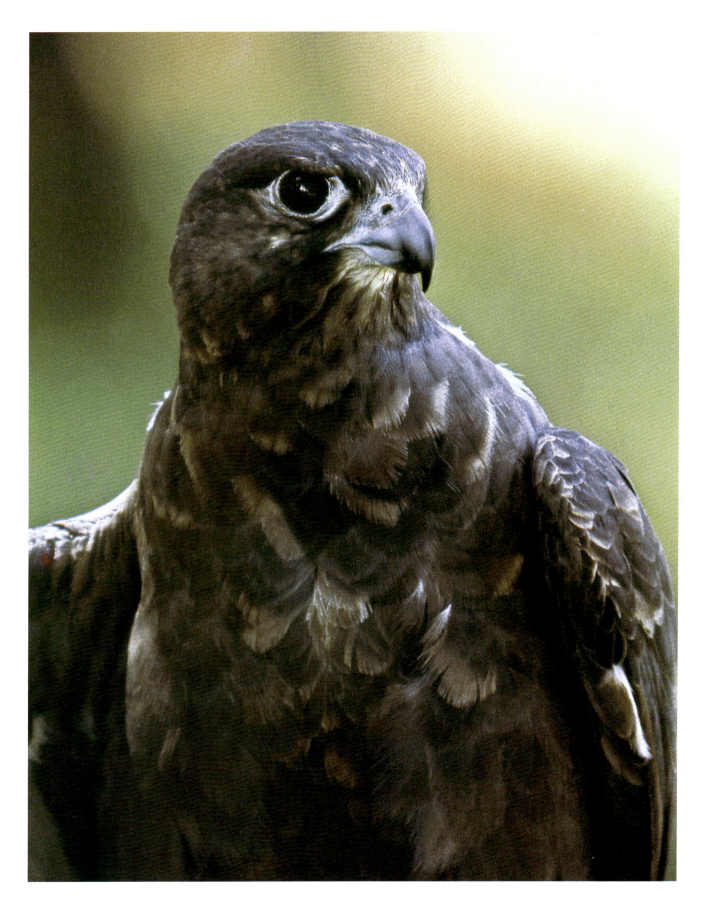

they appear darker, partly due to fading of the adult feathers after a year of wear and partly due to less phaeomelanin in the feathers. The old falcon on the right shows how much the black plumage can be faded during the year, resulting in feathering paler than some Brown Falcons. This bird was photographed in May, towards the end of its moult, observed in a cotton field near Hay, NSW. The dark moustache, found in so many of the world's falcons, is quite obvious; in many Black Falcons, probably younger birds, the cheeks are almost as dark as the moustache (opposite), but I have seen recently fledged birds with freckled cheeks that make the moustache more obvious.

The Black Falcon shown opposite is a younger bird from South Australia with a reduced white chin and dark cheeks, shown just before the annual moult was completed; if I remember rightly the shot was taken in March. Anyway, the old feathers still to be moulted illustrate just how pale the plumage can become. The new plumage has a slaty hue with an attractive bloom. Clearly seen also in this photo is the Black Falcon 'frown', caused by the overhanging brow ridge; most other falcons seem to have a more benign look.

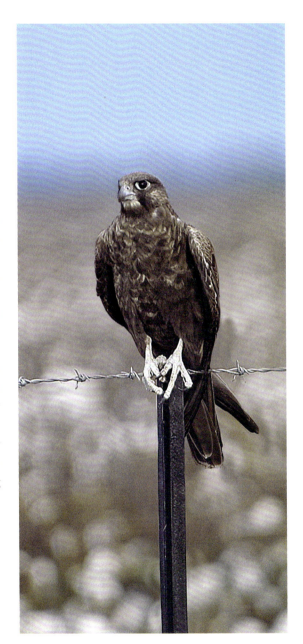

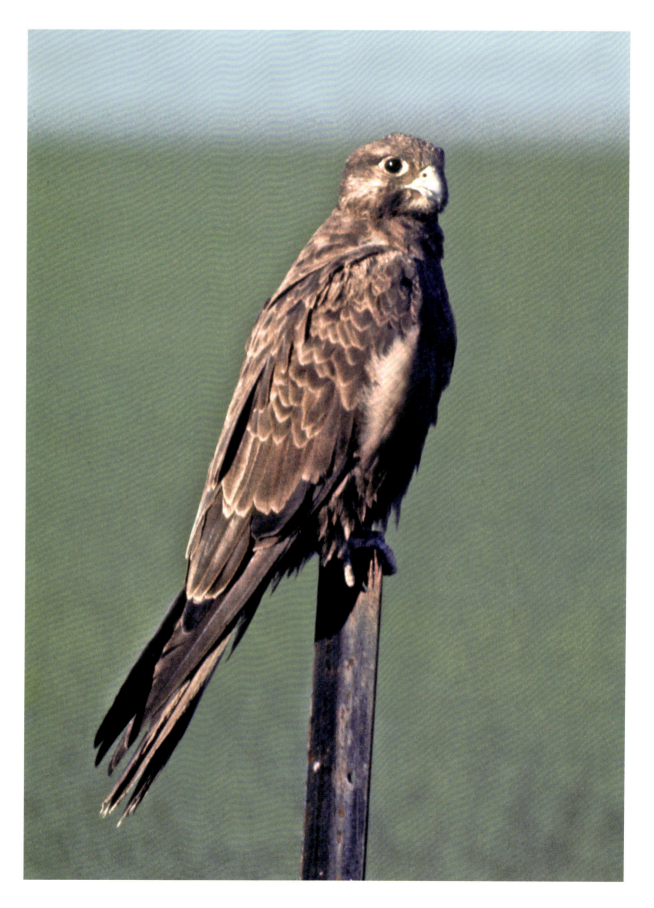

I photographed a rather scruffy-looking Black Falcon many years ago, in September 1975, just north of Dalby in Queensland. It relaxed on a picket in the midst of an oat crop while I turned my car around, enabling me to poke the 1000mm lens through the window. As one can judge from the picket it is perched on, this was a very big bird, obviously a female. It was latish in the day so the plumage in the resulting photo is probably a bit warmer than it was in life. I didn't notice at the time some of the features that become apparent in studying the picture. First, it looks like an old bird, judging from the pale cheeks and pale stripe above and behind the eye, characters seen in more exaggerated form in juveniles of the Indian Laggar Falcon, which is probably the Black Falcon's closest relative. It has just started moulting; one new primary, a secondary and a few scapulars are visible, appreciably darker than the very faded old feathers. The most interesting thing, however, is the apparent yellow colouring of the eye-ring and the cere, although the feet are blue. In 99.9 per cent of the other couple of hundred Black Falcons I have seen, these soft-part colours were pale blue (but see p. 179; the adult appears to have a yellow cere). In 1969 Graeme Chapman gave me a photo of a bird on a nest at Hay, NSW, which appeared to have yellow soft-parts; that persuaded me to use yellow in my first field-guide, to my eternal regret. The lithograph in Silvester Diggles's 19th century book, *The Ornithology of Australia*, hand-coloured by his niece Rowena Birkett, has yellow soft-parts as well, at least in the copy I saw. The rather oddly-shaped Black Falcon in Gould's *The Birds of Australia* has yellow feet. Neville Cayley, too, painted yellow legs and cere in *What Bird is That?* and in his 'big bird book'. Amadon and Brown in *Eagles, Hawks and Falcons of the World* correctly describe the soft parts as bluish, but when discussing the Brown Falcon, state that the best way to differentiate the Black Falcon from dark-morph Brown Falcon is by the former's yellow legs.

One cannot discount the vagaries of colour film, so more evidence than the photo opposite is needed before it can be claimed that perhaps a few Black Falcons have yellow soft-parts. The Laggar juvenile fledges with blue soft-parts and looks remarkably like the Black until the cere, orbital rings and legs turn yellow within a month or two. I saw two adult Laggars at Jurong Park, Singapore – they appeared to be broader in the chest, have shorter wings and tail, and bigger feet, but the juvenile in flight has a very similar profile to the Black Falcon (right), although, because of the shorter outer tail-feathers, the Black has a rather more fan-shaped tail when spread. In the Middle East I saw Saker Falcons, including the rare dark morph (Adham) which looked like a bigger, shorter-tailed, broader-winged version of the Black. Anyway, the Black fits comfortably with the other 'great' falcons: Gyr, Lanner, Saker and Laggar.

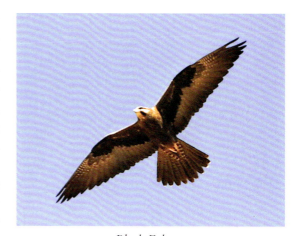

Black Falcon.

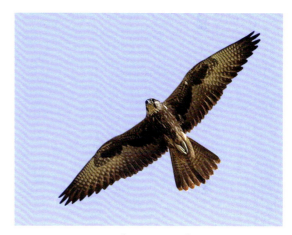

Juvenile Laggar Falcon.

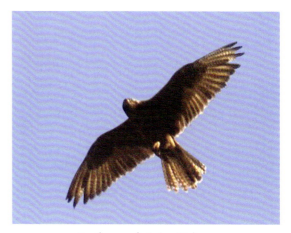

Dark-morph Saker Falcon.

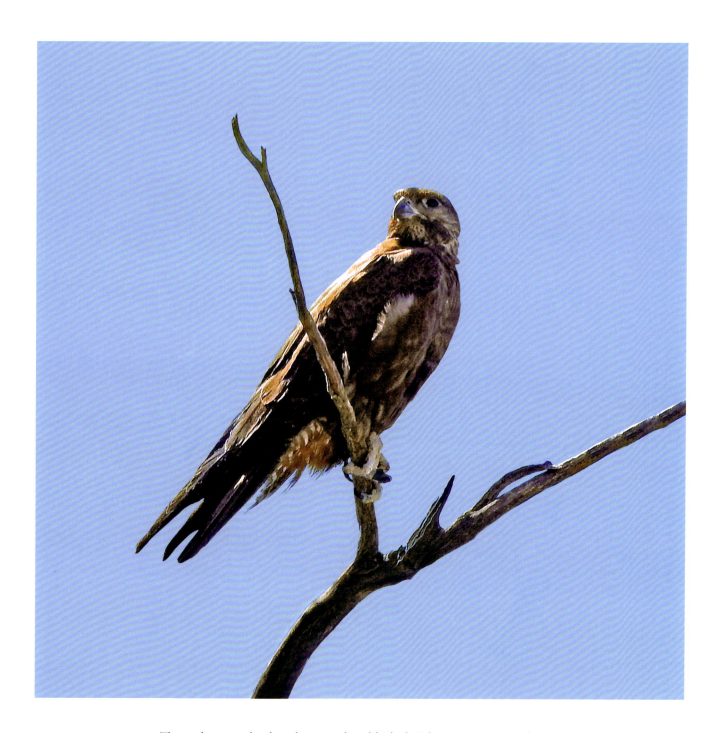

These photographs show how similar old Black Falcons are to juvenile Laggar Falcons. Above is an old Black Falcon with pale ear-coverts, throat and upper breast. Opposite right is an old Black Falcon with pale eyebrow, ear-coverts and throat. Opposite above left is Sunil Singhal's juvenile Laggar, still with blue soft parts; Sally and I have seen several old adult Black Falcons with similar markings and there is one in the Queensland Museum, although it lacks a pale eye-brow (opposite below left). Adult Laggars are quite different in plumage and judging from the two I saw at Jurong Park, Singapore, I think they have shorter tails and wings.

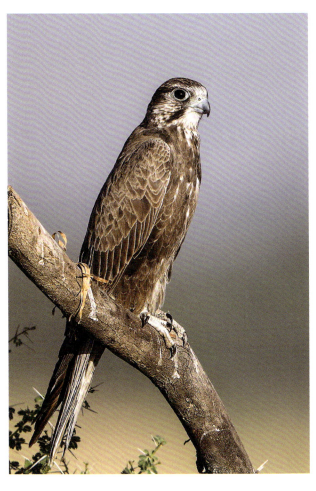

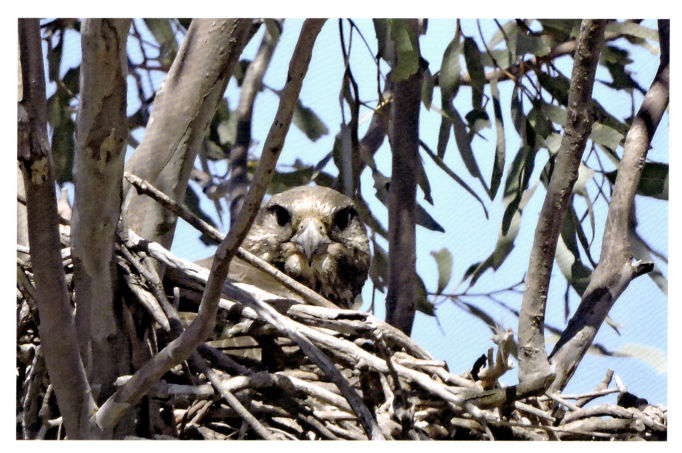
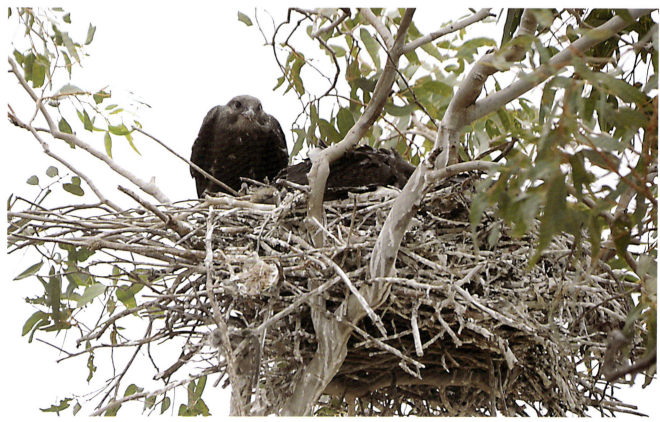

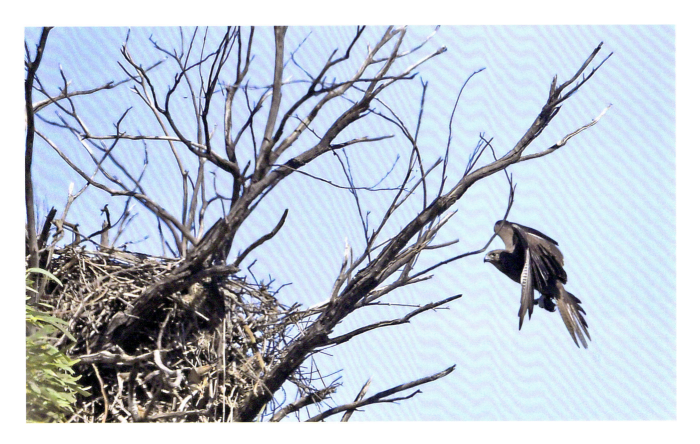

The Black Falcon doesn't build its own nest but uses one abandoned by corvids or raptors. Three or four eggs are laid, typically buff, profusely marked with dark brown or reddish brown freckles and blotches. When the chicks are born the white down is sparse, but a thicker coat, also white, appears during the third week. At about twenty-eight days chicks at one nest had reached a stage equivalent to eighteen days in a goshawk, and fledged at between six and seven weeks. In western Queensland channel country, where we have seen most of our Black Falcons, pairs breed early; the earliest I have seen eggs is the end of June, and the latest I have seen chicks in the nest is 7 September. In late August we photographed a female at its nest containing eyasses ready to leave (opposite below) during one of the periodic 'plagues' of Long-haired Rats. There were rat carcasses evident in some of our photos. Above is a female returning with food to an old Whistling Kite's nest on Eyre Creek, Qld. On a number of occasions in August we have recorded juveniles already confidently flying with adults (p. 179). Further east, breeding is later; at Windorah we found a nest with eggs being attended by a female on 27 August (opposite above). Further south, breeding is also later than in the channel country; at one nest near Hay, NSW, small chicks were being fed in August, and I was shown flying juveniles near a nest on Tom Brandon's property, presumably still being fed, late in the year near Port

Adult Black Falcons nesting at Winton, Qld (opposite above), Bedourie, Qld (opposite below), and Cuttaburra Crossing, Qld (top). Nestling Black Falcon at Hay, NSW (above).

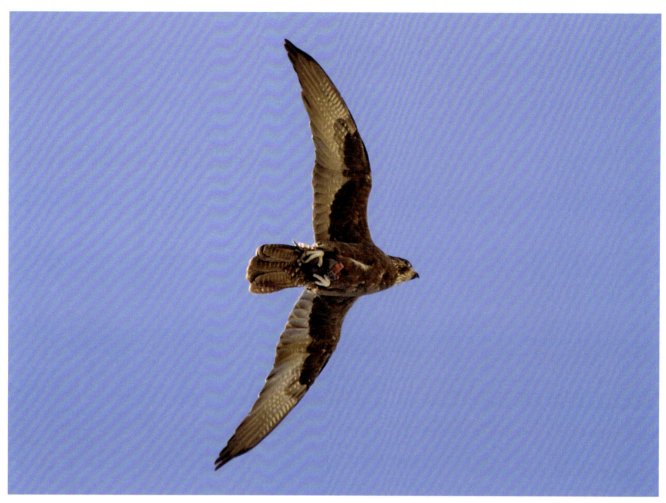
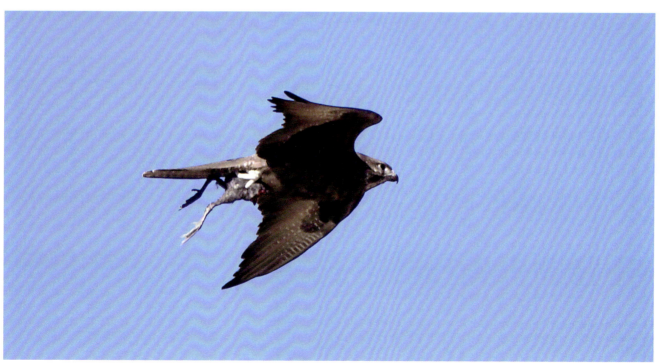

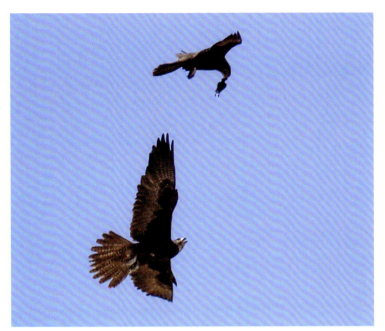

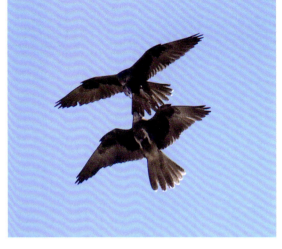

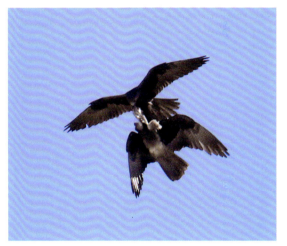

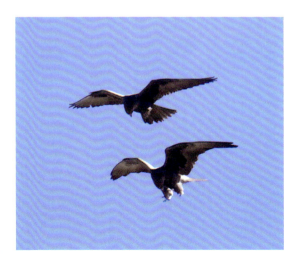

Augusta. I found a similar family group near Dalby, Qld, in late November.

We were able to watch a breeding pair on Eyre Creek on the edge of the Simpson Desert. They had chosen an abandoned Whistling Kite nest in a dead tree, so there was no shade for the chicks. Also, the site was alongside a bush track in a popular camping spot, causing a fair amount of disturbance from people walking or driving along the track looking for secluded places to camp alongside the creek. The falcons must have been aware of that before they chose the nest, so it was their decision. Consequently, our observations, made from a concealed position, could not be regarded as typical. For instance, the female spent most of her time perched above the nest rather than brooding the chicks, which were quite small when we first arrived. Apart from the occasions she was feeding the chicks, the only times we saw her on the nest during the day was for a few hours at midday, when she shaded her three offspring. We are pretty sure this is not normal behaviour, because at another nest we watched, the female stayed with her chicks even when they were due to leave. Just before sundown, the Eyre Creek female dropped down to the nest and covered the chicks for the night while the male perched in an adjacent tree.

Every hour or two during the day the female would begin calling, take off and 'ring up' quickly, a sign that her mate was approaching with food. Ringing up is a falconry term used to describe a falcon quickly making height with rapid wing-beats, a manoeuvre I find exciting to watch, particularly so with the Black Falcon. We were

Above: Male passing food to female, which she then took to the nest.

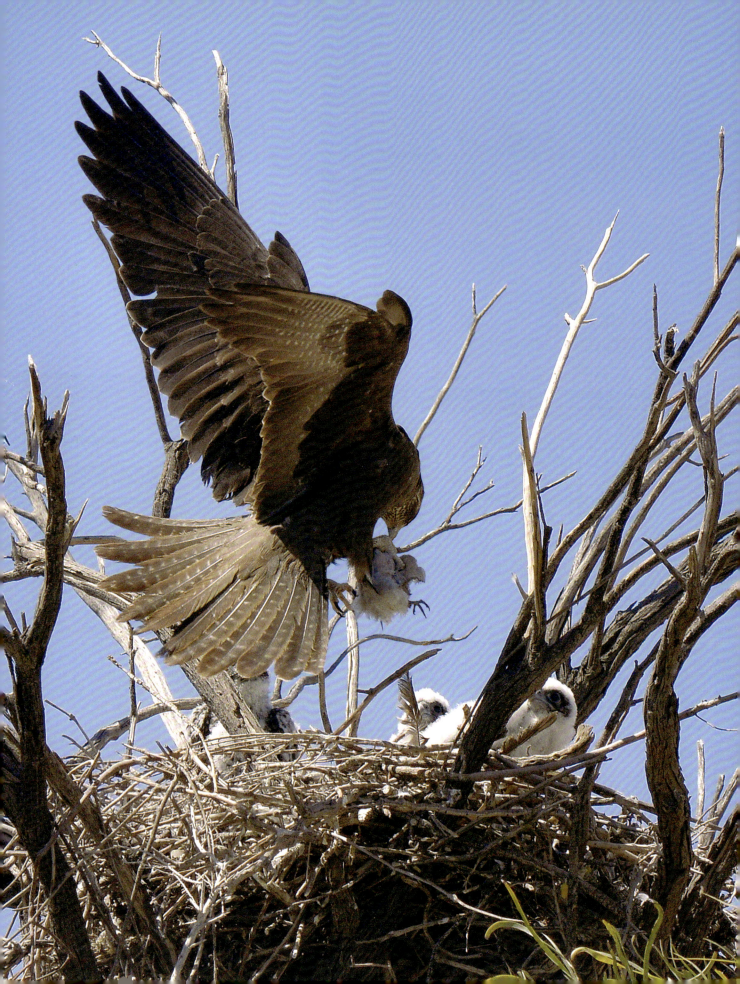

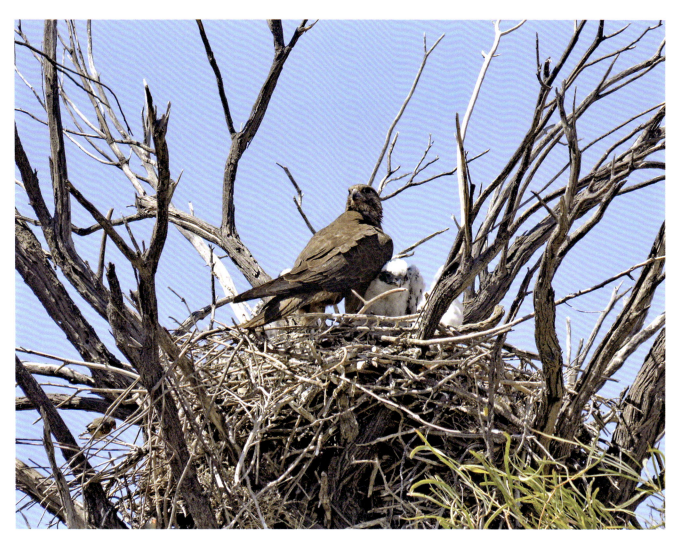

lucky enough to witness some food-exchanges in flight between the pair on Eyre Creek. The male arrived carrying the prey in his claws, in each case a deplumed bird. As the female approached, he transferred the offering to his beak and she flew up underneath and took the bird in her claws. She either first fed herself on a perch in a tree next to the nest before flying over to attend to the hungry eyasses, or flew directly to the nest, fed the chicks, then ate any leftovers herself. Several times the food was exchanged on a horizontal branch in the tree next to the nest. Only on a few occasions did the male linger after supplying food; usually he left immediately, heading off each time in a north-westerly direction. Because the quarry had been plucked by the male before delivery it was not possible to identify which species were involved, but in two of our photographs a foot of the victim is visible; in one case it appears to belong to a parrot, possibly a Cockatiel. The leg of the other one is long, and could be a Brown Songlark, although the hind toe looks too short; the leg is not long enough for a pratincole.

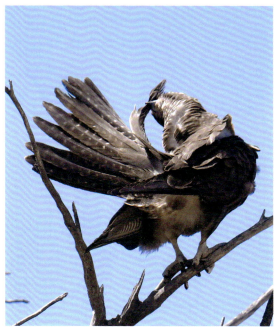

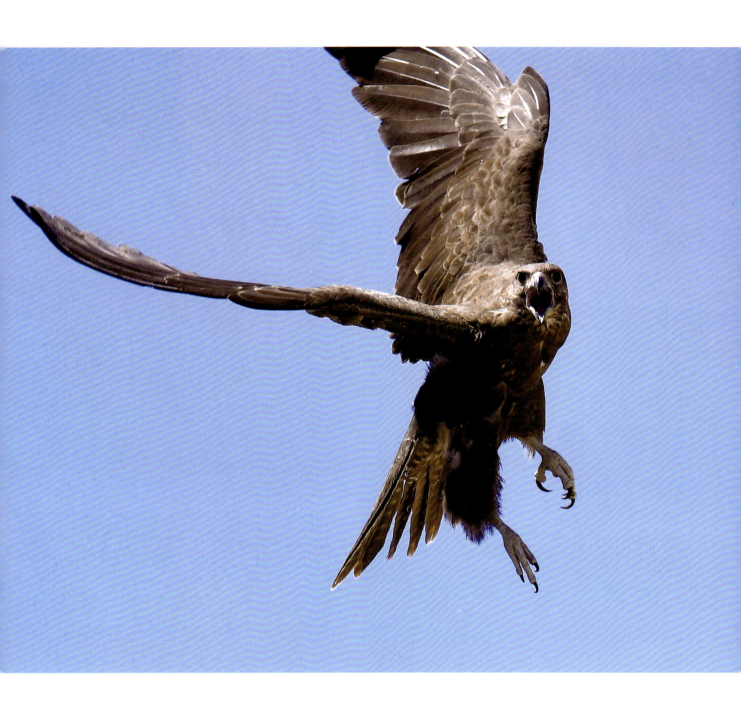

The female Black Falcon above looks as if she is flying straight at me, seated in a hide near her nest, but actually she has taken off to attack a Whistling Kite that got too close (opposite above). This is on Eyre Creek where there are plenty of these kites, but she only seemed to chase one in particular that was nesting on the other side of the creek. It was a different matter with Black Kites; she chased away any that came near the nest (opposite below).

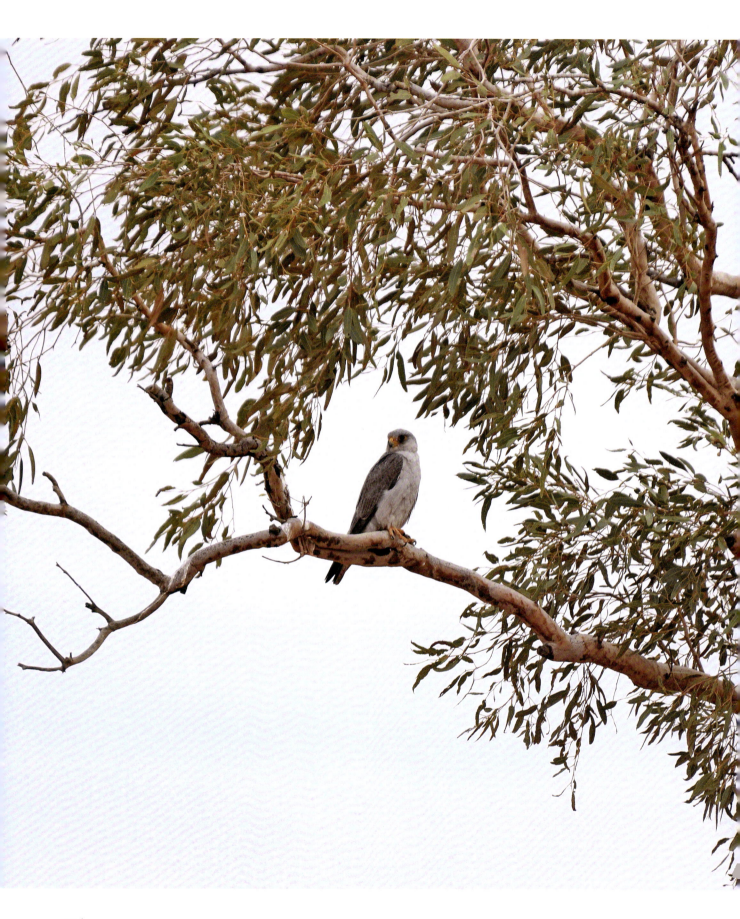

GREY FALCON
Falco hypoleucos Gould 1841

Falco hypoleucos Gould, *Proceedings of the Zoological Society of London*,
 viii, p. 162, 1841.
Gennaia hypoleucus Kaup, *Contributions to Ornithology*, p. 55, 1850.
Hierofalco hypoleucus Bonaparte, *Revue et Magasin de Zoologie*, p. 536, 1854.
Falco hypoleucus Gould, *Handbook to the Birds of Australia*, p. 24, 1865.
Falco hypoleucus ashbyi Mathews, *Austral Avian Record*, vol 2, p. 73, 1913.
Falco hypoleucus ashbyi Mathews, *The Birds of Australia*, v, p. 234, 1916.

The first known specimen of the Grey Falcon was an immature bird collected close to York, WA, by Lockier Burges (some accounts give the name as Lock Burgess). It was presented in 1839 to John Gilbert, who forwarded it on to John Gould. The bird was shown and described by Gould at a meeting of the Zoological Society of London in 1840, and published in the society's journal in 1841. In his remarks he likened it to a smaller version of the Gyr Falcon. In 1842 Gilbert collected a bird himself near the Moore River, WA. Charles Sturt's storekeeper, Mr Piesse, collected two at the Depot, near Tibooburra, NSW, in May 1845, and the explorer wrote a moving account: "A pair, male and female, were observed by him (Mr Piesse) on Sunday in May, whilst the men were at prayers, hovering very high in the air, soon afterwhich he succeeded in killing both... Nothing could exceed the delicate beauty of these birds when first procured. Their large full eyes, the vivid yellow of the cere and legs, together with their slate-coloured plumage, every feather lightly marked at the end, was quite dazzling; but all soon faded from the living brightness they had at first." Gould obtained both of Sturt's birds; Jonny Schoenjahn in an impressive, closely-reasoned account of the early Grey Falcon specimens, suggests that Gould then sold Gilbert's bird to the Earl of Derby. After the Earl died his collection formed the basis for the Derby Museum; the Grey Falcon specimen was for many years presumed to be lost, but was located in 2009 by curator Clemency Fisher following enquiries by Schoenjahn.

In 1841 Elizabeth Gould used Burges's juvenile specimen (the type) to prepare a lithograph for *The Birds of Australia*. Later, after Elizabeth died, John Gould decided to replace it with a lithograph by Henry Richter of both adult and juvenile, probably Sturt's, as well as an amended text. Elizabeth's lithograph is regarded as 'suppressed'.

When Gould's large collection of birds was sold to the Academy of Natural Sciences of Philadelphia, the specimens went first to the Verreaux brothers in Paris for preparation in 1847, thence to the academy in 1849. One of the Grey Falcon specimens did not arrive at the academy; Schoenjahn makes a credible case that this missing specimen is the type. Rodolphe Meyer de Schauensee in a discussion of Gould's types in the academy used the name Gray Falcon, and listed a juvenile, probably the one collected by Piesse, as the type.

A number of authorities who later wrote about the Grey Falcon, including Gould himself, wrongly spelt the specific name *hyperleucus*. In 1913 Mathews

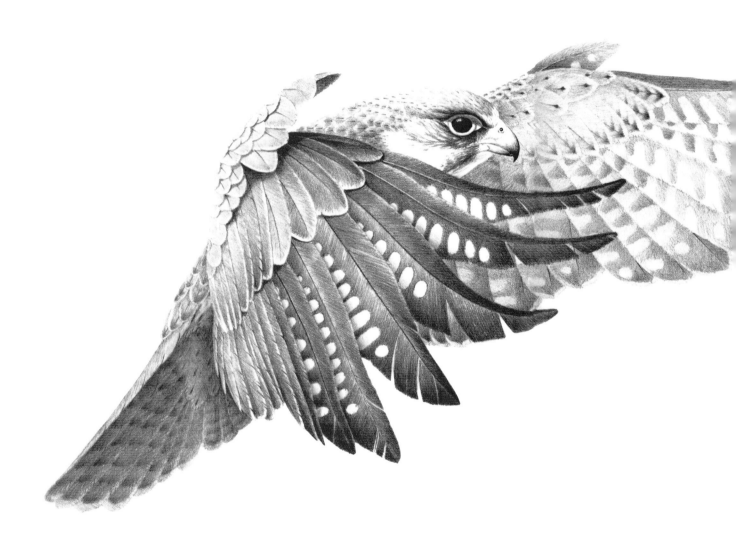

described a subspecies, *Falco hypoleucus ashbyi,* calling it the Eastern Grey Falcon. From his notes, it appears Mathews compared Elizabeth Gould's 'suppressed' lithograph of Lockier Burges's bird with Richter's later lithograph in John Gould's *The Birds of Australia* and thought there was sufficient difference between the two artworks to warrant a subspecific name. However, there doesn't appear to be enough variation to deserve the name.

...one of the most beautiful birds I ever gazed on.
John Gilbert, 1842

I remember one day the day of all days
 In summer's shadeless shimmer and horizon's heat haze
 Fast flying flicker of ghost grey wings
It passes too quickly my happy heart sings

To read a description of its plumage, or to see a specimen in a museum, leaves one totally unprepared for the dramatic impact of one's first view of the Grey Falcon. Being almost wholly grey it is a bird that one might expect to be rather anaemic looking, a bird of icy wastes or snowy mountains. But I remember seeing it first in more than forty-degree heat coming towards me out of a shimmering mirage, appearing and disappearing in the waves of heat bouncing off a Kimberley claypan, becoming less illusory as it approached, acquiring solidity with proximity, transmuting into the bird I most wanted to see, its grey plumage not the wisp of smoke I'd expected but a compact cool bundle of dynamic energy. Its dark yellow-ringed eyes stared down at me as it flew past twenty metres away and I watched, elated, but with frustration as it disappeared back into the quivering heat haze all too soon.

 Having seen one, Pat and I spent the next few weeks investigating old tracks through the pindan and along the edge of the Fitzroy River floodplain, passing gnarled baobab trees with massive trunks, looking so ancient they could have been old when William Dampier landed nearby at Roebuck Bay in 1697. However, Mr Archer, who was the mayor of Derby, told me a very large one at the sports ground was planted by him when he was a boy, perhaps sixty years before, so maybe they are not as old as they look. Many of the baobabs in the pindan held either Black Kite or Whistling Kite nests and we were hopeful of finding a pair of Grey Falcons using one. We eventually came across a pair out towards the leprosarium, where one of our students from the Derby State School was being treated. Over the next three years we located three more pairs, but the nests they used were inaccessible and we were unable to photograph them; the equipment we had at the time wasn't much help either. Back then we knew very little about the Grey Falcon, including the fact that they require very large territories, so we didn't think it was unusual to find so many in a relatively small area, about thirty kilometres long by ten kilometres wide. It is probable that the multitude of doves in the area was the explanation. There were several waterholes we knew of and often saw at least one Grey Falcon hunting at one or the other.

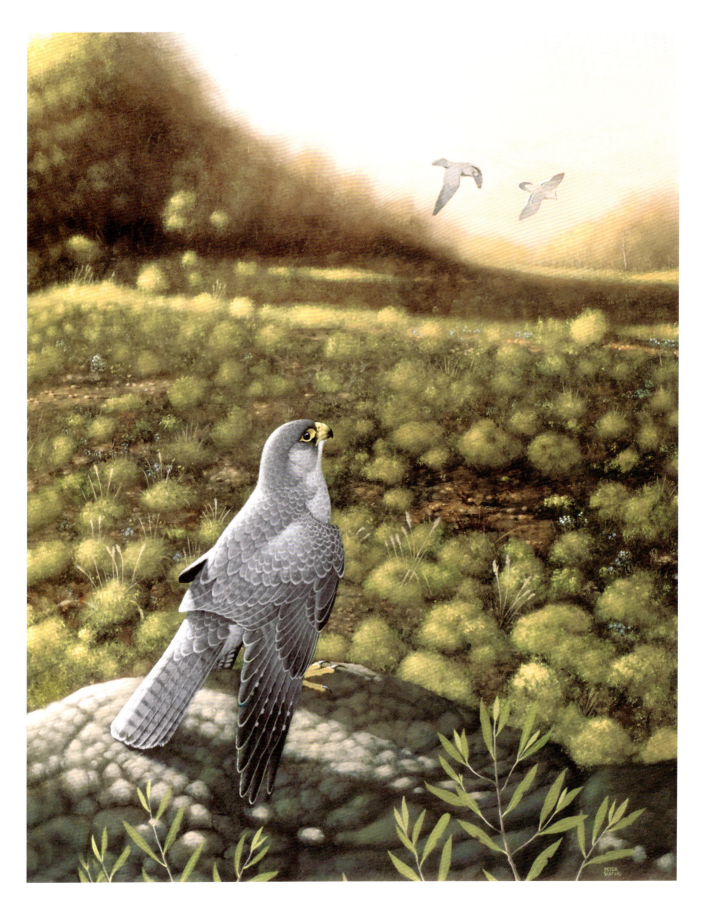

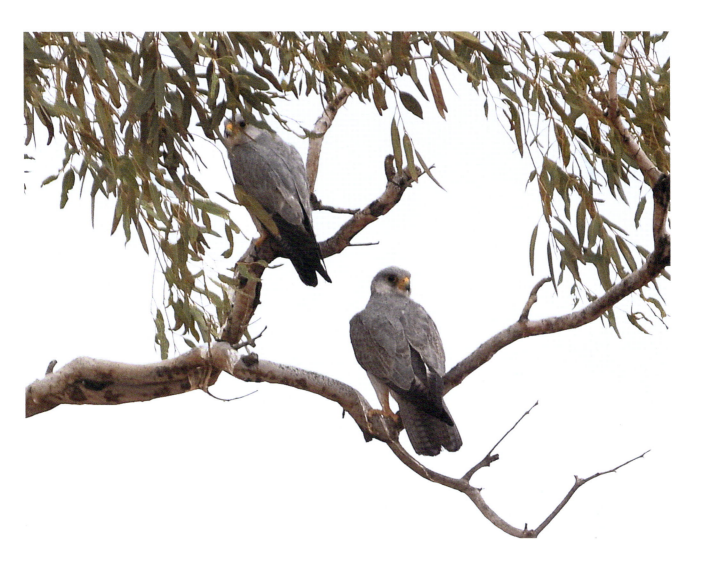

In flight the Grey Falcons we have seen appeared rather reminiscent of the Peregrine, with rapid wing-beats and tail often slightly fanned, but comparatively less heavy-looking, with seemingly longer wings, broader at the base, and longer tail. A female Grey Falcon weighs about the same as a male Peregrine, but has wings and tail about two centimetres longer. When I saw a trained juvenile Barbary Falcon in the United Arab Emirates, I thought it similar to the Grey; when I checked measurements later I found that the wings and tail of the two are about the same length but the Barbary weighs substantially more so is more compact. The head of the bird I saw was smaller, and the 'trousers' didn't cover the legs to the same extent as the Grey; in fact, the Grey's trousers are more like the Gyr Falcon's. One remembers that Gould thought the Grey Falcon was like a small Gyr Falcon, Gurney likened it to the Lanner, and Peters to the hobbies. Some German falconers visited me and when I showed them the Cuppers' photos said: "Oh, it's just a kestrel!" They may have been thinking of the African Grey

Most of our admittedly limited sightings of Grey Falcons have been of pairs. One pair (above) was near Tibooburra, north-western NSW, not far from where explorer Charles Sturt's storekeeper, Mr Piesse, collected a pair in 1845.

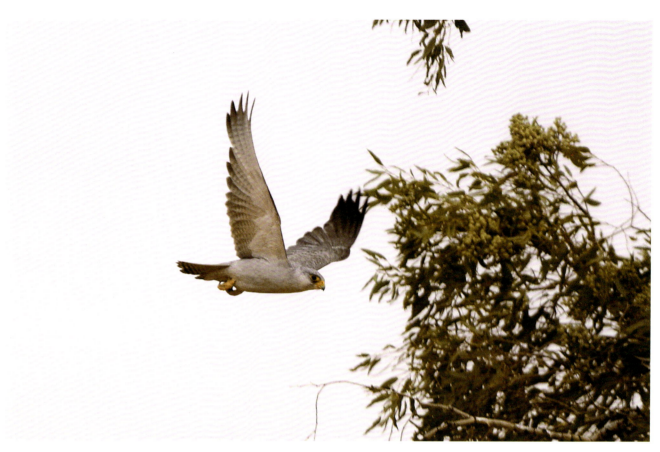
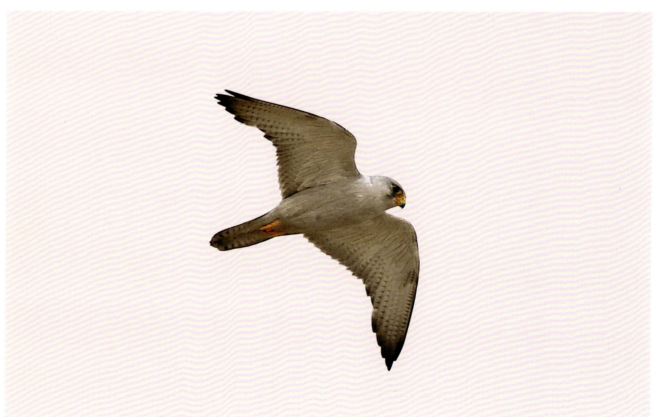

Kestrel. Anyway, so much for opinions. Back in 1989, Penny Olsen and co-workers with more scientific methodology (a comparison of feather electrophoresis, before the DNA techniques of today) suggested the Grey, Black, Brown and New Zealand Falcons derived from a shared ancestor, a conclusion I am not really happy with, depending on how far back in time the ancestor was. I had the opportunity to hold a Barbary in Dubai while a vet was administering medication; I remember thinking: 'This bird is pure muscle!' Much the same thought came to me when I held a Grey. The juvenile Barbary has much the same plumage pattern as a juvenile Grey, but brown, not grey; in the Australian bird the markings on the breast and abdomen are much reduced, but involve much the same feathers. In the field the Grey Falcon appears to have a bigger beak, but I think that may be an illusion caused by the yellow colouring of the cere extending onto the beak; in other falcons the yellow, if present, is confined to the cere and, in some, the base of the lower mandible. Some other observers have suggested the Grey is lethargic in flight, preying on ground mammals and insects, but that is not the case in my limited experience.

Near Derby we were lucky enough to see Grey Falcons hunting on a number of occasions. The prey we saw taken each time was a dove, either Peaceful or Diamond; we also witnessed Grey Falcons

*Above: Peter's last unfinished painting,
'Grey Falcon chasing a Cockatiel.'*

chasing Cockatiels, Crested Pigeons and Flock Bronzewings without recording a kill, but at one of the nests in a baobab we found feathers of all three as well as those of Galahs. One would have thought a Flock Bronzewing might be a bit much to handle, but Common Bronzewing is listed among the prey as well as similarly sized fast-flying birds such as Crested Pigeon and domestic pigeon. At no time did we see Grey Falcons taking reptiles, but other observers have; possibly around Derby there are so many easily-caught small doves that reptiles are of less importance.

Some memories of our time in Derby: Pat and I were sitting hidden among some vegetation at a small waterhole near Munkejarra when a pair of Grey Falcons arrived. They circled overhead for a few minutes at a height of about a hundred metres. A Diamond Dove that should have known better alighted to drink only a few metres from where we sat and one of the falcons stooped, straight down, absolutely vertical, incredibly fast. The dove took off and was knocked by the falcon into the bushes alongside us, still alive and fluttering. The falcon flew in a tight circle, landed on the ground beside us, almost close enough to touch, and, for such an elegant bird, waddled rather clumsily into the bushes after the dove, which was grasped in one foot and rapidly killed with the beak; the neck was broken just behind the head. Carrying the dove in its beak, the falcon backed out of the bush, transferred its victim to a foot then took off, circling straight up where it was joined by its mate and the pair soared out of sight.

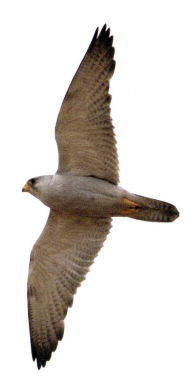

Top: Queensland Museum skins showing Grey Falcon dimorphism, with the larger female above. Above: A Grey Falcon on a grey, dusty day.

This grandstand view was re-enacted for us some months later at Munkejarra waterhole, where virtually the same thing happened, and the same sequence of events occurred. On every occasion (in fact, not all that many) we saw a Grey in the Kimberley make a kill, the victim was first knocked spinning to the ground, then picked up and carried away. We have seen all the other fast falcons knocking their prey in similar manner, but in each of these species we have also seen them often bind to their victim, that is, strike, clutch and hold it in mid-air, to be carried away and consumed on a convenient perch.

There was one occasion, many years later and a thousand or more kilometres away, when Sally and I did see a Grey Falcon bind to its quarry. While we were camped just outside Boulia, the flowering eucalypts were full of Masked and White-browed Woodswallows. One afternoon they all took off in a hurry and started to make height. A few moments later, a pair of Grey Falcons whizzed past just above the tree-tops. They too began to thermal up, just below the woodswallows and we watched them soaring higher and higher. One of the woodswallows must have panicked because when they were two or three hundred metres up a falcon swooped (above), grasped its luckless victim and continued soaring, eventually moving away out of sight with its mate.

I don't know how often Greys need to drink; much of their range is in arid country where there is limited access to water for much of the year. Perhaps their overall scarcity and the large size of their territories is dictated by availability of water as well as by suitable prey. In the west Kimberley where we found four pairs in a relatively small area, there was plenty of surface water throughout the year and a plenitude of small doves.

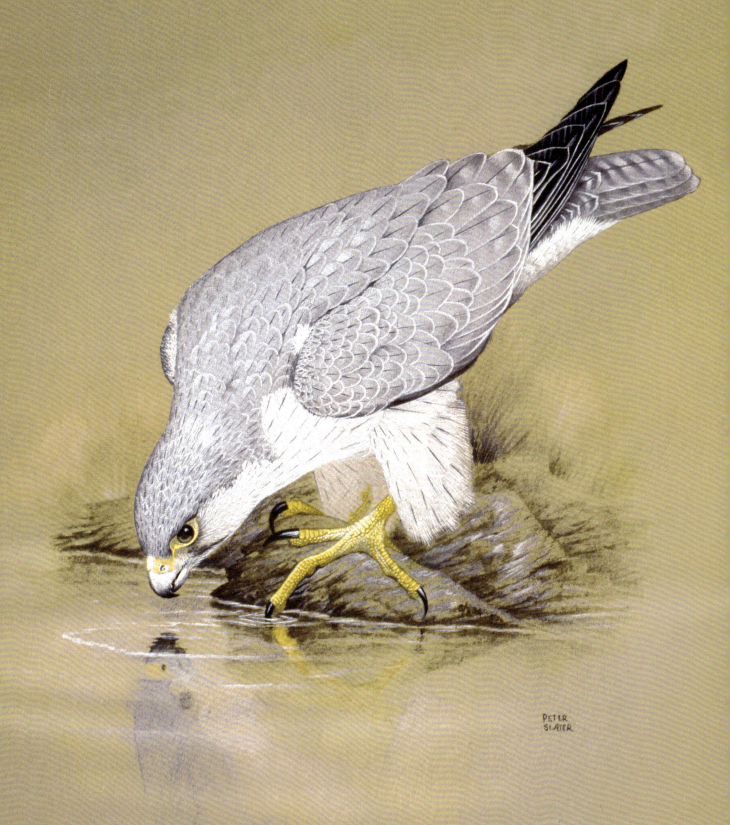

PEREGRINE FALCON
Falco peregrinus Tunstall 1771

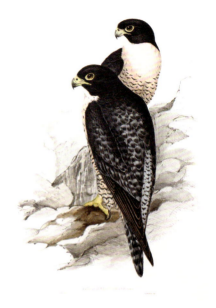

Falco peregrinus Tunstall, *Ornithologia britannica*, p. 1, 1771.
Falco peregrinus Vigors and Horsfield, *Transactions of the Linnean Society*, xv, p. 183, 1826.
Falco macropus Swainson, *Animals in Menageries*, p. 341, 1 January 1838.
Falco melanogenys Gould, *Proceedings of the Zoological Society of London*, p. 139, 1838; *Synopsis of the Birds of Australia*, ii, 1838.
Falco peregrinus submelanogenys Mathews, *Austral Avian Record*, i, p. 33, 1912.
Rhynchodon submelanogenys Mathews, *The Birds of Australia*, 1914.
Falco peregrinus macropus Hartert, *Novitates Zoologicae*, xxii, p. 174, 1915; Swann, *Synopsis of the Accipitres*, p. 201, 1922; *Monograph of the Birds of Prey*, ii, p. 393, 1945.

The Peregrine occurs in one form or another in most parts of the world. Its scientific name, *Falco peregrinus*, was first used by Tunstall in a small publication listing the birds of Great Britain, but without a description. George Caley collected one while he was in Australia in the early 1800s. Vigors and Horsfield examined it at the Linnean Society's museum and wrote: "Upon a minute comparison of the specimen before us in the society's collection, which is in a fine state of preservation, with some European specimens of this species, we can discover no material difference between them. The native name is *Wolga*".

Swainson thought otherwise when he received a specimen from T Winter esq, collected in Tasmania, and, considering it to be a new species, named it *Falco macropus*. He remarked that the feet and beak were very large, hence the name *macropus* (= large foot), and stated that it was a perfect adult bird. However, his description appears to fit a juvenile. At about the same time, 1838, Gould described a bird he received from Australia, possibly collected by his Coxen brothers-in-law, giving it the name *Falco melanogenys*, but as Swainson's name appeared first, currently Australian Peregrines are classified as *Falco peregrinus macropus*. Gould's name was used in many books, including North's *Nests and Eggs of Birds found Breeding in Australia and Tasmania*, Campbell's *Nests and Eggs of Australian Birds* and Gould's own publications.

Gregory Mathews described a bird from south-western WA as *Falco peregrinus submelanogenys*, the Western Black-cheeked Falcon, in 1912. The accompanying description refers to "much more rufous underparts and larger size" although no measurements are given. In *The Birds of Australia*, 1914, Mathews included this bird as a separate species, the Western Australian Peregrine Falcon, *Rhynchodon submelanogenys*, with an illustration by the famed raptor artist, George Lodge. Birds with dark rufous underparts have been recorded elsewhere in Australia and may represent a rare dark morph, so Mathews's name could be invalid. Males I have seen in the south-west seem smaller than eastern males I've come across. Some males from the Murchison River, WA, that were used by the Longwings team at Mascot Airport for gull control, were tiny, about the size of a female

Above: H C Richter's lithograph from Gould's The Birds of Australia, *1848. Below: George Lodge's illustration of a south-western bird from* Birds of Australia *by G M Mathews.*

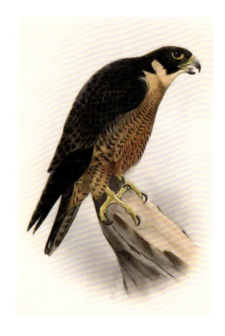

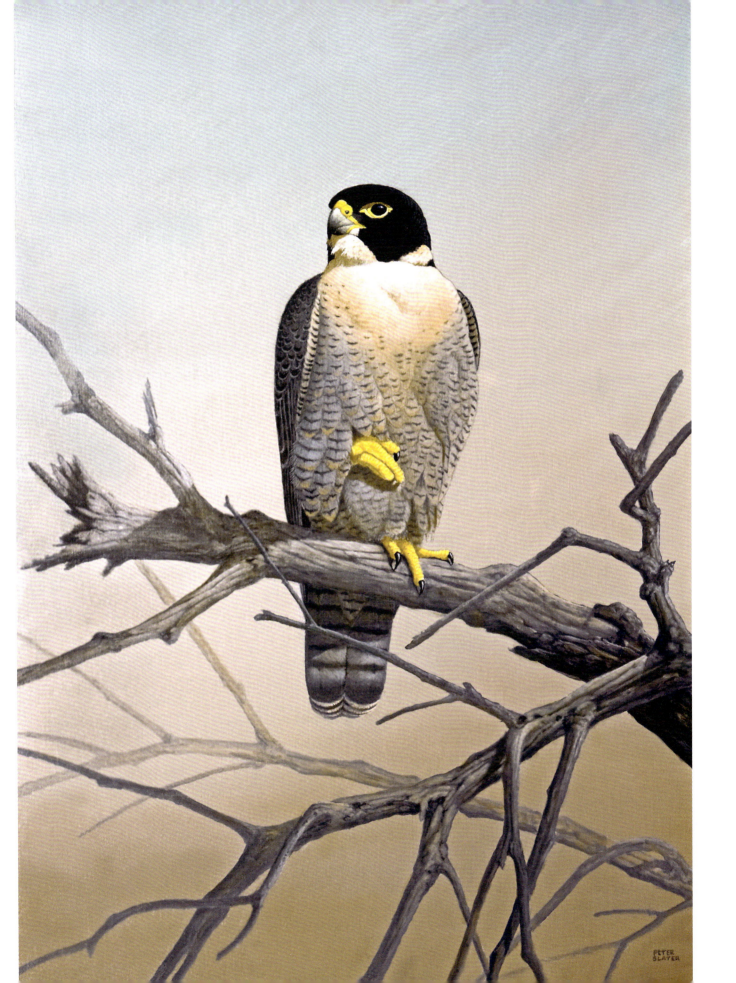

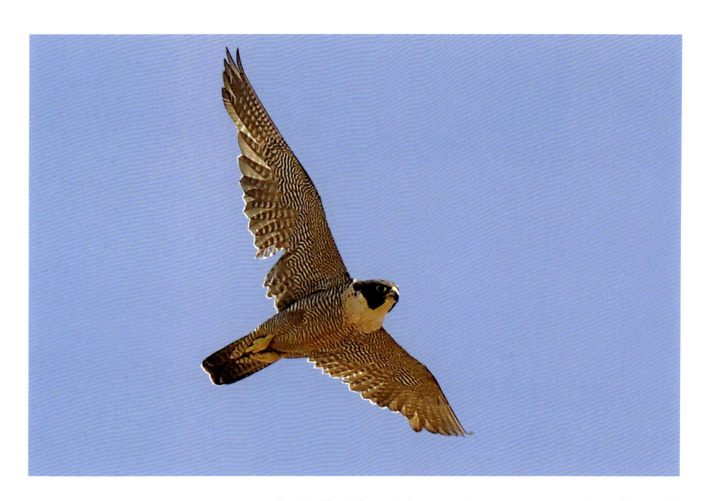

Australian Hobby. White, Cade and Enderson in *Peregrine Falcons of the World*, suggest that *submelanogenys* is a valid subspecies on the strength of isolation in the south-west, coupled with a sedentary nature. One of their arguments is the paucity of cliffs in the desert between the south-west and SA, but there are records along the cliffs around the Great Australian Bight, and Peregrines are well-known to breed in Wedge-tailed Eagle nests well away from cliffs. DNA analysis should settle the matter.

'The Peregrine could be called the world's most successful flying bird…'
 Brown and Amadon, Eagles, Hawks and Falcons of the World.

The Peregrine Falcon is generally hailed as the most perfect combination of strength, health, speed, variety of flight and courage of all birds… Moreover, another fact adds to the unique position of this falcon…, she is found in nearly every part of the world, a true cosmopolite.
 Casey Wood, translator of De Arte Venandi Cum Avibus.

I am in good company when I declare my unqualified enthusiasm for the Peregrine Falcon, for wherever one looks in the literature one finds untempered praise, from monarch, scientist and layman alike. It is a bird that elicits superlatives.

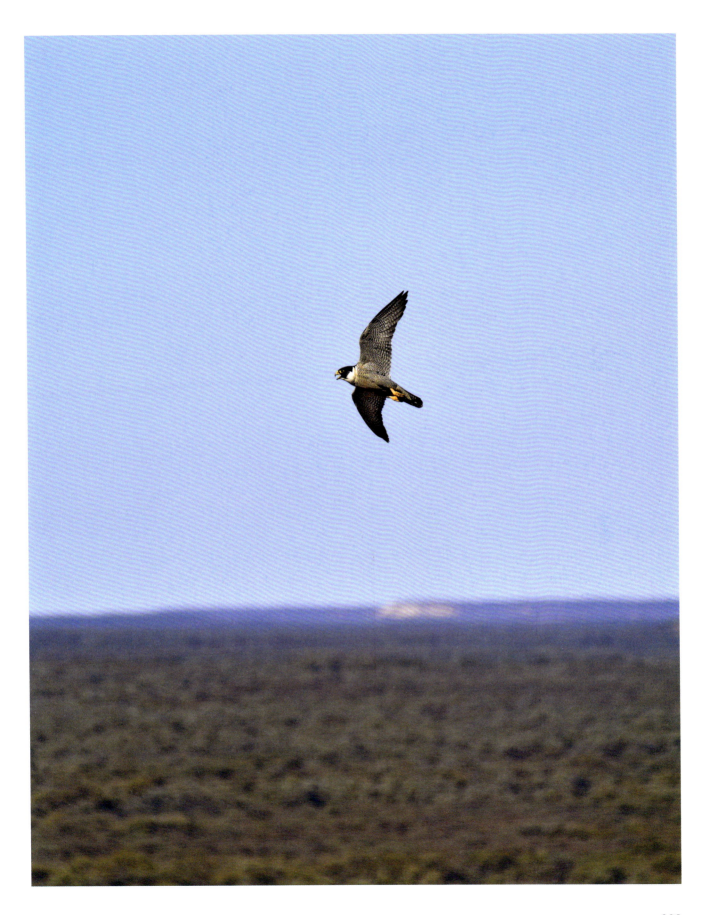

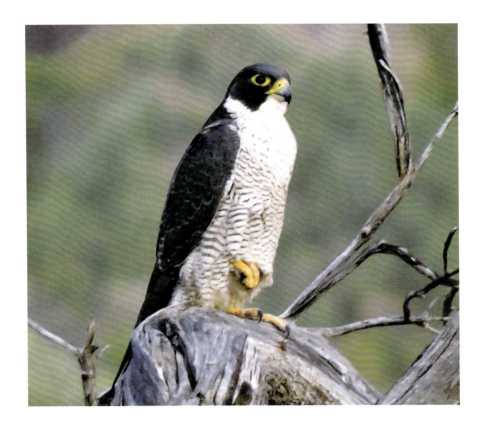

I remember every encounter, etched into memory like an intaglio print by Rembrandt, but, looking back, nowhere near enough; sometimes there will be twelve months when I don't see one, a period I regard as a drought year. But among the many droughts there are other years of plenty, like the time a wild Peregrine and I shared a daily relationship that lasted for nine months. So all of those moments when one comes into view, even fleetingly, are precious, retained among my synapses to be retrieved later with unappeased visual hunger.

My first close encounter was on an island off Esperance, WA. In January 1956 Eric Lindgren and I arranged for a large boat to take us out into the Recherche Archipelago where we planned to spend a week or so on Lion Island. As we approached the island, a pair of falcons took off from the cliff face. Eric and I leapt ashore, and, as our skipper Don Mackenzie later reminisced, "hared up the cliff face like a pair of mountain goats, yelling: 'Peregrines, Peregrines'." In those days, more than sixty years ago, we pronounced the name 'Pere-green'; nowadays it's 'Pere-grin' (occasionally I come across someone who rhymes the name with 'fine'). Once we had set up camp on the only level patch, we went exploring and found a

Above: An old female Peregrine Falcon at a nest site in western Qld. This bird had the palest underparts we have encountered. Two years later we checked the same eyrie, but her place had been taken by a more typical, and probably younger, bird.

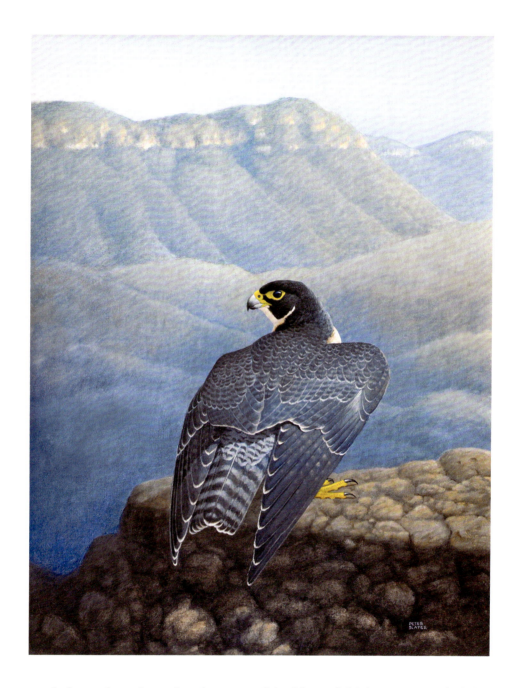

platform where obviously at least one of the falcons fed. The remains included feathers of Rock Parrots and legs of White-faced Storm Petrels and Little Shearwaters. The falcons were absent during most of the day but came back later to roost. During the night I remember storm petrels landing on my sleeping bag, returning to their burrows among the vegetation. Next morning just before sunrise I was woken by a Singing Honeyeater calling from a bush only a metre from my head. A Peregrine appeared in the sky a hundred metres away, directly behind the honeyeater, then stooped, screaming an indrawn *ee-aargh*, straight at the bird and incidentally, at my head. In the space of a second I watched the falcon magnify alarmingly, saw in the time it takes a heart to beat the eyes grow from dots to yellow-rimmed marbles, and felt something of the onrush of

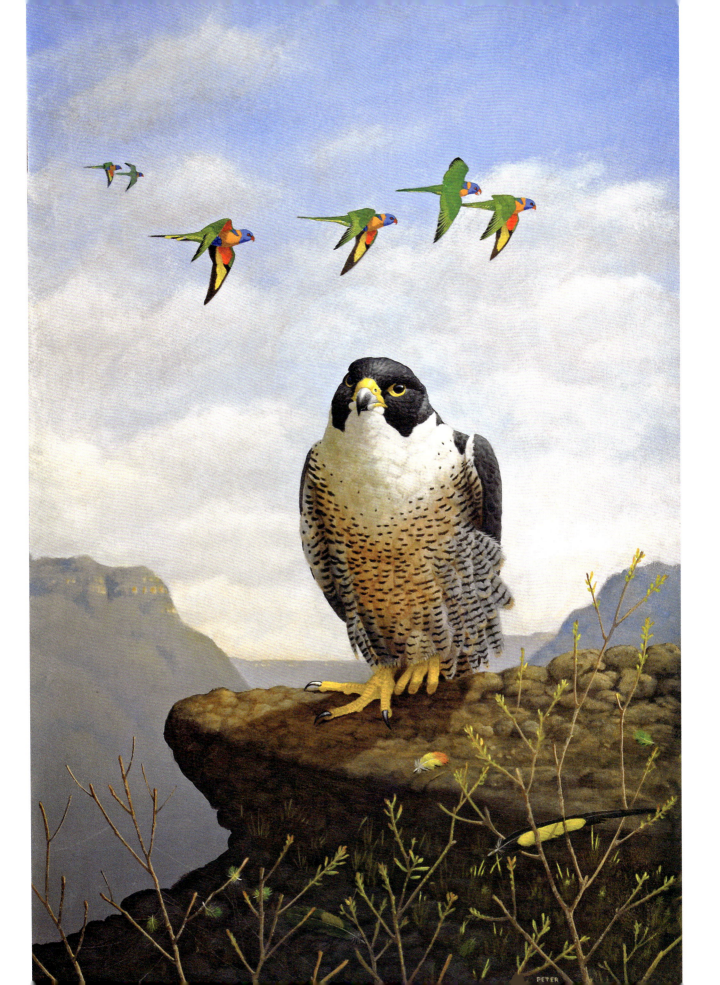

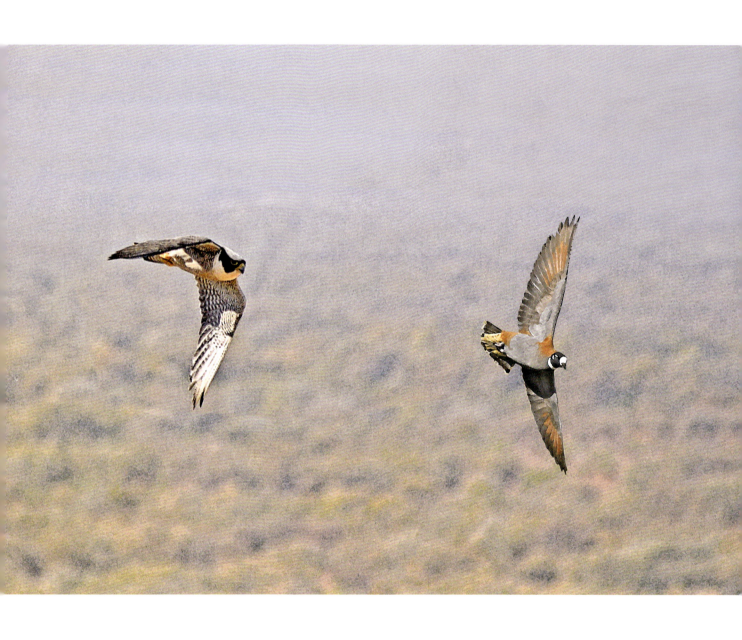

inevitable doom that the Peregrine's victims must feel. Apparently paralysed the honeyeater waited atop the bush, but at the last moment dropped into the thick foliage and the falcon whistled over my head, seemingly within inches, with roaring wings and deafening scream. Both Peregrines then raced around the island about a metre above the rock-face, following all of its contours at high speed, a manoeuvre they performed each morning while we were there. They were both adults with blue backs and barred breasts; if they had bred that year the chicks had already left.

As a hunter the Peregrine has an awesome record of success; most of the prey recorded consists of birds, but occasionally rabbits are taken as well. On one occasion I was in the bush near Katanning, WA, with a tame Square-tailed Kite. I used a stuffed rabbit skin as a lure to bring it down after it had spent half an hour or so soaring among the trees. We startled a real rabbit and the kite gave chase, probably thinking it was the lure. A Peregrine appeared from nowhere and stooped at the rabbit, just missing the kite, saw me and decided to try elsewhere. The kite hurried back to me and sat on my glove, huddled close. It was the only Peregrine I saw in the district; a farmer near Katanning told me he had shot a Peregrine because it was "killing his miners". Perhaps that's why.

Peregrines are remarkably efficient hunters; a particular instance I recall happened one morning while I was seated in a hide watching an eyrie. The female, who was attending the chicks, began calling. The male was on his preferred perch in a dead tree nearby. He took off and returned seven minutes later with a Dollarbird, which he plucked and delivered to his mate.

Despite its prowess as a hunter the Peregrine is not always successful. Near Lake Biddy, WA, Ray Garstone and I spied a Peregrine perched only a few meters up in a low tree. As we approached it left the tree and sped, almost touching the ground with its wing-tips, towards a small salt lake where a raft of Grey Teal was feeding about twenty metres from the bank. As the falcon burst into the ducks' sight they dived, just in time, so quickly that they sent up a tremendous splash of water that caused the Peregrine to shoot up into the air. I made a rough sketch in my notebook and later used it as a basis for a painting. While I was at Pajinka, near the tip of Cape York, I often sat watching the Peregrines flying around nearby York Island. There was a constant stream of Torresian Imperial-Pigeons flying between their nesting islands further out and the mainland where they feed. On a particular morning, one of the Peregrines began circling the island, soaring and quickly

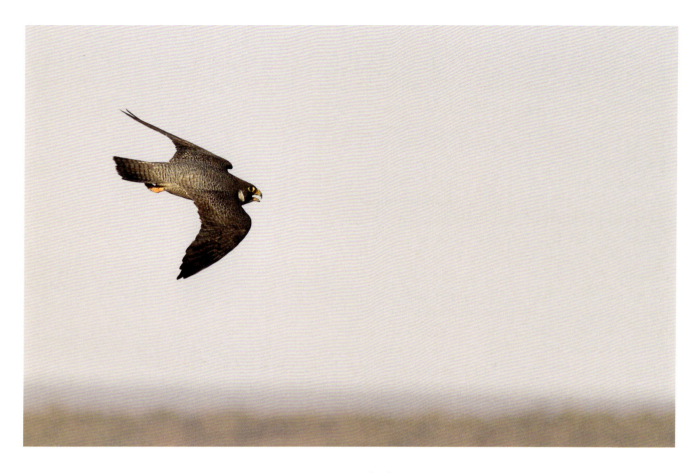

gaining height, probably assisted by updrafts from the steep cliffs. As soon as it reached a considerable height it turned and began to fly very, very fast on a shallow trajectory out over the ocean. I could see it was aiming at an imperial-pigeon flying quite low, heading to the mainland. As the falcon approached, the pigeon took the only alternative to assured destruction and ditched into the water. The sea was quite rough, and the falcon made several unsuccessful attempts to retrieve its intended victim, flying around in tight circles for a while then headed off back to the island. I watched for half an hour but didn't see the pigeon make it back into the air, so I presume it eventually drowned. A few days later we saw one of the Peregrines on the ground near the Pajinka Lodge, feeding on an imperial-pigeon, surrounded by white feathers. I've read somewhere that these pigeons often feed on a particular rainforest fruit that taints the flesh with an unpleasant taste. It certainly didn't seem to bother the Peregrine that day.

At Werribee, Vic, I watched a juvenile Peregrine chase and catch a Little Raven with no difficulty (above). A few days later in the same locality the falcon attacked an Australian Raven, knocking it to the ground near a flock of sheep. When the falcon landed the raven fought back until it was held down. Then another raven, presumably its mate, arrived and tackled the falcon, which released its hold and both ravens fled into the flock of sheep, where they remained hidden.

During the first few months we lived on 'Wallace Brae' near Guluguba, Qld, an adult Peregrine appeared each evening just before sunset flying low at high speed, taking the same course over the ox-bow bend of Guluguba Creek

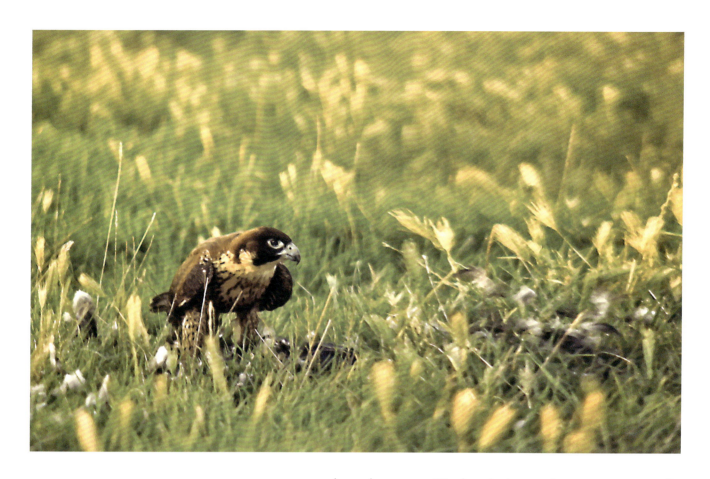

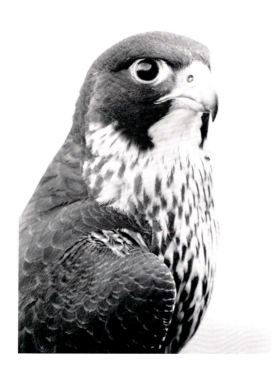

and a rushy swamp. We thought it must have a nest not too far away and spent a lot of time investigating without success. Then in April a juvenile Peregrine took up residence on the creek with a regular perch in a large tree about fifty metres from our home. Each morning when my dog and I went for a walk, the falcon would follow and chase anything we put up. So began a relationship that lasted for the rest of the year, a memory as precious as any other. Many times, the falcon chased ducks without appearing to have any intention of making a kill. Once, quite close to me, it flew behind a Maned Duck, then turned almost upside-down and grasped the duck's foot, flipping it over. The duck seemed to lose all coordination and fell to the ground, flopping around for a few seconds while the falcon landed in a tree. I walked over to the duck which was unharmed; it half fluttered, half flew away just above the ground. The falcon watched it go and made no attempt to follow. On another occasion, a flock of Sulphur-crested Cockatoos arrived and flew around above the falcon. I expected it to use its speed to escape but it just flew slowly in a circle looking up, with the cockatoos keeping directly above squawking loudly. It landed in a dead tree, and the cockatoos settled on the branches above. After some noisy moments the cockatoos abandoned their harassment and departed. A few minutes later the dog flushed a Pacific Black

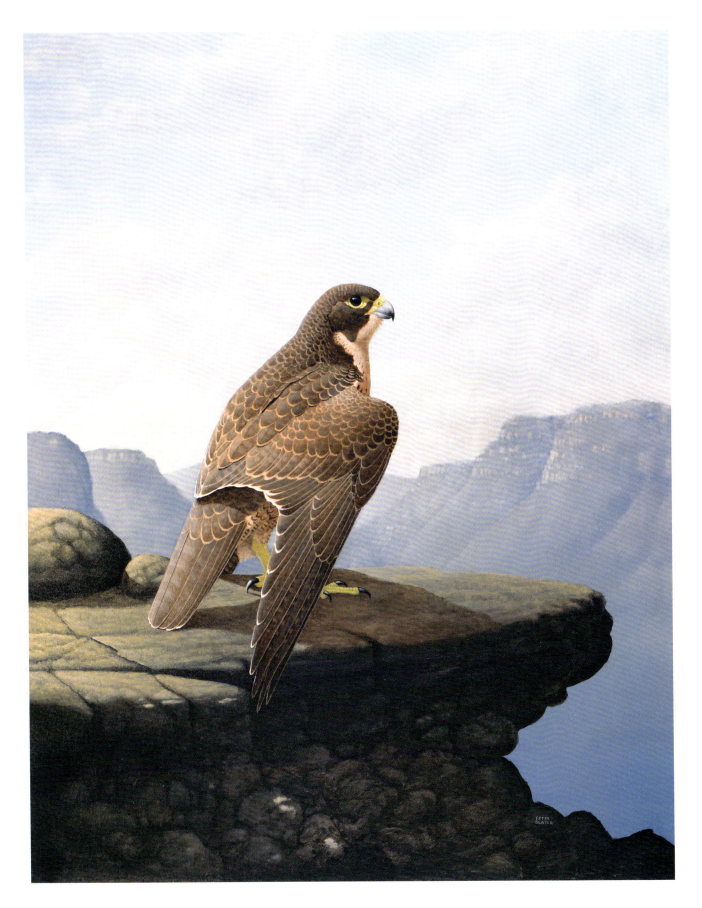

Duck which headed towards the rushy swamp four hundred metres away. When it had gone at least two hundred metres the falcon took off and in the most electrifying burst of speed I have ever seen hit the duck before it reached the swamp. I had this anthropomorphic fancy that it had been embarrassed by the cockatoos and just wanted to show me what it could do.

Another fancy the falcon inspired was that Peregrines can 'read the wind'. On 16 August the dog flushed a snipe, which surprised me because I thought it was a bit early in the year to see migrating snipe. Anyway, it leapt up in typical zigzag fashion, rapidly making height, heading south. The Peregrine took off and headed due west. I wondered what was going on. Both birds continued ascending, seeming to get further and further apart; I kept switching my gaze from one to the other. Then the falcon turned abruptly and headed due south at incredible speed, rapidly overtook the snipe, bound to it and returned, taking a leisurely meal in the tree above my head. I fantasised that it had detected a gust of wind that it exploited with such dramatic effect. I remembered this event when I was in the United Arab Emirates many years later. Sheikh Sultan bin Zayed Al Nahyan had invited Pat and I into the desert to see his falcons being trained. We spent a fortnight with half a dozen of the sheikh's falconers among the desert dunes; most of the birds were captive-bred Gyr Falcons. Training involved flying a huge kite with a feather-covered lure tied to it. The kite was attached to a revolving drum with what seemed like a kilometre of rope. Towards evening a strong wind blew up and the kite was released, eventually flying at a hundred

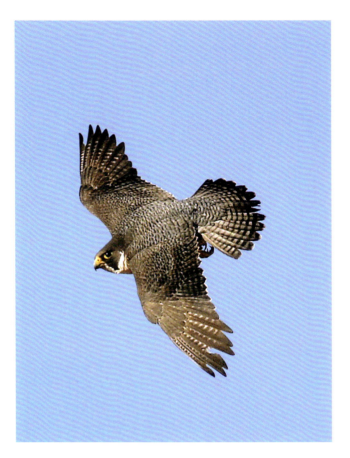
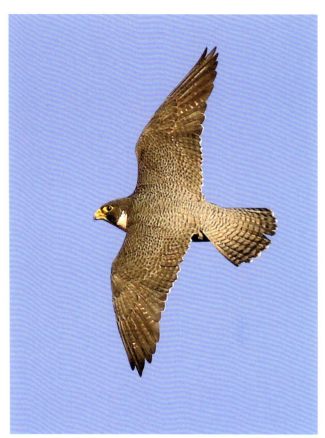
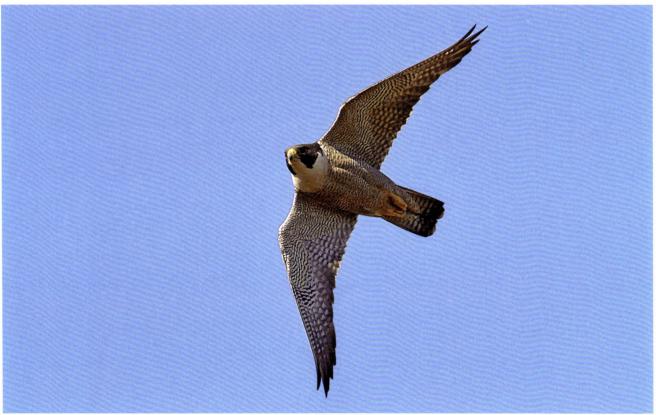

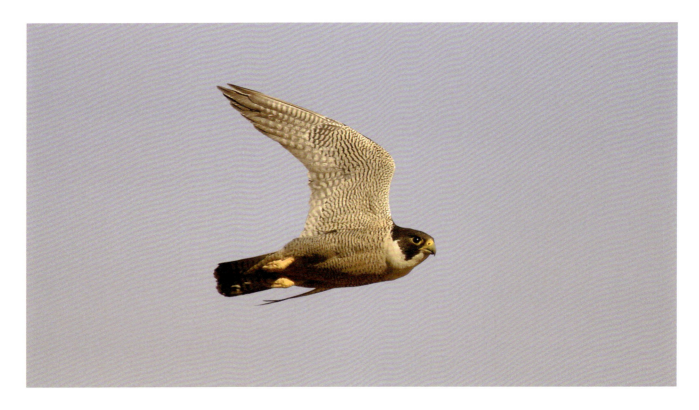

or more metres above the ground and several hundred metres away. Each Gyr was released in turn, flying in wide circles to gain height until it reached the kite and hit the lure, which was released by an ingenious ratchet so the falcon could land with it and be fed. The kite was reeled in, another lure attached and run out again. In this way each of the Gyrs had five to ten minutes of strenuous exercise. One evening, in a nice gesture, I was given a Peregrine to release at the lure; it had been captured recently on migration from the Arctic to southern Africa. When I cast it off, instead of making height as the Gyrs had done, it headed off over the desert, only five metres or so above the sand. 'Yippee,' I thought, 'it's gone, on its way to Africa.' Then it approached a large dune about half a kilometre away and caught an updraft; with hardly a wing-beat it zoomed up to the kite and hit the lure. Obviously a very experienced bird. Had it seen the updraft? I like to think so. My already enormous respect for the Peregrine as master of its environment went up another notch.

The feature of the Peregrine that elicits most admiration among observers is the awesome majesty and power of its stoop and that is the manoeuvre that I most want to see. However, over many years watching wild Peregrines I have only seen a few genuine stoops, that is, an almost vertical dive from a great height, and I suspect wild Peregrines don't need to stoop often to capture their prey, relying on sheer speed in more level flight. Those few I have witnessed were difficult to follow with binoculars, so I had to rely on the optics evolution granted me. That is the best way to appreciate the spectacle anyway, against the wide panorama of boundless sky, when that tiny plummeting dot seems to dominate the universe. The most impressive of the few I have seen was at Munkejarra, a wetland near Derby, when a big female, which I believe was a

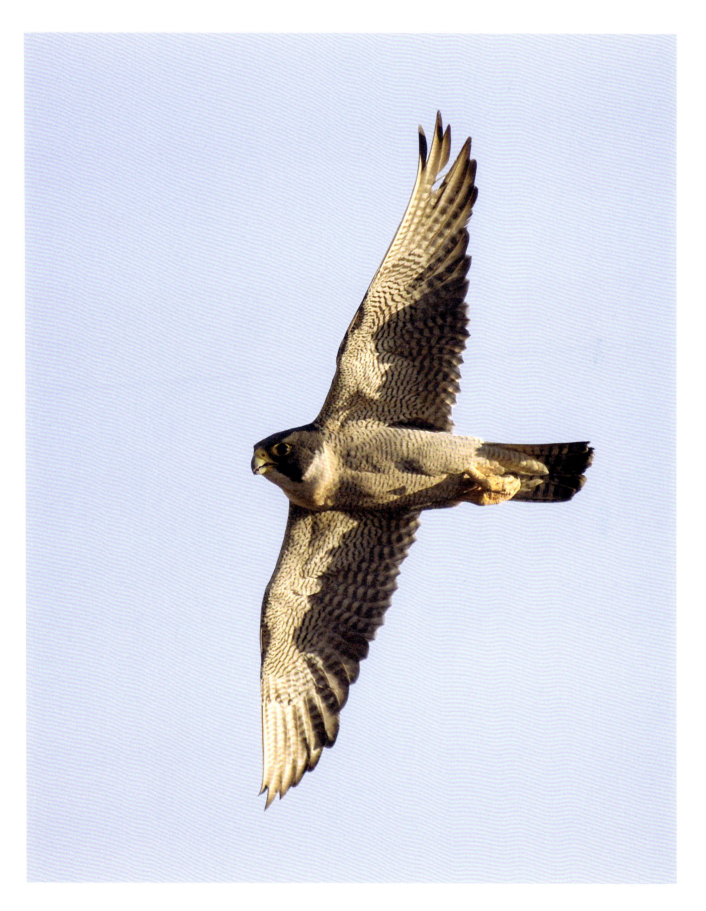

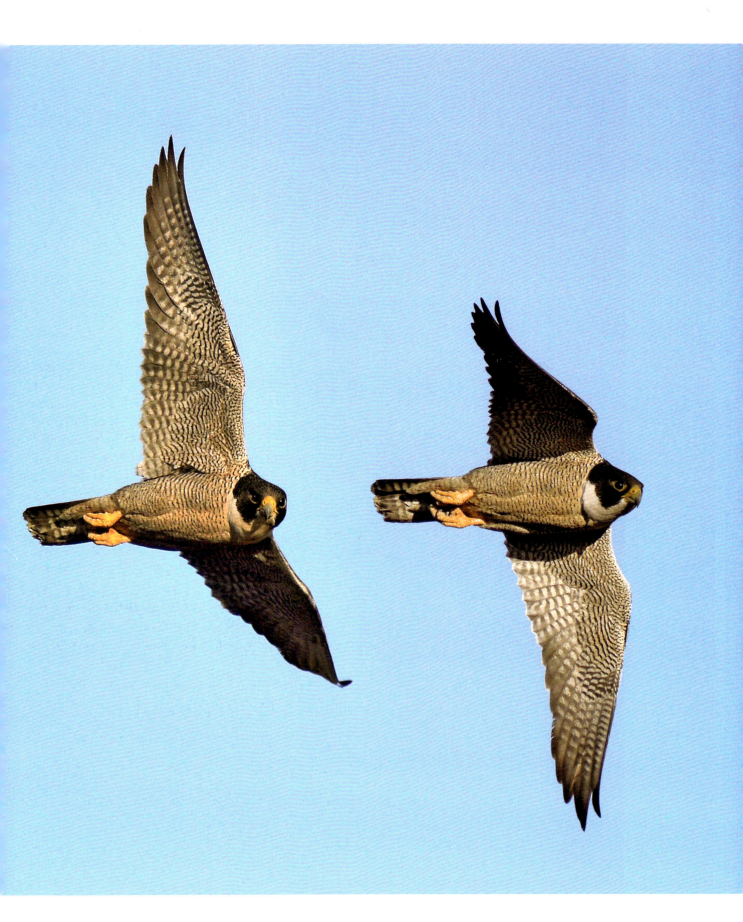

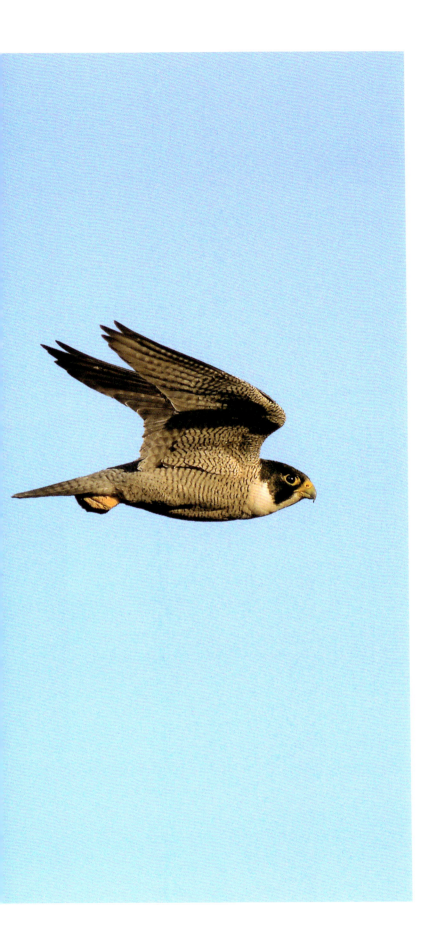

This composite photo by Sally illustrates the massive feet of Australian Peregrines, to us appearing comparatively larger than those of races overseas. When English ornithologist and collector William Swainson received a Tasmanian specimen of the Peregrine from T Winter esq he noted the big feet and gave it the name Falco macropus *(meaning 'large-footed falcon') in his book* Animals in Menageries *in 1838. There must be a reason for such an anatomical feature to be acquired, perhaps necessitated by items of prey such a Galahs that need to be subdued rapidly to avoid being bitten. The image on the right illustrates the aerodynamic perfection of the Peregrine's body in flight; when the wings are tucked in during a stoop drag is reduced to a minimum.*

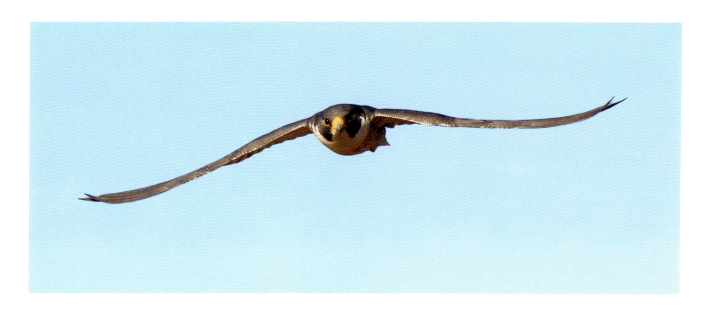

migrant from the Arctic, appeared while we were watching other birds. She was circling very high, then dropped, gaining speed, faster and faster, wings tucked in. As she approached the ground the dive flattened out until she was skimming over the water. So rapid was the momentum that she didn't need to open her wings as she approached a Grey Teal with a raft of ducklings. The whole procedure had been timed to such perfection that she reached the ducks before they realised and neatly plucked a duckling from the water, then opened her wings and sped away.

I was with a group of birdwatchers at Luke's Bluff in the Lamington National Park when a Peregrine arrived, carrying food for the eyasses in a crevice on the bluff face. The young ones could see their parent so high above them and started calling. The falcon was well up, circled awhile then dived at more than 300 kph, deep down into the valley, wings tucked in, pulled up in an awesome parabola and, with perfect timing, alighted like thistledown alongside the screaming youngsters, with wings still closed.

There has been much conjecture in the past over the speed that Peregrines achieve in the stoop. Terminal velocity of a falling object is about 195 kph, but streamlining can increase this figure considerably. Sky divers can accelerate to above 300 kph by orienting the body vertically. The Peregrine's shape is maximised for acceleration and the nostrils have baffles that enable breathing at high speed. The highest reported speed, relying on tame birds carrying a recording device, is 395 kph, but I suspect unencumbered wild birds would exceed this figure. In level flight an average speed would be between forty and sixty kilometres per hour, depending on the conditions, but I have seen incredible bursts of speed on a few occasions. Sally and I once drove alongside a Black Falcon for a few hundred metres in western Queensland at just under 70

kph; I'm sure a Peregrine could beat a Black Falcon in a speed contest if both were hustling, a subjective judgement based on the difference in feathers and body shape, but the Black Falcon excels in manoeuvrability.

Probably the best place and time to see memorable flights is near an eyrie prior to the start of the nesting season, when a pair performs incredible feats of flying as part of the courtship ritual. Raoul and I located an eyrie near Emily Gap in the MacDonnell Ranges in late July. While I was watching, I noticed another pair further along the range, and raised binoculars to watch them. Incredibly I could see yet another pair still further away and I had the unparalleled delight of watching three pairs of Peregrines displaying at the one time. Equally good viewing can be had once the chicks are flying strongly. They chase each other, almost like playing tag. It is amazing to me how quickly the eyasses learn the skills necessary for survival. At an eyrie I was watching one year there was only one chick, for which I had an approximate hatching date. Grant Squelch called in to our place and I took him out to the eyrie, 45–50 days after the presumed hatching date. As we approached, the eyas flew from the eyrie ledge and glided away through the trees. I was most concerned that it had landed on the ground somewhere, and we were about to go searching when the female arrived, carrying a bird. There was a sudden screaming and the eyas came hurtling above the trees. When it reached the female it flipped upside-down and neatly took its meal – an amazing, perfectly timed feat of flying for one so young and inexperienced.

In the 1970s, at a time when Peregrines were still not protected, I positioned a hide at an accessible eyrie. On one occasion I was sitting in the hide and a chick waddled over and sat down near

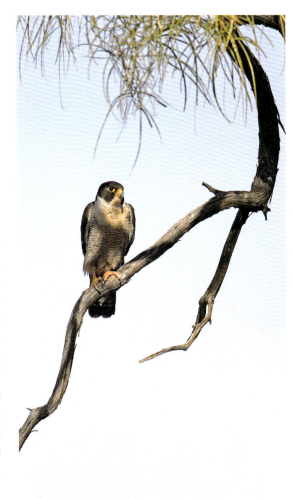

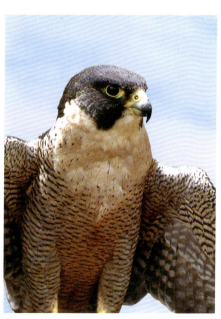

the canvas, just below my peep-hole. The female arrived with a plucked bird and commenced feeding the chick right up against the hide. Her head was about fifteen centimetres away and I had the unparalleled experience of looking a wild, free, unaware Peregrine in the eye. My eye was a centimetre from the peep-hole so I didn't dare move a muscle, hardly breathing, just watched, marvelling at the brilliant yellow colouring of her cere and orbital rings as she tore up the carcase and gently fed her chick. I have seen quite a few captive Peregrines, but none have achieved the intensity of the bare-part colours of that bird. I didn't take any worthwhile photos; the following year protection was afforded to the Peregrine, so I didn't try again; the birds reared only one chick that year. I checked the eyrie a few years later, and the pair had moved to a smaller ledge; once again they only had one chick. This was at a time when DDT was still being used. One morning when I went to the eyrie, a falcon flew from the ground below the ledge. I investigated and

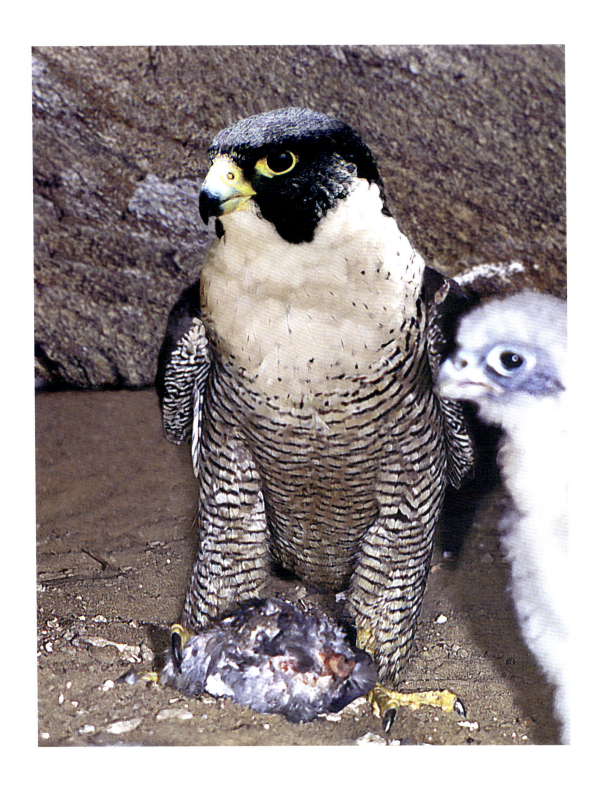

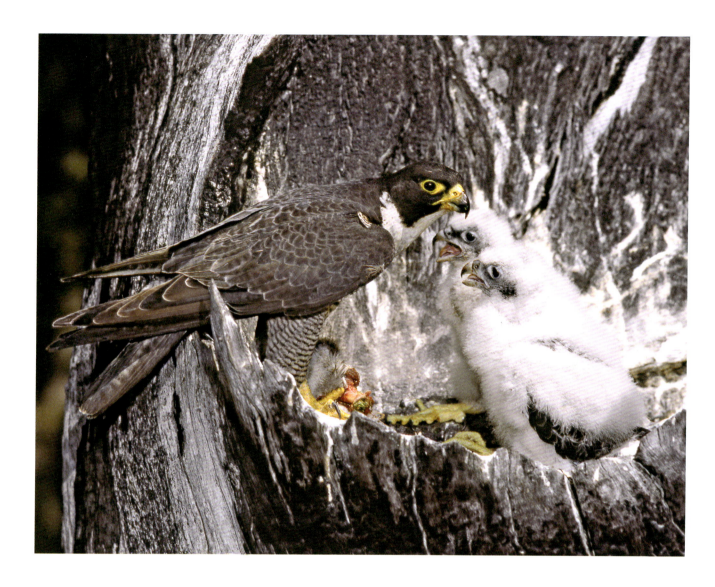

found a recently-dead chick; it had obviously over-balanced and fallen from the small ledge, one more tragedy to add to the decimation attributed to DDT.

Due to the effects of DDT, which caused the thinning of egg-shells, populations of Peregrines in many parts of the world declined, in some countries dramatically. Subsequent to the phasing out of the chemical, Peregrines have made a recovery. In Australia there are instances of breeding on high-rise buildings in cities. Louise Egerton, who edited one of my books, sent me a video of a Peregrine feeding on a pigeon on a high-rise balcony in Sydney. It proved to be a Topknot Pigeon, a species not often seen in the city. Some city eyries have been monitored by cameras and interested viewers are able to watch proceedings online.

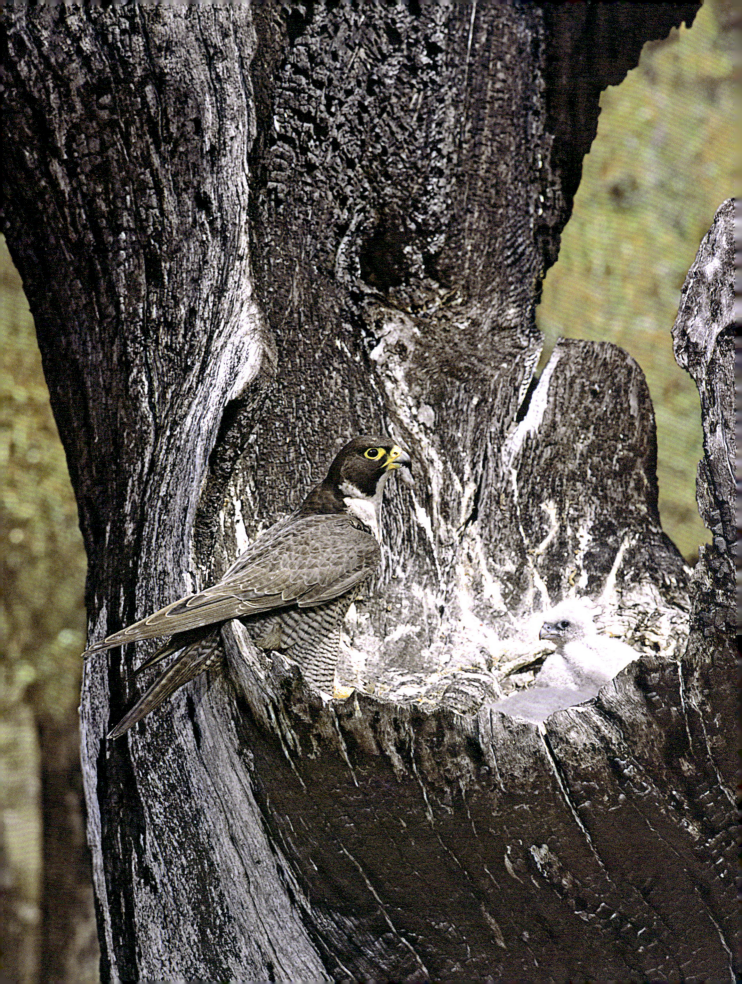

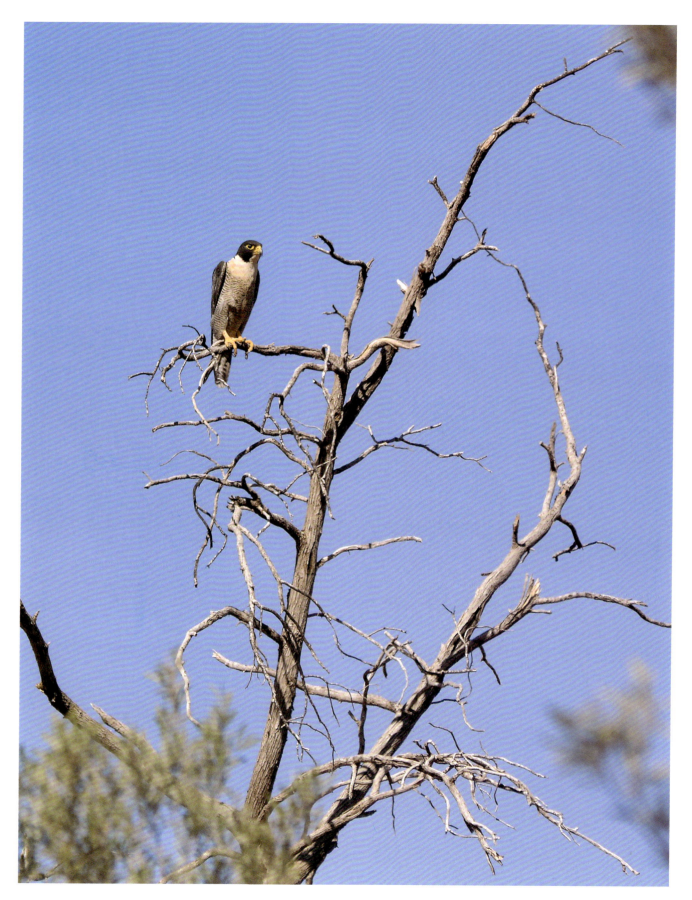

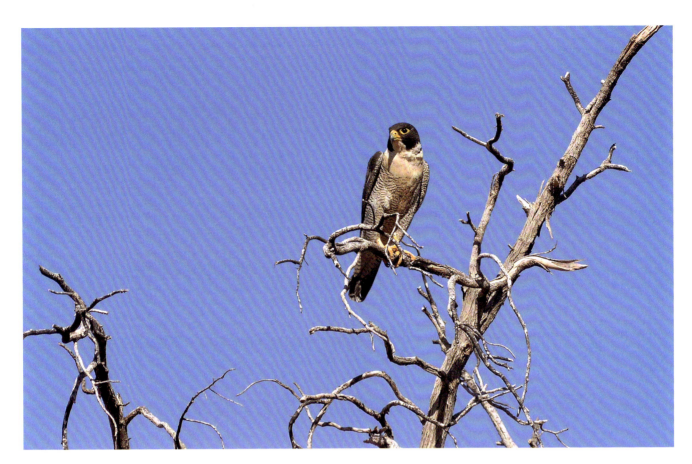

Between Cunnamulla and Bollon in Queensland there is a grove of old cypress trees which I have found over many years to be a good place to explore. The last bird I would expect to find there would be a Peregrine Falcon, as there are no cliffs within a hundred kilometres, but Sally and I spied one sitting near the top of an ancient dead cypress one September. There were two nests in the tree, abandoned by either corvids or kites. Occasionally Peregrines will use nests, usually something bigger than either of these, preferring those built by Wedge-tailed Eagles. We assumed this bird was a female waiting to be fed by its mate. Although we watched for a few hours no mate appeared and the falcon didn't move to either nest. Occasionally it flew off but each time it soon returned to the cypress, without food. We spent a few days in the area photographing a Black Kite on its nest, and each time we passed, the Peregrine was in the tree. There was a possibility something had happened; perhaps because the nests were rather small. Eggs or chicks may have rolled off, so we checked beneath with no sign of remains of either. There were plenty of feathers from Cockatiels, Mulga Parrots and Australian Ringnecks, and one Peregrine tail-feather, from an immature bird. So it remained a mystery: why was a solitary Peregrine Falcon localised in such an unlikely place during the breeding season?

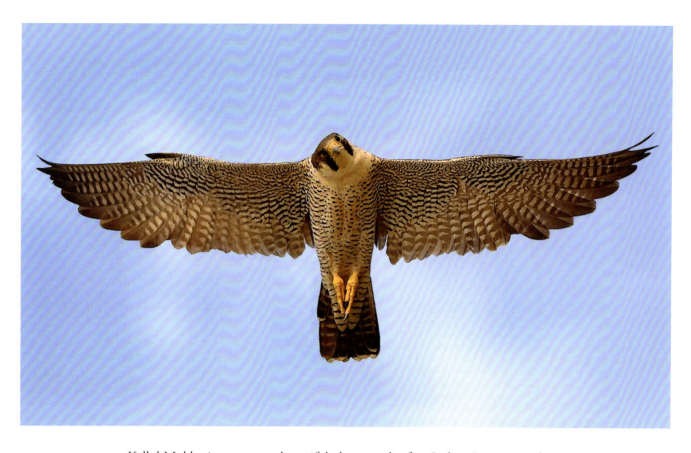

Kallol Mukherjee sent me a beautiful photograph of an Indian Peregrine Falcon (opposite) of the subspecies *peregrinator*, which is often called the Black Shaheen, taken at the Buxa Tiger Reserve in West Bengal. The reason I have included it here is because it is very similar to a small number of Peregrines that occur in Australia, which I think may represent a rare dark morph. Such a bird from south-western Australia was described as *Falco peregrinus submelanogenys* by Gregory Mathews in 1912, and illustrated by George Lodge (p. 206). David Fleay had one at his sanctuary, which was locally acquired in south-eastern Qld; I saw it in the 1970s, and later made a painting. Similar birds are also seen in the Indonesian Archipelago and New Guinea (race *ernesti*), and on islands in and around Fiji (race *nesiotes*).

Kallol also sent me a photo of an Peregrine of the Arctic subspecies *calidus* taken in India (above). This Peregrine regularly migrates southwards to escape the northern winter, and a few have been seen in our region. I think a big, rather lanky, female I saw at Munkejarra near Derby in 1962 was a *calidus*, and, with Gordon Beruldsen, I observed a male just north of Bamaga on the Cape York Peninsula, Qld, that had markings consistent with northern Siberian birds, either *calidus* or *japonicus*. Kallol's photo shows the reduced black cheek and the white forehead seen in *calidus*; it is rather more heavily barred than the birds I saw. Kallol's bird shows comparatively smaller feet than Australian Peregrines, which are well named *macropus*.

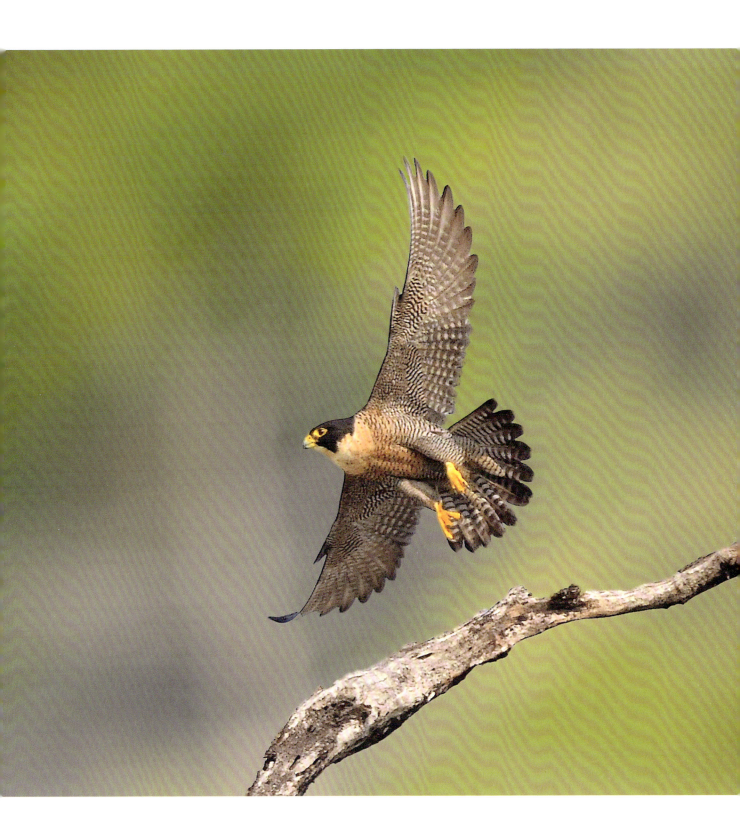

The Peregrine
On burnished black-barred wings in witch-wild gyre
Circles sun-burst clouds of fleece-flecked fire
Needle-crisp eyes spy crest-crowned dove
That fast-flees sickle-scythe shape up above
Feared-falcon plummets from a g-force loop
Thor-thrown hammer in wind-whistle stoop
Snow-cloud feather-storm and crop-burst seeds
Silently drifting: a famished falcon feeds

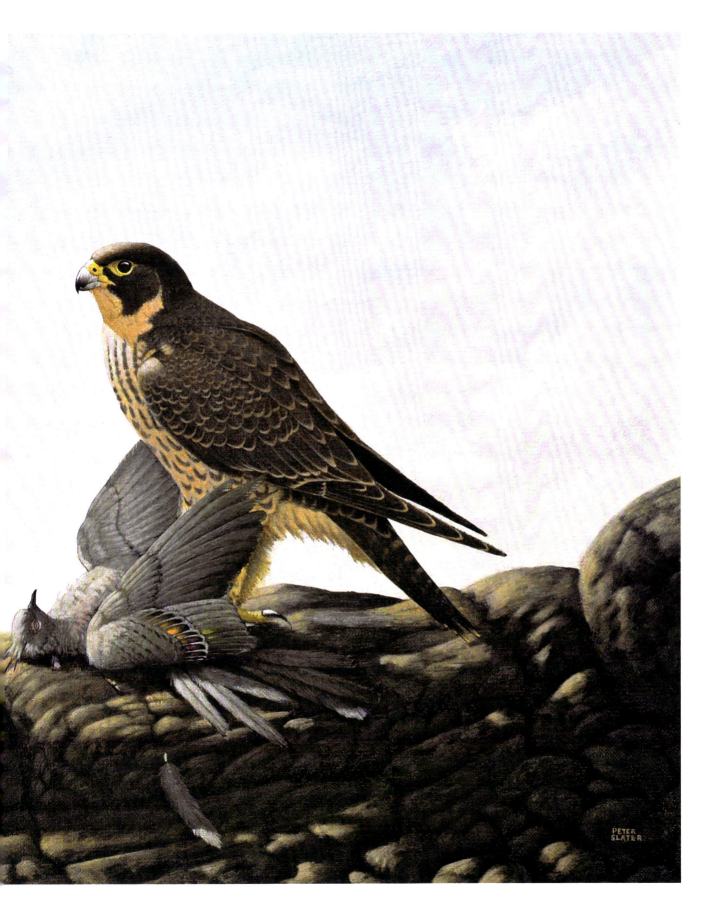

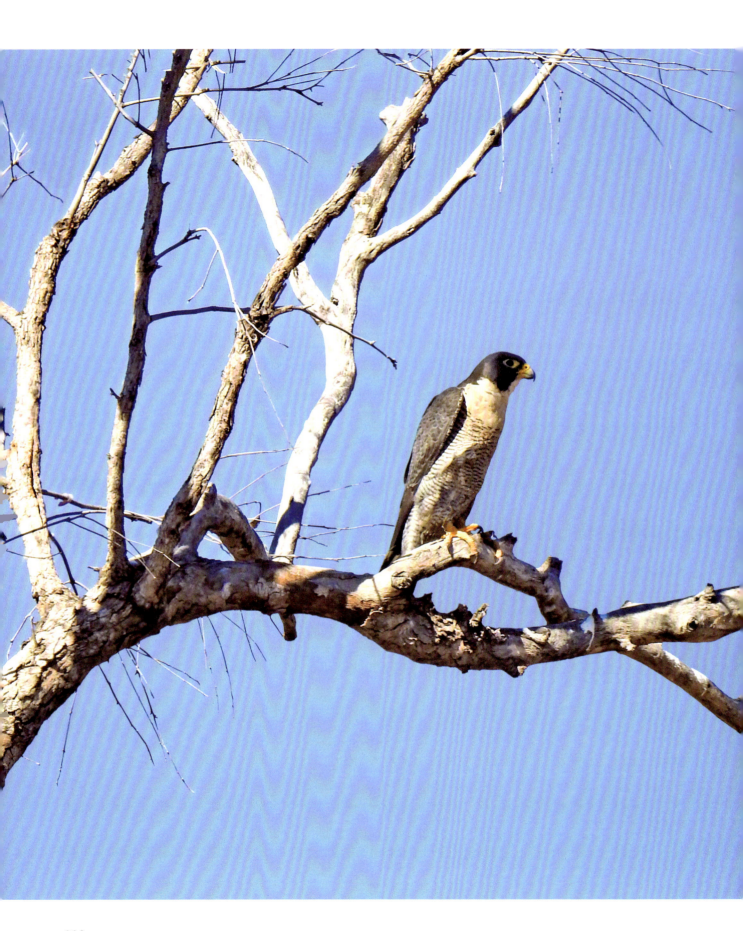

ACKNOWLEDGEMENTS

All photographs were taken by Peter Slater and Sally Elmer, with the exception of:

Ray Garstone, pages 68, 230 and 231
Eric Hosking, page 158
Kallol Mukherjee, pages 234 and 235
Sunil Singhal, page 185
Raoul Slater, pages 152, 153, 154 and 155

All paintings, drawings and haikus were executed by Peter Slater, except where acknowledged.

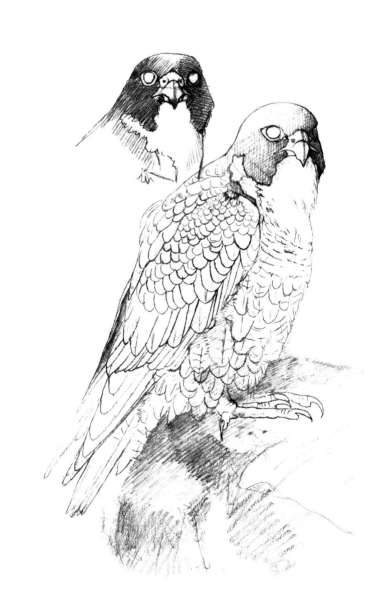

AUSTRALIAN FALCONS

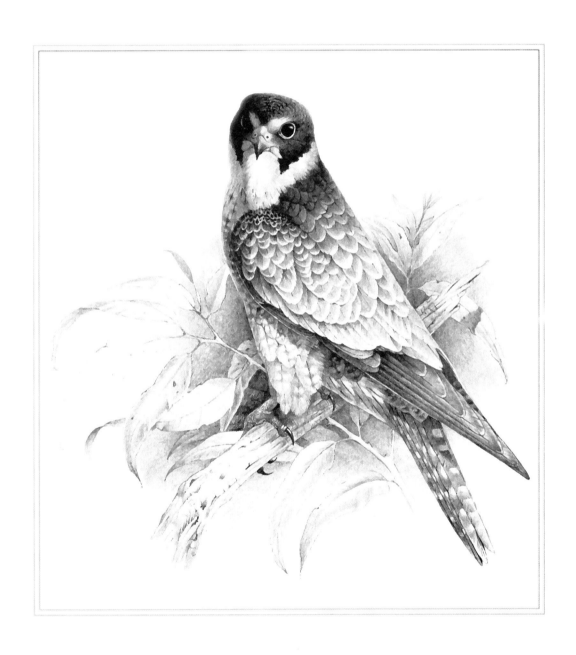

Dedicated to:

Alistair McKissock
Joan and Ray Garstone